WELDED SCULPTURE
OF THE TWENTIETH CENTURY

WELDED SCULPTURE

OF THE

TWENTIETH

CENTURY

JUDY COLLISCHAN

HUDSON HILLS PRESS NEW YORK

IN ASSOCIATION WITH THE NEUBERGER MUSEUM OF ART, PURCHASE, NEW YORK

For Brien and Noah

First Edition

© 2000 by Neuberger Museum of Art

Welded Sculpture of the Twentieth Century is published in conjunction with an exhibition of the same title held at the Neuberger Museum of Art from May 14 to August 27, 2000.

Published in the United States by Hudson Hills Press, Inc., 122 East 25th Street, 5th Floor, New York, NY 10010-2936.

Distributed in the United States, its territories and possessions, and Canada by National Book Network.

Editor and Publisher: Paul Anbinder

Manuscript Editor: Virginia Wageman

Proofreader: Lydia Edwards

Indexer: Karla J. Knight

Designer: Martin Lubin

Composition: Angela Taormina

Manufactured in Japan by Toppan Printing Company

Library of Congress Cataloguing-in-Publication Data
Collischan, Judy.
Welded sculpture of the twentieth century / Judy Collischan.— 1st ed.
 p. cm.
Includes bibliographical references and index.
ISBN: 1-55595-167-8 (alk. paper)
1. Welded sculpture—20th century. I. Title.
NB1220.C65 2000
735'.23—dc21 99-53999

CONTENTS

FOREWORD AND ACKNOWLEDGMENTS

The Neuberger Museum of Art is pleased to co-publish with Hudson Hills Press this landmark publication devoted to the history of welded sculpture, a technique that had its naissance in the third decade of the twentieth century.

While essentially a technique of European origin, as seen especially in the works of Julio González and Pablo Picasso, by the mid to late 1930s welding had made its way into the artistic vocabulary of many American artists, including, among others, David Smith, Seymour Lipton, Theodore Roszak, and Herbert Ferber. Also in the 1930s, New York financier and later founder of the Neuberger Museum, Roy R. Neuberger, was establishing a collection of the work of young American artists, and eventually he acquired a significant number of welded pieces by these early pioneers in the medium.

Prior to accepting her appointment as Associate Director of Curatorial Affairs at the Neuberger Museum, Judy Collischan had dreamed of putting together a comprehensive survey of welded sculpture. Given the strength of the Neuberger's holdings, the idea of pursuing such a project took hold, resulting in this book and exhibition.

As with any project of such magnitude, there are many people without whom this exhibition and publication could not have come to fruition. Dr. Collischan organized the exhibition, wrote the text for this publication, and, aided by Curatorial Assistant Jacqueline Shilkoff, implemented every aspect of bringing the works together for exhibition and gathering photographs for publication.

We thank Publisher Paul Anbinder of Hudson Hills Press who put together the editorial, design, and production team of Virginia Wageman, Martin Lubin, and Angela Taormina. At the Neuberger Museum, the registrarial and installation staff, led by Patricia Magnani and Dan Gillespie respectively, saw to the exhibition's management and installation.

We owe an enormous debt to the lenders to the exhibition, to whom we express our profound gratitude, and we also express our thanks to the many institutions that provided photographs for publication. In addition to individual artists who lent their work to the exhibition, we wish to thank the following: Addison Gallery of American Art, Phillips Academy, Andover, Mass.; Edward Albee; Albright-Knox Art Gallery, Buffalo; Linda and Stuart Barovick; Doreen and Gilbert Bassin; David Beitzel Gallery, New York; Blanche and Bud Blank; Colby College Museum of Art, Waterville, Maine; Danielle and Marc Cousins; Marc de Montebello Fine Art, Inc., New York; Greenberg Van Doren Gallery, St. Louis; Grey Art Gallery and Study Center, New York University Art Collection; Solomon R. Guggenheim Museum, New York; Hirshhorn Museum and Sculpture Garden, Smithsonian Institution, Washington, D.C.; Hood Museum of Art, Dartmouth College, Hanover, N.H.; N. Richard Janis and Janet Hirshberg; Marcella and Max L. Kahn; Locks Gallery, Philadelphia; The Frances Lehman Loeb Art Center, Vassar College, Poughkeepsie, N.Y.; Los Angeles County Museum of Art; Catherine and Bruno Manno; Joan Marter; McKee Gallery, New York; Elaine and Melvin Merians; National Gallery of Canada, Ottawa; New Orleans Museum of Art; PaceWildenstein Gallery, New York; Philadelphia Museum of Art; Michael Rosenfeld Gallery, New York; Salander-O'Reilly Galleries, New York; San Francisco Museum of Modern Art; Anita Shapolsky Gallery, New York; Sigma Gallery, Inc., New York; Steinbaum Krauss Gallery, New York; Wadsworth Atheneum, Hartford; and Yale University Art Gallery, New Haven.

With gratitude, we wish to acknowledge that funding for the exhibition and the catalogue has been generously provided in part by public funds from the New York State Council on the Arts, a State Agency; the Friends of the Neuberger Museum of Art; and the Westchester Arts Council.

Lucinda H. Gedeon
Director, Neuberger Museum of Art

INTRODUCTION

An artist first called my attention to the fact that welded sculpture is a relatively recent phenomenon, unique to the twentieth century. In a conversation with me in the early 1970s, Sidney "Buz" Buchanan, a sculptor who uses the welding technique, observed that the potentials for welding had hardly been tapped because of its short history in comparison to stone carving or bronze casting. Welded sculpture evolved in the third decade of this century as artists adapted an industrial method for aesthetic purposes.

From a curatorial point of view, then, welded sculpture is a manageable exhibition concept. Unlike marble or bronze sculpture, which have extensive histories, welded sculpture has been in existence only about seventy years. Many renowned and respected artists have either made welding their medium of expression or used it for a particular body of work. Although some of these artists have received considerable attention as individuals, this book and the accompanying exhibition are the first to examine the art of welded sculpture as a continuum.

The purpose of this historical survey is to explore the plentiful and varied approaches possible through welding and its companion processes. Some artists have produced a prodigious body of work via welding, while others have advanced this means through a passing but important effort. Though it possesses European artistic roots, welding has been identified particularly with American art. It has transcended several "isms" and trends, by-passing ephemeral styles and marketing mechanisms. Presented here in detail is an examination of a technique, its artist exponents, and the relevant social and political milieu

over the last three-quarters of this century.

Useful in opening up form so that sculpture is less massive, welding also lends itself to association of geometric shapes. At times linear and at times volumetric, welded sculpture has assumed various formations depending on the individual artist's intent. Welded works have been by turns figurative, abstract, organic, and geometric. They can be political in content. Some artists have added pigment or found objects or have introduced sound, movement, and interaction.

For our purposes, welding may be defined as the fusion of metal through the application of heat. This definition encompasses brazing, soldering, and commercial manufacturing or fabrication. Not included here are forms of metal sculpture that are cast, bolted, or riveted. Whether or not welding marks remain or have been smoothed is not of concern, as the methodology receives different kinds of emphasis by individual artists.

This book records and comments on the history of welded art as it has occurred in our time, contributing to and expanding artistic parameters. In addition to welding's connections with a range of contemporaneous aesthetics, it has added to artistic vocabulary as well as to artistic means and ends. Essentially, the organization of this book is chronological, the passing of time being linked with various personal approaches to possibilities offered by welding. The roots of welded sculpture are traced in both art and industry, then its multiple facets are considered in terms of practicing artists. Early exponents form a basis for the many artists involved with the technique.

Humankind's discovery of fire and the manufacture of metal gave rise to means for joining surfaces of heightened tensile strength and durability. Thus space could be spanned and support provided with minimal bulk. Line and plane define modern skylines and products. Hollow as opposed to solid form is a hallmark of this century, as exemplified by the piercing or opening up of form in sculpture and steel-beam construction in architecture. Welding is an important function of society's recent penchant for technology and fascination with space. Artists have used it to express their own thoughts, feelings, and perceptions about this technological epoch.

HISTORICAL SOURCES

In essence, welded sculpture entails two elements—metal and fire. The older of these, fire, was discovered in the early stages of humankind. At first it provided warmth, light, and a means of cooking food. Eventually, the energy of fire proved to be a crucial element in the extraction and production of metal. Ancients knew of and used metals, especially gold, silver, and copper, to form small decorative and useful objects. Bronze, an alloy of copper and tin, was cast for similar purposes. These items constituted early forms of three-dimensional art. Iron, known since about 1100 B.C., encouraged the making of tools, implements, and machinery. Refined iron in the form of steel became valued for its varying degrees of hardness, elasticity, and strength. Alchemists of the Middle Ages, while discover-

ing much about the behavior of metal, also plumbed its properties in search of ways to concoct gold. Like fire, metal proved useful and also inspired conjecture. Steel available in large quantities occurred in the eighteenth century, at the time of the Industrial Revolution. Since 1900 many inventions and developments have improved methods of making both iron and steel and have lowered production costs.

Welding, evolving first in industry and then in art, has only a hundred-year history. By way of contrast to bronze-casting methodology, welding is immediate, direct, and requires less time to realize a final stage. Differences in processes result in varying artistic results. Iron and particularly steel are an integral part of industrial expansion as primary building and manufacturing materials. They have been used in a large portion of sculpture produced in this century. Fulfilling the urge for a "modern" as opposed to an historical aesthetic, welding is disassociated from past technique.

Modernism has been increasingly characterized by an expanded world view that includes incorporation of Western with non-Western art forms, integration of new spatio-temporal relationships, and an interrelationship of aesthetic processes and concepts with those of industry. Cubism constituted a major breakthrough in terms of incorporation of African sculpture, manufactured materials, and concepts of simultaneity or realization of an object from several vantage points. Analysis, dissection, and reassociation of form became more important than replication of natural phenomena. Nature no longer provided the only reference point. It was replaced by man-made constructs.

Cubist aesthetics, begun with Pablo Picasso's *Les Demoiselles d'Avignon*, 1907 (pl. 1), and extended by the invention of collage, provided the artist with independent means to organize formal elements. Cubism's evolution included Futurism, as exemplified by Umberto Boccioni's

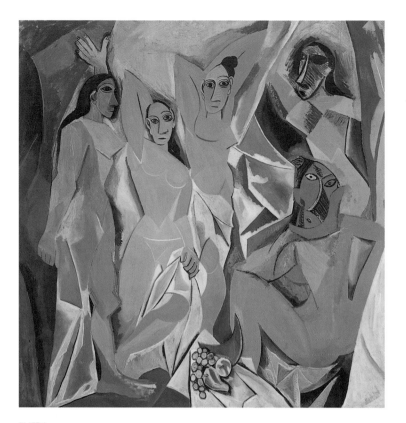

PLATE 1
PABLO PICASSO
Les Demoiselles d'Avignon, 1907
oil on canvas
96 x 92 inches
The Museum of Modern Art, New York
Acquired through the Lillie P. Bliss Bequest

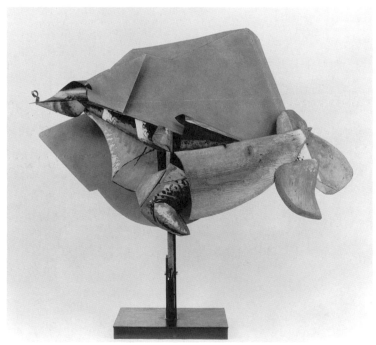

FIGURE 1
UMBERTO BOCCIONI
Dinamismo di un cavallo in corsa + case
(Dynamism of a Speeding Horse + Houses), 1914–15
gouache, oil, paper collage, wood, cardboard, copper, iron, coated with tin or zinc
44½ x 45½ inches
The Solomon R. Guggenheim Museum, New York

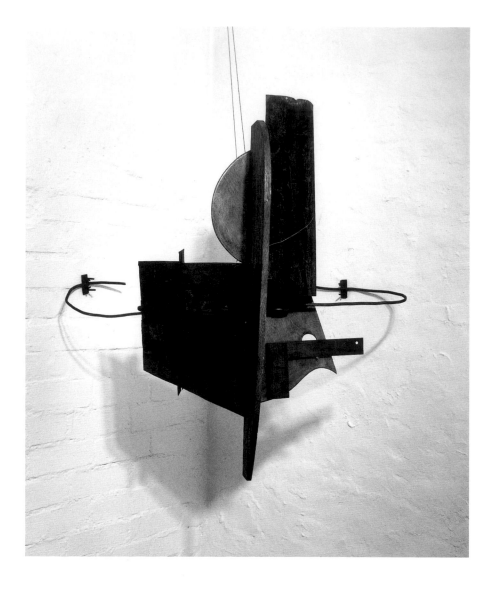

FIGURE 2
VLADIMIR TATLIN
Counter Relief, 1915
(reconstruction, from photographs, by Martyn Chalk, 1979)
wood, iron, wire
30½ x 31¼ x 27¼ inches
Annely Juda Fine Art, London
© Estate of Vladimir Tatlin/Licensed by VAGA, New York, New York

structed primarily with sheetmetal bolted together. In later large works, he used welding for added strength, but inherently his work is not involved with the latter method.[1]

Here our focus is on metal connected through the process of soldering, brazing, or welding—oxyacetylene, arc, or heli-arc welding. Fabrication can be either in the studio or in a foundry or factory, done by factory workers. Each process (defined in the Glossary) dictates a certain aesthetic approach. Factory fabrication, for example, has been used by artists interested in an objective, straightforward approach. Artists doing their own welding, on the other hand, might be more interested in an intense emotional, even impulsive form of expression as well as an intellectually considered mode of communication. Numerous variations in construction and finish are available to the artist working in metal, depending upon his or her goal, space, and equipment. Techniques are derived mostly from industrial production and employed for creative ends.

Dinamismo di un cavallo in corsa + case (Dynamism of a Speeding Horse + Houses), 1914–15 (fig. 1); Vladimir Tatlin's work, such as *Counter Relief,* 1915 (fig. 2), which laid the grounds for Constructivism; Marcel Duchamp's inclusion of the ready-made object in an artistic context, as when he exhibited a urinal in 1917 and called it *Fountain;* Piet Mondrian's evolution of de Stijl in Holland; Walter Gropius's German Bauhaus; and the American architecture of Frank Lloyd Wright. These worldwide tendencies provided a basis for the development of welded sculpture.

METHODOLOGY

Like its ancient components, fire and metal, modern welding means have made possible a transformation in the art of sculpture. Welding can convey intense emotional expression. It can transform metal into detailed or reductive or intellectual or passionate statements. Welding can suggest realms beyond reality. It has been used for utilitarian purposes, but it also can plumb the depths of the human imagination.

In art as in industry, there are several ways of using metal. Often metal pieces are fabricated by cutting and joining sheets with screws or rivets. Alexander Calder's mobiles and stabiles, for instance, are con-

1 ORIGINS

The Industrial Revolution, beginning in the middle of the eighteenth century, transformed the social and economic structures of the Western world. The introduction of power machinery and steam engines revolutionized the textile, transportation, and building industries. Coal and iron were valued commodities, and iron production increased through the use of coke in smelting. Financiers invested vigorously in the development of waterways, roads, and railways, as well as in the purchase of equipment and the expansion of factories. Major wars in the twentieth century called for huge industrial campaigns, accelerating the development of new technologies. One important technology in this industrial advancement was welding.

Arc welding was made possible through the introduction of the coated electrode in the 1920s. The oxyacetylene torch, invented in 1900 and using gas, became another dominant method, along

with heli-arc welding used after 1942. These technologies were used to construct the steel skeleton of a thriving industry. Some artists learned to weld while working in factories.

ART OF THE TWENTIES AND THIRTIES

Dada, a movement in art and literature founded in Switzerland in the early twentieth century, ridiculed contemporary culture and conventional art. The anarchic spirit of Dada led in the 1920s to a tendency called Surrealism. In 1924 André Breton issued his *Manifesto of Surrealism* proclaiming the subconscious as a source for artistic content and form. Play, dreams, and free associ-

ation were validated as creative means. Surrealism was essentially a Parisian movement and involved, among artists, Pablo Picasso, Giorgio de Chirico, Max Ernst, Francis Picabia, Joan Miró, André Masson, and later René Magritte, Salvador Dalí, and Yves Tanguy. Surrealist art, with its strong literary associations, took two directions: representational and abstract, often juxtaposing one with the other. The ultimate aims were romantic and rebellious, with subjects and content that dealt with chance encounter and effect. Control was at least in part relinquished to other-than-human forces. Gravity was utilized, along with collage and rubbing techniques, referred to as *frottage*. The accidental, unplanned juxtaposition of organic shapes and figurative forms served fantastic as opposed to logical ends.

An earlier movement, Futurism, originated in Italy in 1909 and glorified the machine age, celebrating

motion and speed. Futurism joined with Dada and Surrealism to transform the forms and content of sculpture, bringing the realm of fantasy to sculptural creations.

Picasso's work of the 1920s veered from classicism to Surrealism. The former style featured gargantuan human forms with limited spatial backgrounds. Modeled figures appear solid and ponderous. Picasso's classicism is statuesque; that is, the human forms have a weightiness reminiscent of sculpture. Greater distortion and emphasis on line occurred about 1925, during his association with the Surrealists. *Bather (Metamorphosis I)*, 1928 (fig. 3), indicates his concern with curvilinear form including space as well as mass. Gone is the earlier cubist faceting of form, that geometrization of the figure having been succeeded by rounded shapes. This sculpture presages Picasso's urge to span or delineate space rather than occupy it.

It is at this juncture that Picasso's association flourished with his fellow countryman and friend, Julio González, a skilled metalworker and sculptor in his own right. González helped Picasso with his intention to use line and space in sculpture. In turn, González was inspired by the creative experimentation of Picasso. It is with González, then, that we begin the story of welded art.

JULIO GONZÁLEZ

The father of modern metalworking, Julio González (1876–1942) was not recognized as such until after his death. David Smith, Theodore J. Roszak, and others lauded him in the 1950s when a retrospective of his work was presented in Europe, and gradually his work became revered in this country and elsewhere.[1] A Catalonian born in Barcelona,

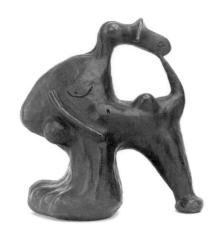

FIGURE 3
PABLO PICASSO
Bather (Metamorphosis I), 1928
bronze
8⅞ x 7⅛ x 4½ inches
Musée Picasso, Paris

González was religious, devoted to his family, and steeped in the decorative arts tradition of northeastern Spain. However, he was sure of his future as an artist and of the place of metal sculpture in modern art.[2]

González came from a line of metalsmiths and served his apprenticeship with his brother, Joan, in their father's shop. Before turning to sculpture, González received solid training in making commonplace objects, such as jewelry, buckles, and other small utilitarian items. His technical ability grew out of not only a family tradition but also a Catalan heritage of iron mining and metalwork.

The city of Barcelona at the end of the nineteenth century was a center of advanced artistic activity. A liberal political and intellectual atmosphere was fueled by interest in Friedrich Nietzsche, Richard Wagner, and Henrik Ibsen. Pre-Raphaelite influence encouraged reappraisal and appreciation of the work of El Greco. Antonio Gaudí was at work on the church of the Sagrada Familia with its fluid combination of abstract and organic elements. His decorative style made architecture look like sculpture and mosaics like painting.

This visionary's work, a precursor of Surrealism, was a constant and public presence in Barcelona. González, however, busy with his family and their successful workshop, did not become involved with the more artistically advanced and Bohemian elements in turn-of-the-century Barcelona.

In 1900 the death of his father and the failing health of his older brother, Joan, caused González's family to sell the metalsmithing shop, after which they moved to Paris.[3] Although the González brothers' livelihood had been based on metalsmithing, they had actively sought fine art training by taking academic courses in Barcelona and had been exposed to the work of Parisian artists. González's drawings and sculpture after his move to Paris are simple and flowing in line, not unlike the work of Henri de Toulouse-Lautrec and Picasso. There is a darkness, a sadness, that pervades González's drawings, perhaps in response to the illness and untimely death of his beloved brother in 1908.

González's work in hammered copper from this period through the late 1920s exhibits a classical simplicity and massiveness. Lines and contours are curved, and there is a fullness to modeled figures and faces, as in *Portrait of Alberta*, 1913 (fig. 4), and *Head with Curls*, 1921 (fig. 5). Ongoing with his explorations of a personal art form was his production of decorative, functional objects that retained an inclination toward linear refinement.

During World War I González worked in a Renault factory, where he learned to weld with an oxyacetylene torch.[4] After the war, friendship continued to evolve between González and Picasso,[5] to whom González had earlier been introduced in Barcelona by his brother. From 1928 through 1931 their alliance was mutually beneficial, resulting in a body of sculptural work for the younger Picasso, who learned welding from González, and encouraging a turn in artistic direction for González. Picasso was

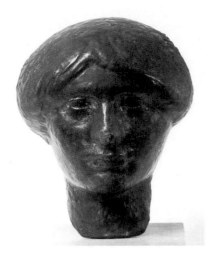

FIGURE 4
JULIO GONZÁLEZ
Portrait of Alberta, 1913
hammered copper
11⅞ x 8⅜ inches
Museo Nacional d'Art de Catalunya, Barcelona
Gift of Roberta González

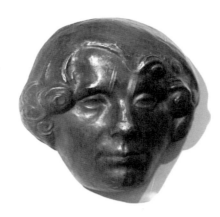

FIGURE 5
JULIO GONZÁLEZ
Head with Curls, 1921
hammered copper
8⅝ x 7½ x 4 inches
Museo Nacional d'Art de Catalunya, Barcelona
Gift of Roberta González

engaged himself with his family's business and welfare. By about 1927 his work in cutout iron shapes for masks, faces, and figures indicated the beginnings of a new direction. *Pensive Face,* 1929 (fig. 6), demonstrates his turn toward form abstracted into plane and line in a cubist fashion. Artistically, González was ripe for expansion of his new approach to sculpture.

His work with Picasso piqued an already formed interest in the analysis of figurative form. The collaboration confirmed Picasso's faith in metal as a fine art medium, and he used it to further his lifelong exploration of the human body. Instead of his former decorative designs consisting of curvilinear shapes based on nature, González began to employ flat planes and geometric lines in direct combination.

able to realize a highly abstract form of sculpture based on his earlier cubist work and his interest in the surrealist connection of mind and abstract space. González, on the other hand, developed an interest in the abstract play of light and shade via plane and void.

Picasso, though five years younger than González, was well established in art by the late 1920s, having changed the course of painting and produced a respected and acclaimed body of work. Until just before their collaboration, González had emotionally and artistically

Roberta au soleil (Roberta in the Sun), ca. 1929 (fig. 7), and a later drawing, *Masque austère (Austere Mask),* 1940 (fig. 8), illustrate his translation of bright light and dark shadow into physical, geometric shapes. Several masks of this period, still-life work, and full figures reveal his reduction of natural forms and

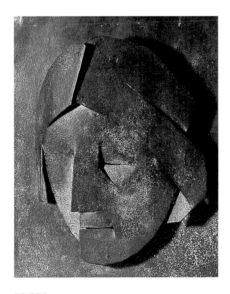

FIGURE 6
JULIO GONZÁLEZ
Pensive Face, 1929
forged, cut, cut-out, and bent iron, tacked to painted wood
9½ x 7¾ x 1¾ inches
Cleveland Museum of Art

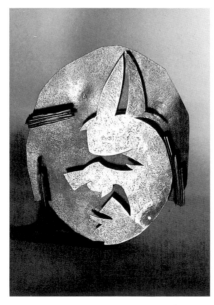

FIGURE 7
JULIO GONZÁLEZ
Roberta au soleil (Roberta in the Sun), ca. 1929
cut-out iron, soldered to iron plate
7 x 6¼ x ¾ inches
IVAM, Centre Julio González, Valencia
Courtesy Galerie de France, Paris

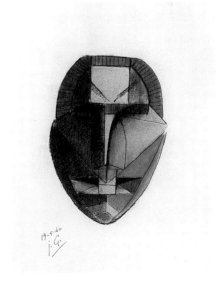

FIGURE 8
JULIO GONZÁLEZ
Masque austère (Austere Mask), 1940
pen and Indian ink, wash on paper
12¼ x 9¼ inches
Estate of Julio González
Courtesy Galerie de France, Paris

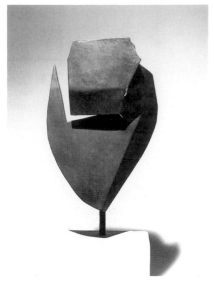

FIGURE 9
JULIO GONZÁLEZ
Tête aiguë/Masque aigu (Angular Head/Angular Mask), ca. 1930
cut, bent, forged, and soldered iron
10 x 6¼ x 4½ inches
Galerie Hoss, Paris
Courtesy Galerie de France, Paris

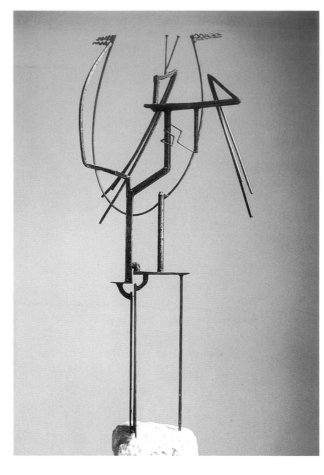

FIGURE 10
JULIO GONZÁLEZ
Femme se coiffant II (Woman Combing Her Hair II), ca. 1934
forged and soldered iron
47¼ x 23½ x 11¼ inches
Moderna Museet, Stockholm
Courtesy Galerie de France, Paris

association of their abstract equivalents. From 1927 his production was decidedly planar and focused on simplification. A culminating work is the dramatic *Tête aiguë/ Masque aigu (Angular Head/Angular Mask)* of about 1930 (fig. 9). Bent and cut iron, deftly manipulated, gives the barest suggestion of human physiognomy.

González's work, like that of many other artists of the time, bears resemblance to African sculpture, especially masks. A fascination with African art was pervasive in France and elsewhere early in the twentieth century. Reduction, exaggeration, distortion, disassembly, and reassembly are all processes undertaken by African artists to give form and meaning to masks and sculpture intended for spiritual and ritualistic purposes. Using these methods, European artists did not intend any religious or functional purpose, but inherent in the format was the notion of concealment.

A linear element is prominent in González's oeuvre of the early 1930s, possibly because of Picasso's interest in line during the same period, or perhaps because of González's background in the decorative arts. His *Femme se coiffant II (Woman Combing Her Hair II),* ca. 1934 (fig. 10), is especially indicative of this tendency. The emphasis here is on openness of form. It is a sculpture of line moving through space suggesting contours. Elbows akimbo, the woman lifts combed sections of hair. Her arms are portrayed by lines bent and curving outward in space, and combed hair is suggested by short, squiggly lines in rows. Abstract and dependent upon suggestive linear activity, the work leaves viewers to complete the image. This type of openness was technically suited to welded metal. The desire to span space without occupying it required a means of linking forms at junctures that would be strong and permanent. The tendency was also undoubtedly inspired in part by the surrealist

emphasis upon insubstantial, otherworldly realms.

Throughout his career, González was occupied with variations on the human head and body, in some instances highly abstract and in others less so. *Woman with Bundle of Sticks,* 1932 (pl. 2), remains close to the masks of the prior decade in its translation of light and dark into two-dimensional planes.[6] There is a noticeable degree of realism in the artist's more traditional depiction of a figure completing a task. Further, he has delineated the figure's breasts, feet, hair, and the folds of her garment. The delicacy of the feet, sticks, and dress pleats contrasts with broad, unrelieved background planes. An anterior building is suggested through crudely cut and intersecting planes forming a corner. The figure's placement in front of two abstract shapes indicating an architectural backdrop juxtaposes realism and Constructivism. The charm of this work exists in

its vignette quality, as though a section of life has been removed and displayed as art. Its power lies in this artist's emphatic juxtaposition of woman and building. The sculpture presents a juncture of abstraction and realism. Although small in scale, the work is monumental in its statement of a figurative-architectural theme.

Woman with Bundle of Sticks is indicative of the essential strength of González's work—its immediacy and spontaneity manifest the means of welding itself. It is a compact and potent statement. His abrupt integration of form reflective of process attracted later artists, among them David Smith.

González's work from the early to mid-thirties veered toward curved as well as straight planes connected in space to suggest figurative origins. *Head Called "The Tunnel,"* 1933–34 (fig. 11), is highly abstract. A cylinder suggests the volume of a head with a plane indicating a neck. Based on previous renditions, the protruding lines at the top may represent hair. This particular period of the artist's career is constructivist in bent, recalling the early experiments of Vladimir Tatlin, who used disparate materials to build art that incorporated surrounding space. González is related to this constructivist tradition, as he exploited the possibilities of sheet metal—his favored medium. Circular, cylindrical, triangular, rectangular, and trapezoidal shapes characterize a geometrical translation of the human head. These forms demarcate space more than they indicate a human form.

About mid-decade González's work began to bear resemblances to that of Picasso. His well-known *Head,* ca. 1935 (fig. 12), presents anatomical curvature via a sliced section. This graduated shape suggests transition from line to volume and back, while maintaining its function as rounded contour. The teeth represented here suggest Picasso's treatment; they relate to a ferocious aspect present in

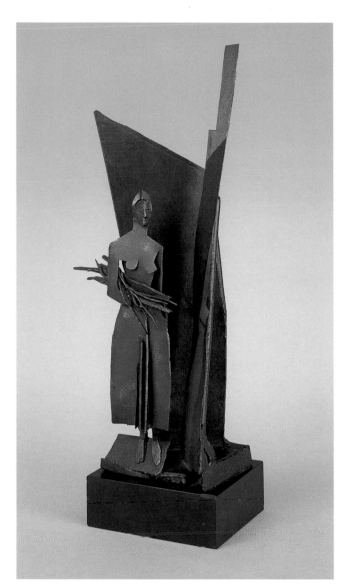

PLATE 2
JULIO GONZÁLEZ
Woman with Bundle of Sticks, 1932
welded iron
14³⁄₈ x 6⁷⁄₈ x 4¹⁄₈ inches
Hirshhorn Museum and Sculpture Garden, Smithsonian Institution, Washington, D.C.
Gift of Joseph H. Hirshhorn, 1966

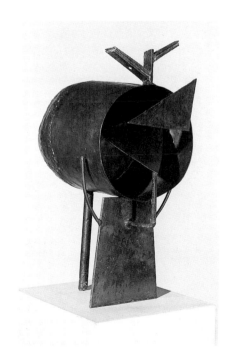

FIGURE 11
JULIO GONZÁLEZ
Head Called "The Tunnel," 1933–34
steel
18³⁄₈ x 8¹⁄₂ x 12⁷⁄₈ inches
Tate Gallery, London

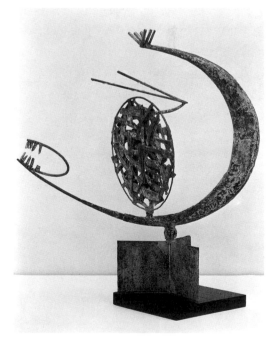

FIGURE 12
JULIO GONZÁLEZ
Head, ca. 1935
wrought iron
17³⁄₄ x 7¹¹⁄₁₆ x 15¹⁄₄ inches
The Museum of Modern Art, New York
Purchase

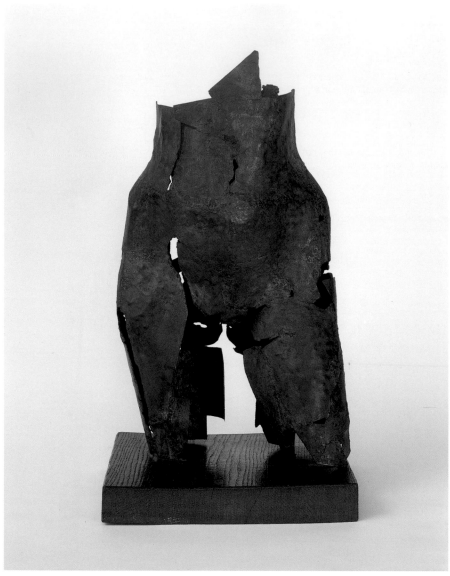

PLATE 3
JULIO GONZÁLEZ
Torso, ca. 1936
hammered and welded iron
24³/₈ x 14¼ x 10⁵/₈ inches
The Museum of Modern Art, New York
Gift of Mr. and Mrs. Samuel A. Marx

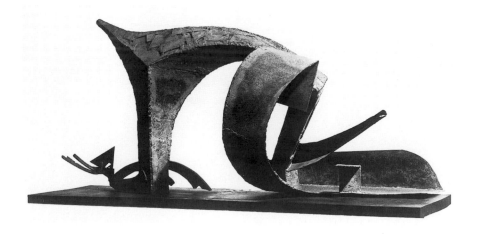

subsequent work. Also present is a cubist interlocking of abstracted forms represented by *Reclining Figure,* 1934 (fig. 13), and his return to a theme in *Woman Combing Her Hair,* 1936 (fig. 14). In comparison to the earlier version, the latter suggests fleshier aspects of the female, namely buttocks and breasts.

Torso, ca. 1936 (pl. 3), is indicative of González's enduring devotion to the female form. In this piece he deftly relates metal to the human shape by means of subtly curving planes, suggesting belly, hips, and thighs in a display of sensitive realism. He examines mythological and patriotic themes through a woman's figure in his monumental *Montserrat,* 1936–37 (fig. 15). This piece, which arose from González's Spanish Republican political sympathies, is named after a mountain in Catalonia, suggesting the figure is a symbol of Spanish resistance to Nazi aggression. Recalling *Woman with Bundle of Sticks, The Montserrat* reiterates the artist's interest in peasant themes. A simple, generalized treatment of the body portrays the woman as hardy, forbearing, and noble. This sculpture's monumentality results from a basic, undetailed juxtaposition of forms. In spite of González's devotion to abstraction, his is not entirely an objective or intellectual approach. *The Montserrat* is a political and social statement of the strength of the Spanish people. Later, during the Spanish Civil War, González made *Mask of Montserrat Crying,* 1936–39 (fig. 16). Like Picasso, González portrayed his outrage over atrocities in his native land through depictions of anger as well as anguish.

The discomfort of this period in González's career is additionally reflected in drawings and sculptures employing aspects of the cactus

FIGURE 13
JULIO GONZÁLEZ
Reclining Figure, 1934
welded wrought iron
18 x 37 x 16³/₄ inches
The Museum of Modern Art, New York
Nelson A. Rockefeller Bequest

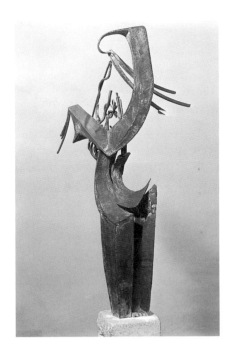

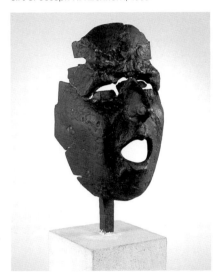

native to his homeland. Combining teethlike forms reminiscent of Picasso's work and the prickly aspects of the plant, he presents barbed and discomforting imagery. In *Madame Cactus,* 1939–40 (fig. 17), the artist portrays a full figure stretching vertically into space—the upward thrust beginning in a slow curve and ending with a stark, vertical element. One interpretation might be that this piece represents a triumphant Spain in the face of diversity.

When the Germans invaded France in 1940, González was forced to leave his studio. He spent his remaining two years creating drawings. Though lasting only about twenty years, his production of welded sculpture has continued to provide inspiration for artists to this day.

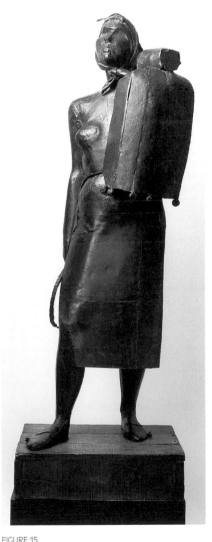

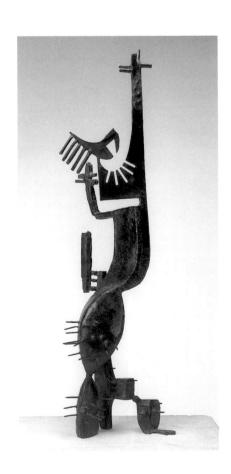

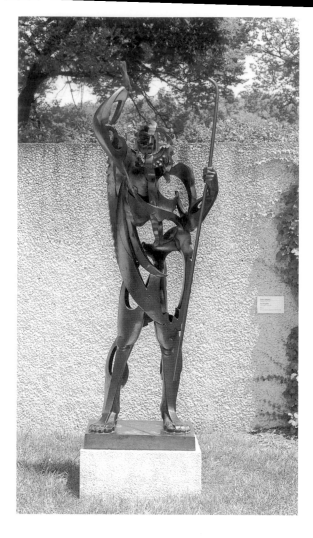

FIGURE 18
PABLO GARGALLO
**The Prophet
(Saint John the Baptist),
1933 (cast 1954–68)**
bronze
92¼ x 29¾ x 19 inches
Hirshhorn Museum and Sculpture
Garden, Smithsonian Institution,
Washington, D.C.
Gift of Joseph H. Hirshhorn, 1972

PABLO GARGALLO

González's adaptation of a cubist opening of solid form may have proven inspirational to a fellow artist and countryman. Pablo Gargallo (1881–1933) was an early acquaintance of González when both were in Paris in the first decade of the century. Not long after meeting González, Gargallo returned to Barcelona, where he embarked on a series of works using sheet metal, soldering, and oxyacetylene welding processes.[7] He evolved a style of figurative work, exemplified by a bronze cast, *The Prophet (Saint John the Baptist),* 1933 (fig. 18), using metal sheets to create heads and figures that reflected his ability to abstract human anatomy, emphasizing interactions between solid and void, positive and negative space. Although his dissection and reassembly of forms was influenced by Cubism, his use of curvilinear line and flowing form had more in common with Art Nouveau and the modernist tendencies prevalent in Barcelona at the time.

PABLO PICASSO

Born in Málaga, Pablo Picasso (1881–1973) migrated to Barcelona and Paris, where he associated with avant-garde artists of the time. In painting, his work underwent several stages, including the so-called Blue and Rose periods, before his major breakthrough with Cubism. The latter body of work, with its analysis and reconfiguration of form found in nature, influenced welded sculpture. His reduction of the picture plane to geometric units allowed Picasso to merge motif with surrounding area. In subsequent paintings, sculptures, collages, and relief constructions, he continued to link mass with space. A later surrealist phase of his work is distinguished by curvilinear forms punctuated with openings and extensions.

In the late 1920s line became a major sculptural focus for Picasso. In order to make line three-dimensional, Picasso needed a means to join wire parts. González helped by showing him how to weld. *Figure,* 1928 (pl. 4), epitomizes this body of work as it defines space by means of a linear construction. Although it is essentially abstract, the sculpture traces a body's form. Its openness relates more to a gestural sketch than to traditional modeling or carving. With line moving around open areas, Picasso produced a drawing in space.

Another example, *Tête de femme (Head of a Woman),* 1929–30 (pl. 5), of welded and painted iron, features found objects. In his earlier work, especially the collages and relief constructions, Picasso had inserted manufactured materials and utensils. Though more substantial in comparison to *Figure, Tête de femme* is essentially a three-dimensional outline of form. Hair, eyes, and neck are schematically represented in approximation of human anatomy. Lines of metal assume not only a solidity but a spiky aspect related to the fierce and even savage aspects of Picasso's representations of women in the twenties and thirties.

Assertions have been made as to whose influence was dominant. Did the "technician" González inform this short-lived phase of Picasso's sculptural oeuvre, or did Picasso's stylistic direction effect González? Study of both men's oeuvres, their mutual extensions of cubist tenets, and the pervasive influence of African art indicate that their work briefly intersected along similar premises. Picasso made a few pieces using welded metal and then went on to explore other sculptural areas, whereas his colleague continued to explore welding as a means of expression.

Comparison can be made between Picasso's *Tête de femme* (pl. 5) and González's *Femme se coiffant II* (fig. 10) or his *Head* (fig. 12). There are similarities in utilization of line for hair and plane for face, but each artist uses these elements in a unique fashion. Picasso's introduction of found objects is novel, and his approach has a playful quality. His lighter approach to sculpture, as compared to painting informed by his academic training, causes him to be more inventive in this format. Generally, González's work

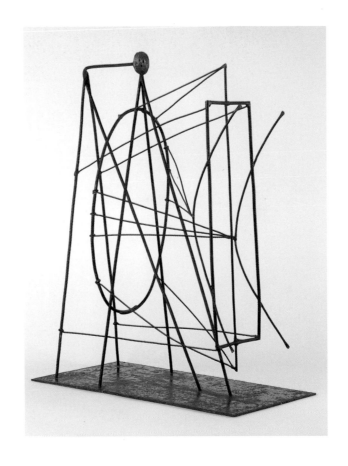

appears weighty in form and serious in content.

Despite Picasso's short foray into welding, he managed to emphasize a linear potential for sculpture that is still tied to figurative form. Different from the constructivist approach, Picasso's did not relinquish reality as a subject springboard. In this regard, relationship must also be made between Picasso's *Figure* (pl. 4) and *The Palace at 4 A.M.*, 1932–33 (fig. 19), by Alberto Giacometti. Executed within a few years of one another, both sculptures consist largely of line and entail figurative subject matter. Both explore the notion of sculpture as delineated space and indicate surrealist influence. However, Giacometti's use of line is rectilinear, basically horizontal and vertical, forming an architectural construct. Picasso's line is less stable, more dynamic. Diagonals and curves transcribe movement in space. *The Palace* is more static in keeping with a sense of enclosure and suspension in time. Giacometti's sculpture sets up a series of clues, like a sequence of nonrelated images in a dream. A subconscious state is evoked by opening form and injecting object fragments. In contrast, Picasso's work captures a sense of motion as though a figure had sped up leaving only traces of a path. His open structure, moving into its surroundings, is not contained in space.

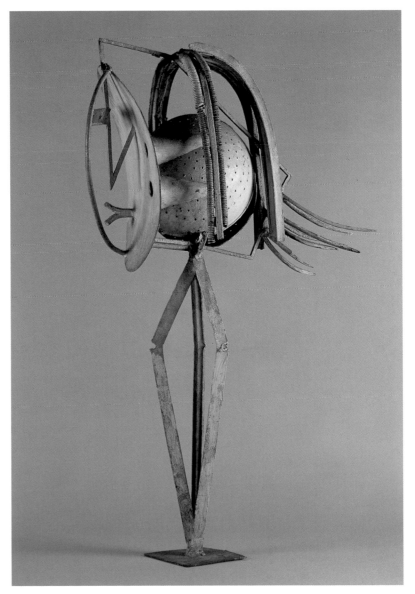

Comparison might also be made with Alexander Calder's *Calderberry Bush (Object with Red Disks),* 1932 (fig. 20). Typically, Calder is concerned with balance and literal movement as opposed to Picasso's illusion of motion. Color is a vital factor in Calder's work as it accentuates form and helps to move the eye around the sculpture. In contrast to the upright, monumental quality of Picasso's *Figure, Calderberry Bush* veers off at an angle, suggesting subjugation to the laws of gravity. Calder's piece is rooted in nature as though he were aping a plant or an insect. It has a more vulnerable feel than the stalwart work of Picasso.

There were in the early thirties, then, several artists creating sculpture that is based on linear configurations and is volumetric rather than massive. Emphasis on opened form was carried into the next two decades in work by such artists as David Smith, Theodore J. Roszak, Herbert Ferber, Ibram Lassaw, and Richard Lippold. A fascination with metal also characterizes some new work of the 1930s, as artists such as González, Picasso, and Calder employed industrial methods and materials. Picasso's interest in welded metal, however short-lived, indicates its acceptance at the time as an avant-garde means of creating art. Another constant factor in the 1930s was the preeminence of Paris as an art center, though interest in Cubism produced several offshoots in Italy, Russia, Germany, Holland, and America. Paris remained a mecca for artists, including visiting and immigrating Americans. Gertrude Stein's presence was a focus for artistic activity, both visual and literary.

Basically, art between the wars was characterized by experimentation with abstraction, though Surrealism remained a major focus. Acceptance of abstraction in various forms, of welding as a viable technique in sculpture, and of space as part of three-dimensional work was important in subsequent explorations of welding as an expressive artistic means.

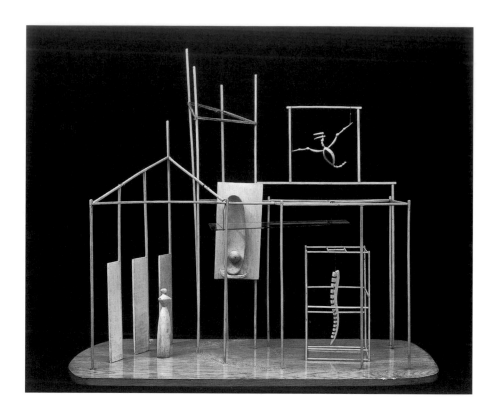

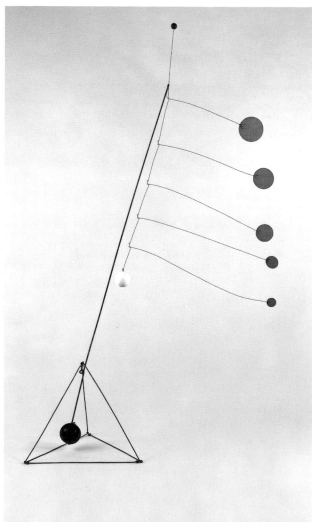

FIGURE 19
ALBERTO GIACOMETTI
The Palace at 4 A.M.,
1932–33
wood, glass, wire, string
25 x 28¼ x 15¾ inches
The Museum of Modern Art, New York
Purchase

FIGURE 20
ALEXANDER CALDER
Calderberry Bush (Object with Red Disks), 1932
painted steel rod, wire, wood, sheet aluminum
dimensions variable; with base: 88½ x 33 x 47½ inches
Whitney Museum of American Art, New York
Purchase, with funds from the Mrs. Percy Uris Purchase Fund

2 DAVID SMITH

The contributions of Julio González and Pablo Picasso in utilizing welding as an artistic method were given new vigor by Americans, particularly David Smith (1906–1965). At a slightly later date than his European predecessors, Smith began to weld sculpture, continuing over the course of a career that exceeded three decades and bringing a unique vitality to the medium. Simultaneous with the emergence of Abstract Expressionism in painting and the ascendancy of New York as an art center, Smith doggedly pursued a number of thematic inspirations, first with figurative and landscape subjects and later with Geometric Abstraction. Contributing his personal aesthetic and stylistic proclivities, Smith moved welded sculpture away from figuration into nonobjective realms.

Photographs of Smith often depict a man conveying displeasure, even hostility. He looks directly into the lens without smiling or posing, with none of the conventions usually associated with a friendly snapshot or formal photography. Such images reflect an uncompromising, straightforward, impetuous individual. He wrote in the 1960s:

You know who I am and what I stand for. I have no allegiance, but I stand, and I know what the challenge is, and I challenge everything and everybody. And I think that is what every artist has to do. The minute you show a work, you challenge every other artist. And you have to work very hard, especially here. We don't have the introduction that European artists have. We're challenging the world. . . . I'm going to work to the best of my ability to the day I die, challenging what's given to me.[1]

Born in Decatur, Indiana, Smith pursued art in high school and attended college for one year. In the summer of 1925 he worked as a welder and riveter at a Studebaker plant in South Bend. He then tried another semester at Notre Dame University, moved to Washington, D.C., and eventually arrived in New York in 1926 to become a professional artist. That year he met Dorothy Dehner (see chapter 7) and enrolled at the Art Students League. They married the next year and in 1929 bought Old Fox Farm in Bolton Landing, New York. Dehner was the more sophisticated of the pair. Trained as a modern dancer and well traveled, she was knowledgeable about several modernist art forms and was herself an accomplished painter and sculptor.

THE THIRTIES

During the 1930s Smith spent time at his farm upstate on weekends while continuing to study in New York City, where he met the Russian

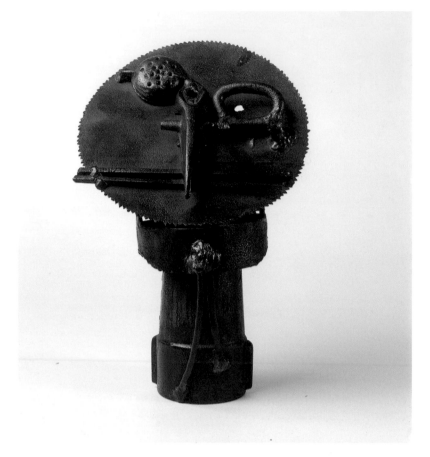

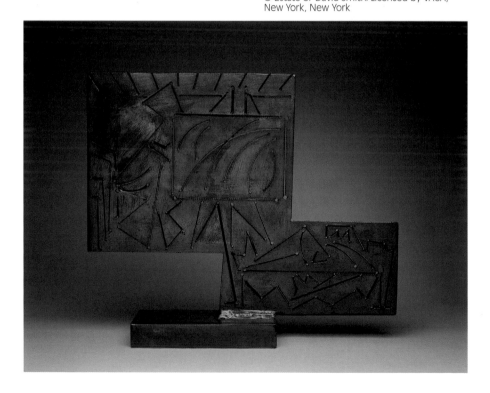

émigré painter John Graham, who introduced him to the art of the European avant-garde. The Czech-born cubist painter Jan Matulka, a teacher at the Art Students League, also influenced Smith, especially his two-dimensional work—prints, drawings, and paintings. In 1931 Smith made his first sculpture.

In 1932 Smith worked at Bolton Landing with a forge and at Terminal Iron Works, a Brooklyn machine shop, where he welded. At this time he made constructions, relief paintings, and sculpture from found objects, reflecting his exposure to European modernism.[2] The series of heads Smith created the next year may be the first group of welded sculptures realized in this country.[3] His *Saw Head*, 1933 (pl. 6), indicates his knowledge of Picasso's welded work, which he probably saw in reproductions in the magazine *Cahiers d'art*. In *Saw Head* Smith, like Picasso, employed a cubist interjection of space into a sculptural mode and incorporated found objects.

In 1934 Smith was given a sculpture by González as a gift from Graham, and the following year he left for Europe with Dehner. He traveled for about nine months, visiting Paris, Brussels, Crete, London, and the Soviet Union. Back in the United States, he learned oxyacetylene welding. In 1937 he began his *Medals for Dishonor*, a series of bronze reliefs denouncing war and social violence, and he was offered a solo show by Marian Willard at her East River Gallery. He met Jackson Pollock, the leading exponent of Abstract Expressionism, the same year.[4]

Occurring at New York's Museum of Modern Art at the time were the exhibitions *Cubism and Abstract Art* (1936) and *Fantastic Art, Dada, Surrealism* (1937), curated by Alfred H. Barr, Jr. These exhibitions and their catalogues exposed Smith and his American compatriots to the latest European art developments. Smith's sculptures by the end of the 1930s, such as *Interior*, 1937 (fig. 21), betray the influence of

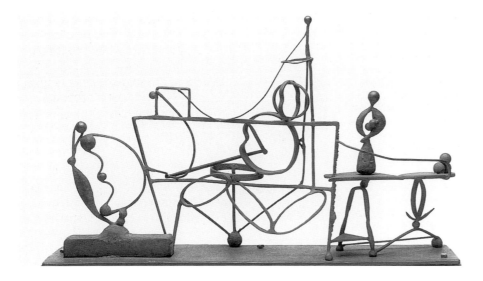

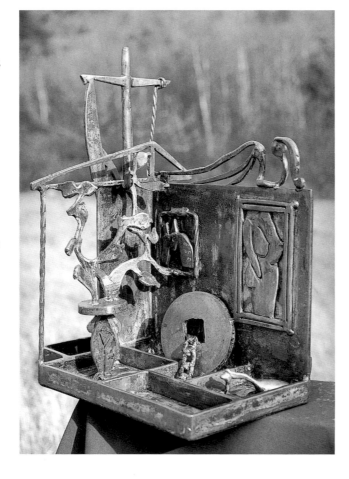

THE FORTIES

By 1940 Smith had moved permanently to Bolton Landing. There he and Dehner lived an independent and self-sufficient life, growing vegetables, planting an orchard, and raising chickens.[5] During World War II Smith worked in a locomotive factory. He had been called to serve in the Army but was declared unfit due to a sinus problem.[6]

Factory work, along with a shortage of metal, limited his art production, and until the mid-forties Smith's pieces are small and intimate. *Home of the Welder*, 1945 (fig. 22), is a somewhat anecdotal and autobiographical example of such work. It continues Smith's concern with interiors as subject but adds intricate narrative and descriptive elements: paintings of a woman and dog on a back wall, a machine-shop chain, and a primitive-looking nude statue surmounted by a plant form. The woman, animals, hardware, and plants within a compartmentalized framework represent the artist's domestic setting.

Other sculptures of this period indicate an ongoing fascination with Giacometti, Surrealism, and the notion of interior spaces reflecting a dreamlike content of free associations. *Steel Drawing I*, 1945 (pl. 7), in which Smith combines drawing and sculpture, graphically associates point and line in what look like diagrams for constellations.[7] The association of drawn planes seems to presage Smith's later *Cubi* series.

Smith's mature period began with a series of landscape images that led to the famous *Hudson River Landscape* of 1951. His choice of landscape for the subject of his sculptures reflects his persistent association of painting and drawing with sculpture. Movement in space via line and plane, made possible by welding, allowed him to create sculptures that were at the same time drawings. Moreover, his predilection for three-dimensional drawing and a willingness to try various modes of expression showed

Alberto Giacometti, especially of *The Palace at 4 A.M.* (fig. 19). The two works have in common an openness of form, figurative references, and situation of a scene along a horizontal span.

Like other artists working in Europe and America during this decade, Smith explored abstraction via

Cubism and Surrealism, and, like other artists, he used his art to speak out against social injustice, as in his *Medals for Dishonor* of 1937–40. Parallels can be seen between Smith's work of the late 1930s and the works of Picasso and González of the same period that were concerned with political issues.

PLATE 8
DAVID SMITH
The Billiard Player, 1945
steel
28 x 23 x 6½ inches
Neuberger Museum of Art, Purchase College,
State University of New York
Gift of Roy R. Neuberger
© Estate of David Smith/Licensed by VAGA, New York, New York

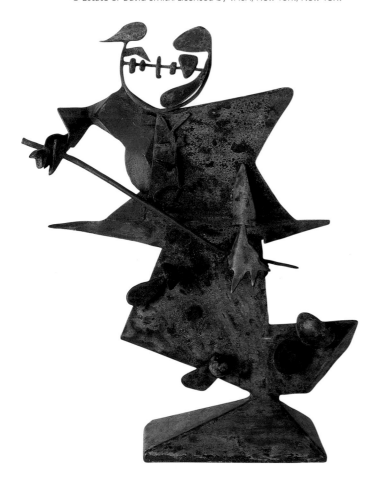

PLATE 10
DAVID SMITH
The Letter, 1950
steel
37⅝ x 22⅞ x 11 inches
Munson-Williams-Proctor Institute Museum of Art, Utica, N.Y.
Edward W. Root Bequest
© Estate of David Smith/Licensed by VAGA, New York, New York

PLATE 9
DAVID SMITH
The Royal Bird, 1947–48
steel, bronze, stainless steel
22⅛ x 59¹³⁄₁₆ x 8½ inches
Walker Art Center, Minneapolis
Gift of the T. B. Walker Foundation
© Estate of David Smith/Licensed by VAGA, New York, New York

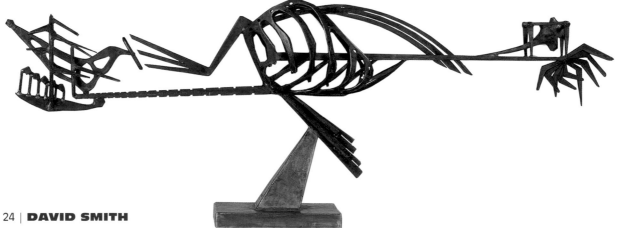

up in figurative work, such as *The Billiard Player*, 1945 (pl. 8). Here, the body expands outward from a small head shape, beneficently enveloping space. The scale of Smith's work had enlarged by this time, as he seemingly tested his limits with experiments in representation.

Another form of representation is evident in *The Royal Bird* of 1947–48 (pl. 9), the source for which was a skeleton he had seen in New York's American Museum of Natural History.[8] Smith's bird forms a trajectory in the direction of its mouth, which is open in a scream. The open, skeletal structure is a fine example of Smith's exploration of linear possibilities in sculpture.

THE FIFTIES

For Smith, the fifties began auspiciously with a Guggenheim Fellowship in 1950, which was renewed the next year. However, at the time he was separated from Dehner and they soon divorced.

He lived alone for several years and had few interactions with other people, a situation that fueled Smith's creativity. He once said:

Yet lonesomeness is a state in which the creative artist must dwell much of the time. The truly creative artist is projecting towards what he has not seen, and can only take the company of his identity. The adventure is alone and the process itself becomes actuality. It is him and the work. He has left the subject behind.[9]

In 1953, though, he was married to Jean Freas, and the next year his first daughter was born; they had a second daughter in 1955.

In the early fifties he continued his experiments with drawing in space. Further extension of line occurs in *The Letter*, 1950 (pl. 10), consisting of found items suspended from metal strips. Symbolizing letters and words, the "letter" is "written" in a foreign and cryptic script. Definitely two-dimensional in its orientation, the piece again states the artist's fascination with linking sculpture and drawing.

During this period he was friendly with the influential critic Clement Greenberg and the painter Helen Frankenthaler, both of whom visited

him upstate. Smith thus connected with advanced thinking in abstraction and with abstract expressionist works. Indeed, Smith's sculpture has an expressionistic character as well as painterly qualities. By this time Smith had begun to sell pieces to museums and was often invited to show his work in one-person and group exhibitions. As his career gained momentum, his individualistic experiments with welded steel became larger and more assertive.

Hudson River Landscape, 1951 (pl. 11), represents Smith's mature sculptural statement of pictorial space. Indicative of the horizontal panorama of landscape, the piece employs an illusionist manner to represent a river, vegetation, terraced or cultivated fields, and clouds. Rather than portraying a single solid object, such as a tree, Smith captures an overall view. The piece radically departs from traditional representational sculpture's reliance on bulk. Through abstract means, the artist is able to achieve a hieroglyphic depiction and a sweeping feeling of terrain, recalling the grand vistas and picturesque depictions of mountain ranges by nineteenth-century Hudson River School landscape painters.

Throughout his career, he continued to draw, realizing work that was relevant to sculpture of the same period. An untitled work on paper of 1952 (fig. 23) is related to *Hudson River Landscape*. Here, in two dimensions, he explored positive and negative space, equating the two. This work is abstract, with organic shapes and freely applied ink. Overall it appears direct, spontaneous, and weighty. The textural and gestural effects of the thick, opaque ink mimic the palpability and heaviness of three-dimensional work.

Perhaps even more "sculptural" in quality is a second untitled drawing of 1954 (fig. 24). The uprightness of three formations on the sheet strongly suggests a sculptural aesthetic. Again, there is a sense of immediacy and acceptance of chance effect that was important to Smith in both sculpture and drawing. Although the figurative

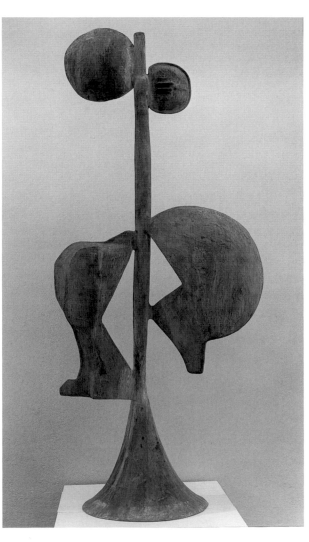

shapes suggest drawings by Picasso or González, there is a decided boldness to Smith's approach that parallels his contemporaneous work in metal. During the time of this drawing and into the next decade, Smith completed a number of vertically oriented sculptures that, like the drawing, have a totemic quality.

One such piece is *Auburn Queen*, 1959 (fig. 25). Rounded shapes branching from a central staff suggest a heretical treatment of body parts. At top are head shapes, and balance is set up in a heraldic fashion. As it does in many of Smith's sculptures, color plays a role in *Auburn Queen* in the form of paint, a medium usually associated with works on canvas. In fact, he expressed his dual interest in modes in these words:

I've been painting sculpture all my life. As a matter of fact, the reason I became a sculptor is that I was first a painter.

I color them. They are steel, so they have to be protected, so if you have to protect them with a paint coat, make it color. Sometimes you deny the structure of steel. And sometimes you make it appear with all its force in whatever shape it is. No rules.[10]

In the fifties Smith created a number of works using found parts, such as *The Letter*. The *Agricola* series consists of fragments of agricultural tools, extending his evolution of collage and assemblage.[11] In a dadaist fashion, he included ready-made forms in a group of works conceived around a similar idea, demonstrating the concept of multiple possibilities. Another body of sculptures is the *Tanktotem* series, also consisting of ready-made forms and basically vertical in orientation. A culminating work in this direction is *Running Daughter*, 1956 (fig. 26), based on a photograph Smith took of one of his daughters racing across a lawn.[12] This piece particularly recalls his drawn forms (figs. 23, 24) and exemplifies work of this decade.

While much of his previous sculpture spreads out horizontally in space,

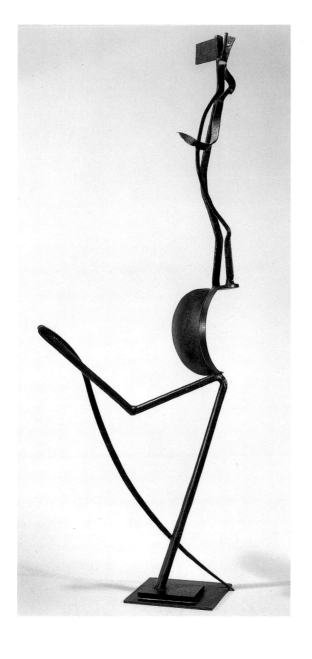

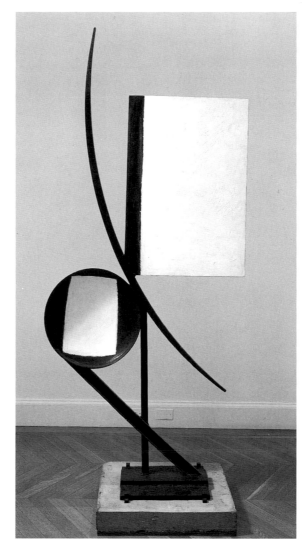

Smith in the fifties pursued open, linear, upright forms. Additionally, there is greater simplicity and less interest in narrative or descriptive elements. This verticality relates not only to the human body but to concepts of monumentality in sculpture.

In 1957 Smith was accorded a retrospective exhibition at the Museum of Modern Art. The next year he represented the United States at the Venice Biennale and at São Paulo. He was included in *Documenta II* in Kassel, West Germany, and in 1960 a special edition of *Arts Magazine* was devoted to his work with an extensive article written by Hilton Kramer. By this time Smith was emerging as one of this country's most important sculptors.

THE SIXTIES

Smith worked more and more serially in the 1960s. In a sense, this tendency reflected a modernist urge to eschew the single masterpiece idea for several versions of a single concept or direction. Simultaneously Smith worked on continuing the *Tanktotem* series as well as beginning several others—*Zigs*, *Circles*, *Beccas*, *Voltri-Boltons*, and *Cubis*. His work became still larger in scale and less detailed, and he began to grind the stainless steel surfaces to make them shiny and reflective.

During this period, flat rectangular planes figured more importantly in his overall production. *Tanktotem VII*, 1960 (fig. 27), of polychromed steel, is a case in point. With a minimum of means, the piece balances straight line and curve, painted and sculptural form. Two white shapes are juxtaposed, the larger being part of a rectangle, the smaller fitting within a circular shape. These are set off by upright and curving linear forms. The overall effect is one of elegance and economy. The work stands as a sophisticated feat of painterly elements combined with abstractly constructed sculpture.

Zig II, 1961 (pl. 12), is another of Smith's successful associations of color with steel sculpture. Their name short for "ziggurat," the *Zigs* typically involve a stepped formation.[13] Smith's bold choice of forms is particularly apparent here in the I-beam set horizontally at the

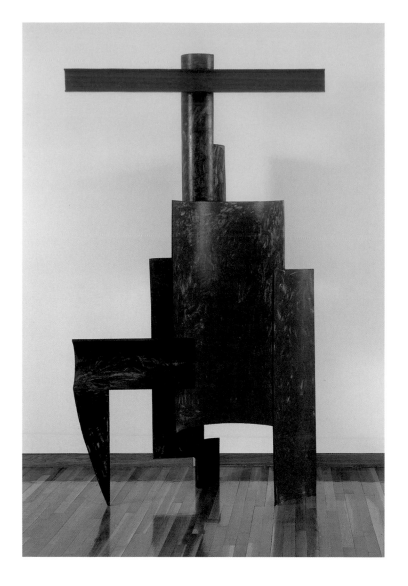

top, stopping the upward thrust of
other parts. The beam's placement
provides a frontal aspect, relating
the work to a painting aesthetic.
Interesting, too, are the textural
surfaces, affirming flat planes but
also lending a tactile appeal gener-
ally associated with sculpture.

Wheels were an interesting feature
in Smith's work, beginning in 1957.
The wheeled *Voltri*s, executed in
Italy in 1962, arose from Smith's
fascination with the wagon as a
sculptural form. *Wagon I,* 1963–64
(fig. 28), is a monumental statement
of this theme. Although simpler in
form, this piece has a slight echo
of the narrative aspects of earlier
work, such as *Home of the Welder*
(fig. 22). A bold association of
shapes, however, makes the wagon
appear more a symbol for mobility.
In a modernist fashion, sculpture
on wheels undercuts a traditional
emphasis on permanence and
stability.

Smith's famous *Cubi* series, begun
in 1963, eventually numbered
twenty-eight pieces. The series'
radical concept demonstrates the
strength of welding in permitting
heavy elements to be extended
upward in space. The *Cubi*s consist
of steel boxes, set one on top of
another and irregularly balanced.
The verticality and anthropomorphic
quality of the *Cubi*s take part in a
totemic current inherent in Smith's
production. There is also a frontal

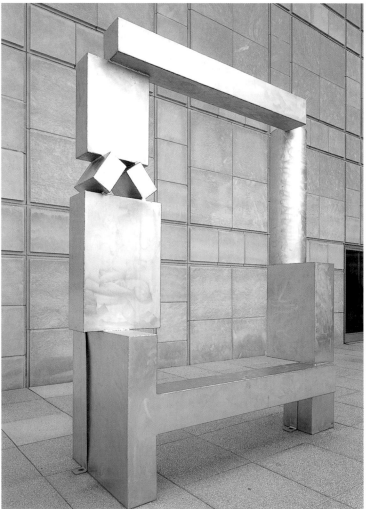

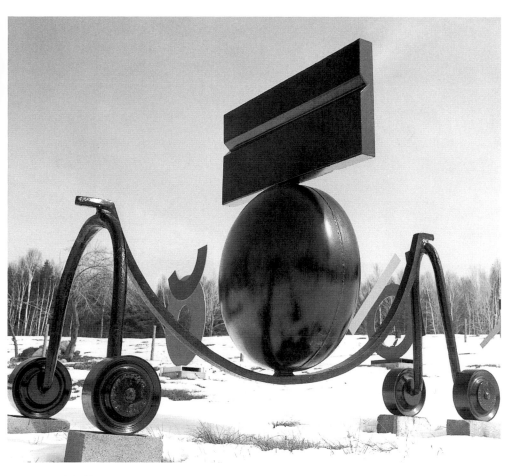

FIGURE 28
DAVID SMITH
Wagon I, 1963–64
painted steel
88½ x 121½ x 64 inches
National Gallery of Canada, Ottawa
© Estate of David Smith/Licensed by VAGA,
New York, New York

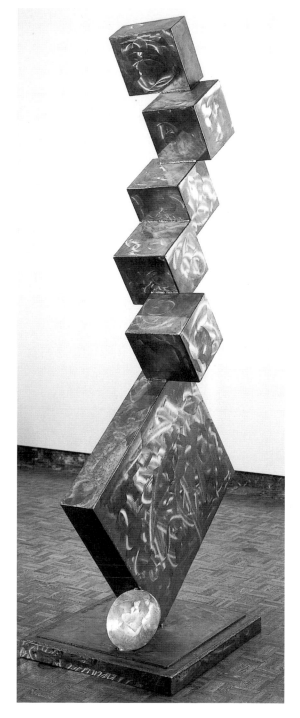

FIGURE 29
DAVID SMITH
Cubi I, 1963
stainless steel
317¾ x 34¼ x 33¼ inches
The Detroit Institute of Arts
Founders Society Purchase, Special Purchase
Fund
© Estate of David Smith/Licensed by VAGA,
New York, New York

orientation to the *Cubi*s, relating them again to Smith's juxtaposition of two- and three-dimensional elements. *Cubi I,* 1963 (fig. 29), is a particularly graphic and powerful example of the assertiveness of this series. Gravity is defied as blocky, irregularly stacked rectangles appear arbitrarily placed and on the verge of toppling over.

Cubi XXVII, 1965 (pl. 13), is framelike, the sculpture outlining a central, open space. It appears like a gate or portal, leading the eye through to another expanse. As with a framed painting, one's attention is channeled inward. Asymmetry plays a pivotal role in this composition, as in other of Smith's sculptures. There is

a feeling of multiple possibilities, as opposed to predictability. Inherent is the dadaist and surrealist reliance on chance effect, on the magnanimity of acceptance and the surrender of the artist's will to other forces. Smith recognized this approach as an important part of his creative process:

When I begin a sculpture I am not always sure how it is going to end. In a way it has a relationship to the work before, it is in continuity to the previous work—it often holds a promise or a gesture towards the one to follow.

I do not often follow its path from a previously conceived drawing. If I have a strong feeling about its start, I do not need to know its end, the battle for solution is the most important. If the end of the work seems too complete, and final, posing no question, I am apt to work back from the end, that in its finality it poses a question and not a solution. Sometimes when I start a sculpture, I begin with only a realized part, the rest is travel to be unfolded much in the order of a dream. The conflict for realization is what makes art not its

certainty, nor its technique or material. I do not look for total success. If a part is successful the rest clumsy or incomplete, I can still call it finished, if I've said anything new by finding any relationship which I might call an origin. I will not change an error if it feels right, for the error is more human than perfection.[14]

Like the others in the series, *Cubi XXVII* is based on Cubism. It is a literal translation of cubist reduction of reality to geometry. Associated abstract units, each defining volume, are piled up in irregular, asymmetrical combinations. Although it presages minimalist creations of geometric volumes in space, Smith's work is distinguished by its eccentricity and unpredictability.

Smith's treatment of surfaces, an ongoing concern for him, culminated with the *Cubi*s. Moving a grinder in circles over the steel, he created illusionistic and atmospheric effects. Light picks out swirling lines, tones, and formations. This surface treatment on the flat planes of the *Cubi* "boxes" again represents Smith's long-standing interest in the linkage of painterly and sculptural traits. Light reflections play an important role, allowing the work to interact with its environs.

Smith left a legacy important not only to artist-welders but to American sculpture in general. With his work he helped establish the United States as a dominant force in modern art in the twentieth century. Moreover, he brought painting developments into sculpture. Heir to Cubism, Dadaism, and Surrealism, Smith was, through his strong personality and creative energy, able to synthesize these factors into an individualistic and expressive statement. Though his work often appears geometric in form, the strength of his sculpture lies in its risk taking, in its unconventional, raw, and imperfect three-dimensional statements. In several ways he tested and improved on artistic protocol. He combined elements of sculpture and painting at a time when the two media were isolated in their respective canons. He used subject matter associated with painting, like landscape, interiors, and still life, as the impetus for three-dimensional objects. He espoused endless possibilities and the influence of chance, rather than concentrating on one solution. Awkwardness, ugliness, and imprecision enliven his work and express a unique and individualistic personality. As he succinctly stated, "Beneath the whole art concept, every pass in the act, every stroke, should be our own identity."[15]

3 POSTWAR WELDING

Technological developments spawned by World War II seemed to expand the world, infusing it with new possibilities. The art world responded with its own experimentation and achievements, like those of David Smith, discussed in the preceding chapter. In the 1950s Abstract Expressionism became a popular term to describe bold, adventurous developments in art. Rather than pursuing scientific advancement, abstract expressionist artists sought new ways to map inner terrain, seeking revelations of the subconscious mind and attempting to present their equivalents in art. Although abstract expressionist artists sometimes strongly asserted their identity in their work, they also allowed elements beyond the ego to enter the process of creation. Control was relinquished to such influences as gravity, intuition, and psychic and spiritual forces. In attempting a free flow from the human subconscious into pictorial language, these artists

relied in part on dadaist acceptance of accident and chance. In addition, the influence of surrealists Joan Miró, André Masson, and Matta was particularly important to artists working in the forties and fifties.

Many American artists were both painters and sculptors, so cross-connections between art forms were facilitated. Abstract expressionist painters were friendly with sculptors, several of whom welded and painted. Many sculptors, like Smith, also made drawings before and after their sculpture. Thus many artists were working in both two- and three-dimensional media. For Smith and others, welding became a viable and widely used method of constructing sculpture. Important to welded sculpture was the intense emotionalism of Abstract Expressionism. Jackson Pollock's "action paintings"—their rawness, immediacy, and possible extension of painted space—paralleled directions in sculpture. Willem de Kooning's

equal emphasis on occupied and unoccupied space echoed sculptors' preoccupation with opened form. Interest in movement and surface effects was shared by sculptors and painters alike.

Welding gained momentum during the course of massive destruction occurring in Europe during World War II, which claimed many artists' lives and caused a shortage of supplies. America, though, emerged from the conflict as a great industrial and technological leader. In addition to new enthusiasm for industrial materials and methods, several factors were responsible for the rise of welding in sculpture, namely the influence of González, Picasso, and Smith; the leverage of Cubism, Dada, Surrealism, Constructivism, and the Bauhaus; and the new authority of Abstract Expressionism in painting. Artists at this time used welding to explore a range of conceptions, most of them abstract and concerned with allowing space into

sculpture. Welding permitted the traditional massiveness of three-dimensional work to be broken up. Primarily using plane and line, artists maturing in the forties and fifties constructed trajectories and outlined or enveloped volumes in space. A key word is *construct* because such sculpture was literally composed and built up of individual units. Certain formal results emerged from the concept of assembling units, such as a more abstract and open treatment of form.

THEODORE J. ROSZAK

One of the most prominent exponents of the welding technique in this country, after Smith, was Theodore J. Roszak (1907–1981). Born in Poland, he spent his early years in Chicago, where his parents settled in 1909. A student of music

as well as art, he played the violin and attended classes at the School of the Art Institute of Chicago. An Art Institute scholarship allowed him, after a brief stint in New York, to travel in Europe from 1929 to 1931. He visited France, Germany, Italy, and Czechoslovakia, setting up a studio in Prague for a few months. He was a painter at the time, interested in Parisian and Italian modernism.[1] Giorgio de Chirico's metaphysical figurations, for example, are suggested in *Early Leave,* 1931 (fig. 30), with its strong contrasts of light and dark tones, distorted scale, and exaggerated perspective. In the same year, a Louis Comfort Tiffany Foundation Fellowship allowed Roszak to work at the foundation's artists colony on Staten Island.

In 1932 Roszak's work was accepted into the first Whitney Biennial of Painting and Sculpture. Also in this decade he embarked on a series of constructions indicating his interest in Bauhaus mechanistic design. One such work is *Small Rectilinear*

Space Construction, 1932 (pl. 14). The delicacy, exacting form, balance, and streamlined design are traits of his constructivist freestanding and wall relief work of this decade. In 1938 he joined László Moholy-Nagy's Design Laboratory in New York City, a WPA–funded program in which the former Bauhaus faculty member implemented German Bauhaus aesthetics. In 1940 Roszak's work was shown at the Julien Levy Gallery in Manhattan.

During the thirties and forties there was considerable interest in abstract form and in relief construction among other artists, many of whom were associated with the Abstraction-Création group. Among those who worked in this style were Gertrude Greene, Charles Biederman, John Ferren, Charles Shaw, and Vaclav Vytlacil. These artists were involved with painted constructions, confirming a contemporaneous urge to link painting with sculpture —an interest shared by Roszak.

During the war Roszak worked in an aircraft factory, and by its end he had forsaken elegance for expressiveness in sculpture. He developed a process in which nickel silver or steel is brazed on an armature of iron or steel. The resultant blotchy surface texture is quite unlike the smooth surfaces of his earlier work. Its roughness projected emotional over intellectual content. This technique was suited to Roszak's turn toward expressionism, fueled in part by his anguish over the ongoing and devastating conflict in Europe. Furthering his professional career was Museum of Modern Art curator Dorothy Miller's inclusion of his work in her *Fourteen Americans* exhibition in 1946.

Roszak's new intensity is apparent in *Spectre of Kitty Hawk,* 1946–47 (pl. 15). This haunting apparition suggests an uncomfortable connection between modern aviation and modern war. It is rough, even spiky in texture. The disturbing tactile effect is amplified by crisscrossing shapes and a jagged diagonal mass curving off into space. A wrathful

FIGURE 30
THEODORE J. ROSZAK
Early Leave, 1931
oil on canvas
16 x 20 inches
Joslyn Art Museum, Omaha
Gift of Mr. and Mrs. Norman Batt, Mr. and Mrs. Louis Blumkin, Mr. and Mrs. Charles Schneider, and Mr. and Mrs. Jerome Cohn

THEODORE J. ROSZAK

Small Rectilinear Space
Construction, 1932

wood, plastic, metal
12¼ x 5¾ x 5¼ inches
Neuberger Museum of Art, Purchase College,
State University of New York
The George and Edith Rickey Collection of
Constructivist Art

THEODORE J. ROSZAK

Thorn Blossom, 1948

steel, nickel silver
32¾ x 19¼ x 12½ inches
Whitney Museum of American Art, New York

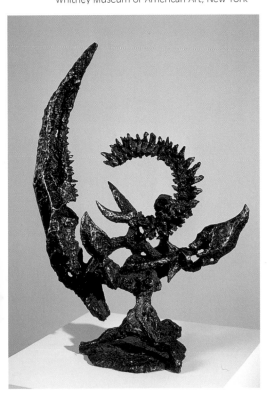

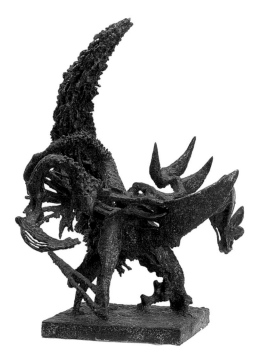

THEODORE J. ROSZAK

Spectre of Kitty Hawk, 1946–47

welded and hammered steel brazed with
bronze and brass
40¼ x 18 x 15 inches
The Museum of Modern Art, New York
Purchase

phantasm, the piece bristles with
agitation, rage, and turbulence.

A comparison with Smith's *Royal
Bird* (pl. 9) of the same period is
interesting. Smith's work may be
interpreted as a specter of death
rather than a direct statement
about war. Derived from his
encounter with a bird skeleton, *The
Royal Bird* shows Smith exploring
the linear potential of welded steel.
Roszak's work is more intricate,
particularly in its surface texture,
where encrustations suggest natural
sea accumulations or a jeweler's
embellishments. Although both
works seem mythic in proportion,
Roszak's is more detailed and there-
fore more specific. It also appears
more emotionally expressive,
primarily due to intersecting shapes
and its thick external accretions.

Thorn Blossom, 1948 (pl. 16), is an
equally disturbing image. Notions
of blossoms and thorns, flight
and conflict, beauty and ugliness
continue in Roszak's work of this
period. His use of welding, not only

for structural support but also
to create irregular surfaces, is a
hallmark of his work, conveying
fervent expressionism.

The contained qualities of Roszak's
early constructions erupted in his
welded work of the forties and
fifties. But after this time he utilized
a more subdued and architectonic
format. He abandoned heavy
brazing, and the geometry of his
forms became cleaner and stronger.
Later sculptures are derived from
a combination of the early uniform
sleekness and the roughened
epidermis of his mature middle
period. Formational elements
became uncovered and prominent.
Relying solely on composition, these
more abstract works have as much
energy as earlier work but with a
more cerebral feeling.

HERBERT FERBER

Compared to Roszak's expression-
ism, the work of Herbert Ferber
(1906–1991) manifests a more con-
structivist direction. A painter as well
as a sculptor, Ferber pursued these
two formats throughout his career.
While Smith used paint to qualify
sculptural surfaces, Ferber consid-
ered painting a separate art form.

Ferber was born and educated in
New York. His interests as a college
student included literature, philoso-
phy, art history, science, and sports.
He excelled in swimming and pur-
sued dentistry as a vocation, study-
ing drawing and sculpture on the
side at night. In high school he had
been a sports reporter, and later he
founded and co-edited the *Partisan
Review*. After receiving the D.D.S.
degree from Columbia University in
1930, he taught on a part-time basis
there while establishing a dental
practice. Simultaneously, he studied
art at the National Academy of
Design and began to exhibit his
work. Also in 1930 he received a

PLATE 17
HERBERT FERBER
**The Flame,
1949**
brass, lead, soft
solder
64³⁄₄ x 25¹⁄₂ x 19¹⁄₄
inches; base: 16 x
10 x 10 inches
Whitney Museum
of American Art,
New York

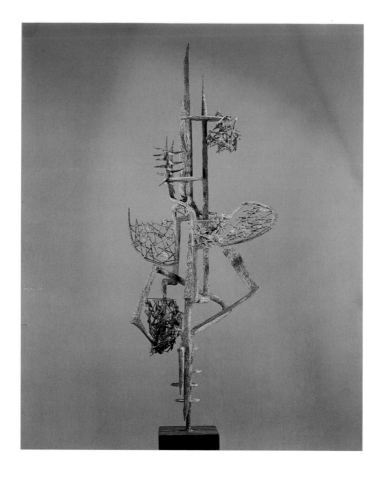

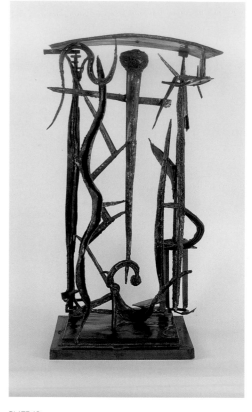

PLATE 18
HERBERT FERBER
The House (The Staircase), 1956
brazed copper, brass
32 x 19 x 12 inches
Neuberger Museum of Art, Purchase College,
State University of New York
Gift of Roy R. Neuberger

PLATE 19
HERBERT FERBER
**Wall Sculpture
1B, 1979**
painted steel
63¹⁄₄ x 72 x 35
inches
Neuberger Museum
of Art, Purchase
College, State
University of New York
Gift of Edith Ferber

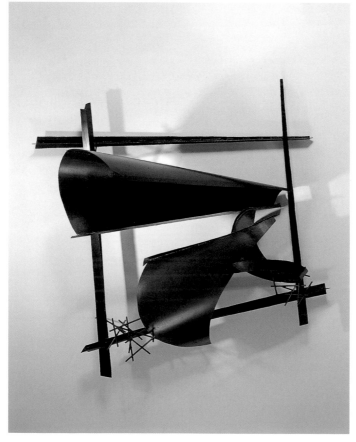

Louis Comfort Tiffany Foundation
Fellowship to work one summer in
Oyster Bay, Long Island. Subsequently
he met Roszak and became influ-
enced by African sculpture through
seeing the Guillaume collection of
African art exhibited in 1930 at the
Valentine Gallery in New York. He
made his first wood carvings in 1931,
while continuing to exhibit his paint-
ings. Four years later he showed his
first sculpture in a group exhibition,
and in two years Midtown Galleries
gave him a one-person show.[2]

Ferber continued working in wood
until 1944, when he began experi-
menting with cast bronze and lead,
concentrating mostly on the human
form as subject. Henry Moore was
a major influence, as were Miró and
Pablo Picasso. Moore's influence,
and that of Picasso and Alberto
Giacometti, can be seen in *Jackson
Pollock,* 1949 (fig. 31), which reflects
the artist's inclination toward atten-
uated forms extending outward
in space. Two spiky entities are
interconnected by a third lateral

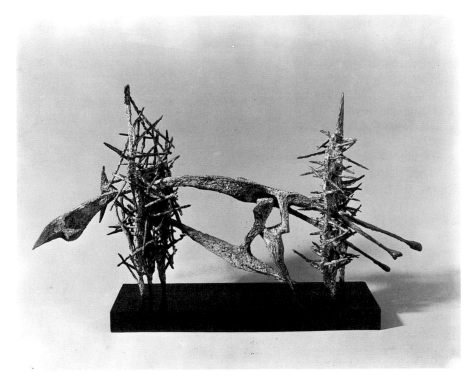

FIGURE 31
HERBERT FERBER
Jackson Pollock, 1949
lead
17⅝ x 30 x 6½ inches
The Museum of Modern Art, New York
Purchase

form that emphasizes both vertical and horizontal movement. The numerous lines suggest Pollock's skeins of pigment on canvas. The work's openness predicts Ferber's development.

Ferber joined the Betty Parsons Gallery in 1949 and became friendly with a number of artists, including Pollock, Adolph Gottlieb, Robert Motherwell, and Barnett Newman. He was especially close to Mark Rothko. A mutual concern among these artists was surrealist notions about the subconscious and how it might be translated into visual form. Ferber became more familiar with Surrealism through visits to Peggy Guggenheim's Art of This Century Gallery, where surrealist work was shown. Expressing his concern with revealing an inner self through art, Ferber had written in 1947: "The artist must actually crawl over every square inch of his work, touching, smearing, retouching, licking and spitting, expending himself over the whole thing and forcing it bit

by bit to become in an intimate and immediate way, himself."[3] In the sense of proximate contact, this statement resembles Pollock's observations about his own working method, in which he achieved a mental as well as a physical state where there is an easy rapport between artist and emergent artwork. Eschewing the easel, Pollock laid unstretched canvas on the floor. "On the floor I am more at ease," he said. "I feel nearer, more a part of the painting, since this way I can walk around it, walk from the four sides and literally be *in* the painting."[4]

Ferber's works of the mid-forties spread horizontally, but by the end of the decade his works exhibited a more vertical format, as in an early welded work titled *The Flame*, 1949 (pl. 17), one of the first works in which he used a blow torch. Secondary linear motifs seem to represent flickering light in this piece; it aspires upward, symbolizing a rising blaze or fervor.

In the fifties Ferber capped this verticality in a series of works that articulate space by framing it. A rectangularity is present in *The House (The Staircase)*, 1956 (pl. 18), which is architectural in its outer form, with a skeletal framework established

around linear contents. There are no walls, simply open spaces among perimeters. Exterior and interior space are depicted simultaneously in this work, and it has an internal tangibility. Comparison with Giacometti's *Palace at 4 A.M.* (fig. 19) reveals differences between these works. While both express interior space, Ferber's piece is more abstract, containing movement up and down via jagged internal forms. Giacometti's "house" is still, conveying a sense of suspension in time and space. Ferber's more detailed work is "roofed," while Giacometti's structure extends upward in space. While Ferber's sculpture is cohesively constructed of abstract shapes, isolated elements inside the "palace" are figurative.

Ferber's concerns with architectural space are manifested in *A Sculpture to Create an Environment*, conceived in 1960 (now destroyed). Though not of welded metal, the work is important in demonstrating the artist's notion of an encompassing form. Inspiration for this architectural sculpture came from two sources, his encounter with Donatello's *Prophets*, which Ferber had seen extending from a Florentine building, and his experience creating a large synagogue sculpture that he had to move within and around in order to install. Again, there is a sense of the artist's interest in an intimate relationship with sculpture and in conveying that relationship to viewers. He wrote in 1952:

If the sculptor succeeds in forcing on the material a transmutation into plastic idea, the spectator will not be misled. However, when materials themselves are held in reverence and when new techniques are mistaken for new plastic ideas, art goes out the door. The artist is concerned with fusing his personal and private vision with form, to make a metaphor for his experience, so exactly constructed that there can be no doubt about his idea, although there may be several layers of meaning.[5]

In the sixties and seventies Ferber explored sculpture on a larger scale, sometimes juxtaposing planes with

linear accents. *Wall Sculpture 1B, 1979* (pl. 19), a wall relief, for example, possesses broad elements that expand outwardly. He continued to paint, a factor that may figure into painted constructions like *Wall Sculpture 1B*, in which forms are partially contained within a frame. His concurrent paintings on canvas were composed works of large, flat, amorphous areas of interactive colors.

Ferber's contribution to sculpture is a blending of interior and exterior space into a single continuum. The object itself is an extension of the artist—it is inside turned out, or internal feeling made public. In turn, the viewer's eye can move in and out of structure, experiencing space and knowing something of the artist's interior, his spirit or his soul.

decade, he became interested in making sculpture.

From the early thirties through the mid-forties, Lipton was preoccupied with figurative wood carvings, which he showed in several New York venues. Exhibiting first at the ACA Gallery in 1938, he moved to Galerie St. Etienne five years later. He eventually had several exhibitions of his abstract work at the Betty Parsons Gallery. As early as 1944 he experimented with sheet-lead construction, and three years later he began soldering. By 1949 he was brazing brass rods onto sheets of steel using an oxyacetylene torch, and by the following year he had developed a signature style that he pursued for the balance of his career.[6]

His manner of working—brazing metal over bent steel sheets—established a hollow, volumetric form that could be oriented vertically

or horizontally. The evenly mottled surfaces contribute to the tactility of the works and to the play of light on surfaces. His manipulation of surfaces and resultant shadows heighten a sense of encompassed and occupied space, much as a painter might mark or mottle a form to suggest roundness. Typically, he melted nickel silver on monel metal, which came in sheets flexible enough for him to hammer and mold, while the nickel silver provided a rich, gold-colored metallic finish. Lipton's methods and their effects did not significantly change as he explored a variety of mythical, social, and religious subjects.

Lipton's typical procedure was to move from drawing to maquette to completed work. He made thousands of drawings and hundreds of maquettes, some of which resulted in larger scale sculpture. Quite academic, this approach would seem to

SEYMOUR LIPTON

The work of Seymour Lipton (1903–1986) is akin to that of Roszak in terms of a common concern for defining space and emotive expression. His approach, however, was thematically more specific, with a crusader or sorcerer, for example, as subject, in contrast to Roszak's generalized spectral imagery. Lipton's uniqueness was manifested in his curvilinear enclosure of volume. Further, he invented a means of coating surfaces to enhance their visual and tactile appeal.

Born in New York City, he kept a home and studio there, where he produced his idiosyncratic form of welded sculpture, giving visual shape to profound themes and emotions. Lipton began to read about art and aesthetic theory in the 1920s. This interest in theoretical constructs continued throughout his career, and he even wrote his own philosophical treatises. He graduated from Columbia University in 1927 with, like Ferber, a degree in dentistry. In the later part of this

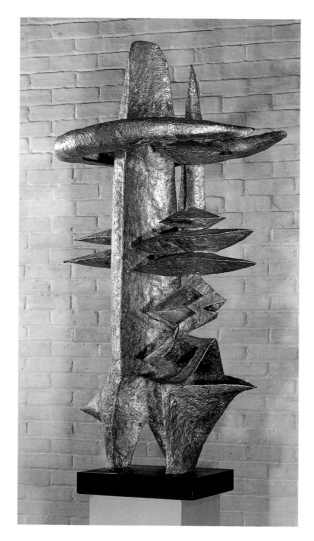

PLATE 20
SEYMOUR LIPTON
Sorcerer, 1957
nickel silver on monel metal
60¾ inches high
Whitney Museum of American Art, New York
Purchase, with funds from the Friends of the Whitney Museum of American Art

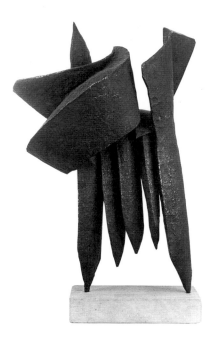

FIGURE 32
SEYMOUR LIPTON
Crusader, 1960
nickel silver on monel metal
32 x 21½ x 15 inches
Neuberger Museum of Art, Purchase College,
State University of New York
Gift of Roy R. Neuberger

diverge from the sense of extemporaneity and immediacy sought by his contemporaries. However, the preparatory stages themselves were spontaneous prerequisites to this artist's selection of final form.

In establishing curved volumes, Lipton parted company with Smith, Ferber, and others who relied on flat metal planes. However, in this his work gains a potent sense of interior. The insides of covered forms signify mystery, contain energy, and provide space for the imagination. Traditionally, sculpture was centered on a core or nucleus—a center of gravity for the basic mass occupying space. Lipton's work reverses this. The middle is vacant; open space occupies the center. The inscrutable suggestiveness of this emptiness is magnified in work allowing partial views into a darkened interior. It is up to the viewer to fill in the gap, to conjure meaning from the assembly of forms around space. This is a romantically expressive approach,

rooted in the enigma and fantasy of darkness, in the recesses of the imagination. Such romanticism is suited to sublime, mystical, and transcendent subjects.

Sacred and secular themes often figured in Lipton's work. Three sculptures serve as examples of this preoccupation. The first, *Sorcerer*, 1957 (pl. 20), typifies his manipulation of abstract form to suggest spiritual themes. The sorcerer is a conjurer, one who possesses extraordinary powers. This being belongs to the realm of the occult and often the diabolical. Lipton's depiction is a twisting, turning form. Elusive and shifting in shape, the sorcerer is from another world and cannot be captured in the human sense.

FIGURE 33
SEYMOUR LIPTON
Archangel, 1963
bronze, monel metal
108 inches high
Lincoln Center for the Performing Arts, Inc.,
New York

Lipton's associations of abstract forms convey the feeling of magic without specific references. *Crusader*, 1960 (fig. 32), also depicts a religious personage representative of an entire phase of history. Here the volumetric sculpture is related to crusaders' armor. A sense of divine mission and purpose is embodied in the form, part of which thrusts forward in space, suggesting a charge into battle. A third sculpture presenting an otherworldly figure, *Archangel*, 1963 (fig. 33), is one of several public commissions Lipton received. This piece, in front of Lincoln Center in midtown New York, presents a grandly unfolding character. Side movements unfurl like wings from a cryptic inner chamber. Set stalwartly upright on a tripod, the figure is an imposing representation of the might and majesty of a biblical archangel. Using abstract form, Lipton has projected the concept of a spiritual being.

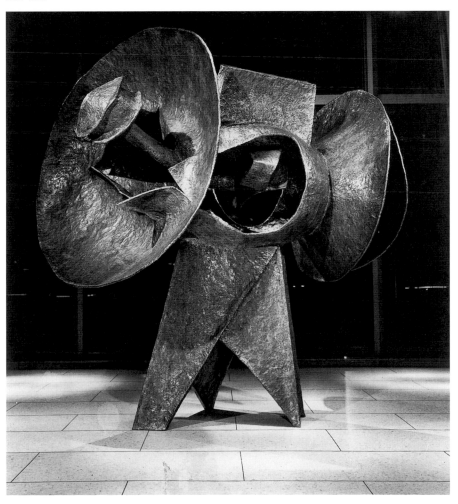

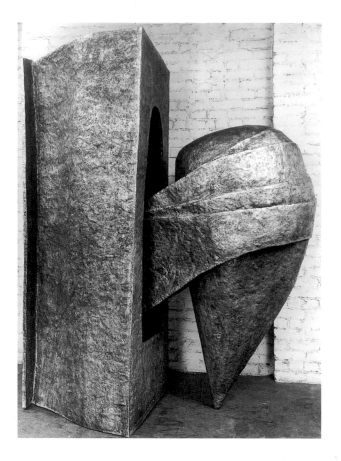

FIGURE 34
SEYMOUR LIPTON
The Returning, 1960
nickel silver on monel metal
74 x 62 x 36 inches
Courtesy Maxwell Davidson
Gallery, New York

The Returning, 1960 (fig. 34), appears as a simplified association of basic shapes. A pod is drawn from, or perhaps into, a rectangular box. Again the interior is dark—perhaps threatening, perhaps welcoming. This is an image of the prodigal son, his departure and return combined into one image. The abstract character of the work and its simplicity lend to its timeless character.

In all of Lipton's work there are both mechanistic and biomorphic qualities, representing an attempt to relate human life to natural and industrial realities. He successfully merges modern technological means and materials with his desire to plumb deeper, more profound issues. A prolific writer on the theoretical basis behind his work, he wrote in 1971:

There is one drive in men more basic and stronger than their penchant for making tools and technology.

That one drive is the quest for unraveling the mystery of their own existence. Man's self-consciousness provides the wherewithal for the ironies of self-exploration. No matter how keen the interest in machines, communication systems and the pulse of aesthetics in machines as formal systems, there is always the gnawing question—what is man, his history and destiny both as individual and as a race?

This is why there will always be a return by artists to areas of man's meaning, and his feelings as life-experience even though the adventure of forms will continue. For artists, the need for man's meaning is almost the same as the religious quest for man's place in the cosmos. Art, I believe, will always soar beyond the sensuous pleasure and excitement of formal aesthetics into the deeper, more searching areas of the human spirit and human existence.[7]

IBRAM LASSAW

Like Roszak and Ferber, Ibram Lassaw (1913–1985) pursued an organic yet structural approach to welded sculpture. In his diagrammatic structures, Lassaw emphasized positive as well as negative space. Largely linear in form, his work is distinguished by exaggeratedly uneven surfaces.

Born in Alexandria, Egypt, Lassaw also lived briefly in France and Italy. He went to New York when he was eight years old and began to study sculpture at the Clay Club at thirteen. Subsequently, he studied at the Beaux-Arts Institute of Design and was employed in government arts projects in the thirties and early forties.

In 1936 Lassaw became a founding member of the American Abstract Artists (AAA), a group important to the acceptance of abstraction in this country. Through their own work, their exhibitions, and published statements, these artists encouraged contemporaneous critics and curators to accept abstraction as a viable art form. At the time there were no galleries in New York showing contemporary American work, except for those owned by Alfred Stieglitz and A. E. Gallatin. In the late 1930s critics of the day such as Jerome Klein at the *New York Post,* Edward Alden Jewell and Howard Devree of the *New York Times,* and Royal Cortissoz called abstract work "derivative," "decorative," "academic," and even "un-American." At times abstract art was referred to as "Ellis Island art," indicating its connection with European artist-immigrants to this country. AAA members struck back with letters to the editor of the *Times* as their only means of putting forth their arguments before a wide readership. The conflict raged between 1936 and 1939, with some relief in 1937 when money and influence established the Solomon R. Guggenheim foundation, dedicated to "nonobjective" art. By the end of the decade and the beginning of the war, the attacks had subsided. The American Abstract Artists group was a wedge between the School of Paris and eventual acceptance of Abstract Expressionism in this country.[8]

Lassaw's early work, like that of many others of the period, was influenced by Picasso, Hans Arp, and Surrealism.

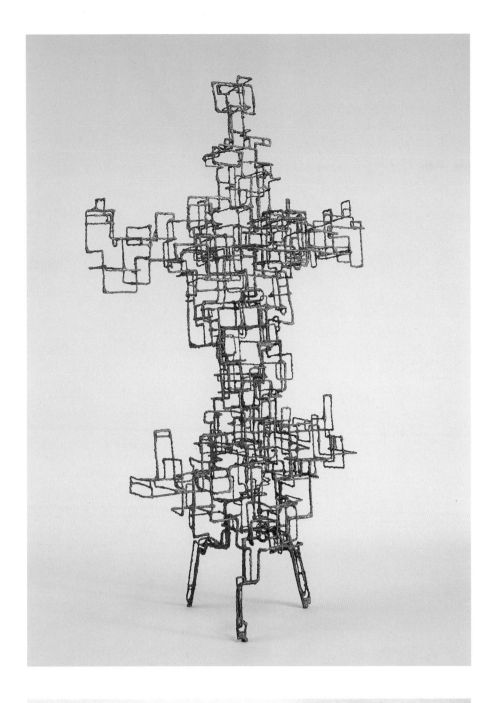

PLATE 21
IBRAM LASSAW
Kwannon, 1952
welded bronze, silver
72 x 43 inches
The Museum of Modern Art, New York
Katharine Cornell Fund

These pieces were biomorphic in form and mostly made of plaster. He subsequently used metal rods in post-and-lintel constructions covered with plaster and Lucite. This system of layering plaster over armatures foreshadowed Lassaw's later open metalwork.

By 1937 he had begun to use sheet metal assembled and brazed with solder. Further experience with direct welding broadened his visual and textural options. His work became more open and more intricate. An early and aesthetically advanced welded work is *Sculpture in Steel*, 1938 (fig. 35). Already, form is opened, and there is a sense of movement into and out of the small, curvilinear sculpture. This piece appeared slightly later than Smith's first welded works.

Piet Mondrian exerted considerable influence in 1940, and his immigration to the United States had an effect on much American abstract art. Lassaw's enthusiasm was expressed in an austerely geometric work of steel and plastic that he called *The Mondrian* (whereabouts unknown), foretelling his format of interlocked rectangles. Essentially, he combined a rectangular juxtaposition of verticals and horizontals with surrealist influence and his own predilection for mottled surfaces. *Kwannon,* 1952 (pl. 21), represents his use of repetitive lines intersecting at right angles, setting up a progressive framework that extends in space. The intricacy of slender,

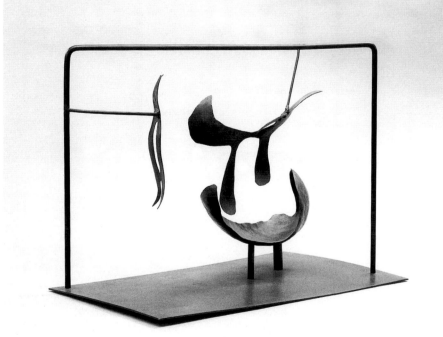

FIGURE 35
IBRAM LASSAW
Sculpture in Steel, 1938
steel
18⅝ x 23⁹/₁₆ x 15 inches
Whitney Museum of American Art, New York
Purchase, with funds from the Painting and
Sculpture Committee

connecting lines suggests natural as well as man-made states of being. Like a model for an elaborate architectural habitat or a celestial formation, *Kwannon* extends organically, seemingly capable of infinite expansion. It appears to have a lifelike ability to assume other configurations while preserving an underlying grid. Modifications to strict geometrical organization cause this work to depart from machinelike precision as it takes on a more organic appearance. Characteristically, *Kwannon*'s linear character allows for interpenetration of form. Irregular surfaces reflect light to heighten sensations of intricate passage in and out of space.

Lassaw's attenuated conglomerations can be compared to early work by Philip Guston, whose paintings in the early 1950s may be grouped with the Abstract Expressionists. Like Guston's, the sculptor's lines seem to coalesce momentarily into an object that could quickly dissipate into external space. Lassaw's technical means might also be compared to the drip paintings of Pollock. In his approach to sculpture, Lassaw shared with Pollock and other artists of the time an insistence upon an intimate participation with art. "[Sculpture] is to be grasped and felt with one's two eyes; at once, one enters and explores a piece of sculpture," he said.[9]

Technically complicated in their underlying construction and overlying coats, Lassaw's works appear organic and changeable. His sculptures have a constructed, architectural quality, at the same time exhibiting a sense of being unplanned, like a natural growth or an organism found in nature. Manufactured and natural elements coexist in his work. He wrote in 1956:

All day long, I observe Nature; people walking in the street, the movements of branches in the wind, the patterns made by neon signs and auto headlights on a wet night; marvelous cracks in the pavements; and equally, the range of one's own feelings; the whole complex of both "outer" and "inner" reality.[10]

RICHARD LIPPOLD

Richard Lippold (b. 1915) shares with Lassaw and others an interest in using line to realize sculpture. However, Lippold's linear elements are more smooth, sleek, and attenuated than Lassaw's. Although Lippold's aesthetic is a constructivist one, in comparison to the work of Naum Gabo or Antoine Pevsner, primary proponents of Constructivism, his creations have a more referential cast, especially toward structures found in nature. He wrote of his approach:

The fragile snowflake appears in more variations of form than any kind of "permanent" sculpture. The spider's web is both a jewel for the branch and a noose for the fly. Nature abhors a vacuum only within the earth's atmosphere, not beyond it where infinity "begins."

With so much variety in truth, where will a man rest his head and his heart? At this moment in history the answer seems to be, "Nowhere," although we still have our preferences, as there are many species of turtles and rockets. My preference in material is Space, captured by the most seductive other materials I can arrange. My preference for social action is simply to have my being among all other objects that exist in Space, "which loves us all," and in which modes of communication today can dissolve barriers of time and energy, of nations and races. Although the word sounds old-fashioned, I thus have my faith in Space. Like every adventure, this being in Space at all levels is full of terror, delight, question, and answer. Has any Material, Society, or Belief had more permanence or finality?[11]

With this statement, Lippold encapsulates both his work and his character. Apparent are an observant eye, a discerning mind, a sensuality, and an openness to the universe as a whole. In his work he attempts to realize his belief in space as a unifying common denominator, a context and container for an infinite variety of forms.

Like other artists maturing in the 1940s and 1950s, but perhaps the most adamant in this direction,

Lippold is concerned with including space in his work, with interjecting emptiness into traditional concepts of sculpture. The importance of airplanes during World War II and the increasing enthusiasm for physical movement into outer space paralleled sculptural developments of the forties. Experiments and technological developments in speed, flight, and movement through space were expressed by sculptors working during this time.

Lippold's background led him naturally into this new aesthetic. He grew up in Chicago, where from 1933 to 1937 he studied industrial design at the School of the Art Institute of Chicago and the University of Chicago. For four years he worked as a professional designer, and in 1940 he began to teach industrial design. At the time Chicago was a site for Bauhaus aesthetics, characterized by a constructivist approach to art and fostering experimentation. In 1941 Lippold made his first construction from wire. The work was largely two-dimensional in format, but he soon moved into freestanding pieces, varying the thickness of the wire, using curvilinear shapes, and sometimes adding tiny glass beads.

He moved to New York in 1945, and two years later he began the series *Variations on a Sphere*. The first five sculptures in the series were dedicated to avant-garde composer John Cage who had taught experimental music in Chicago. Cage's interest in Zen philosophy appears to have influenced Lippold, especially concerning notions of continuous variation.[12] One of Lippold's most acclaimed works is *Variation Number 7: Full Moon*, 1949–50 (pl. 22). The subject reveals his interest in astronomy. *Full Moon* exhibits a radiance achieved through a combination of materials, including various types of wire and rods. It expresses the moon's luminosity extending into surrounding space. Literally, Lippold presents a geometric equivalent for the movement and presence of light.

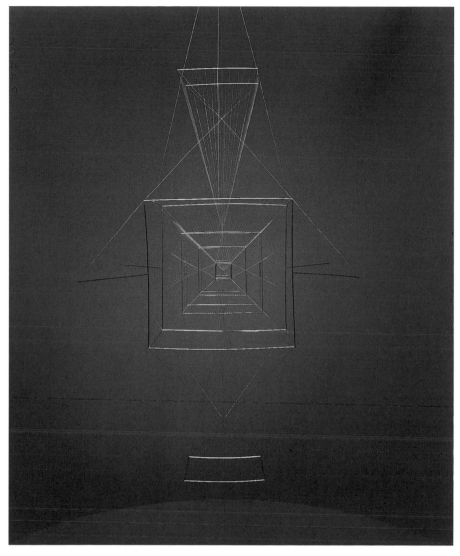

PLATE 22
RICHARD LIPPOLD
Variation Number 7:
Full Moon, 1949–50
brass rods, nickel chromium, stainless steel
wire
120 x 72 x 72 inches
The Museum of Modern Art, New York
Mrs. Simon Guggenheim Fund

This piece might be compared to Lassaw's *Kwannon* (pl. 21), executed about two years later. Both works emphasize line and make use of modules. However, Lippold's work seems a result of detailed planning and controlled effort, while Lassaw's piece shows a willingness to admit the vagaries of the process itself. Lippold's exacting dependence on line held in tension results in a strictly geometric form representing light rays reflected from a single source. Lippold's conception, though bearing the mark of the laboratory,

is reflective of natural phenomena. To him, the world exists in a balance of tensions:

We can hope—even prove—that our wisdom is stronger than our weapons. This construction [pl. 22] is such proof. The firmer the tensions within it are established, the more placid is the effect. Patience and love are the elements which gave it life, and patience and love must be used in all dealings with it, its hanging and its seeing. Fortunately, patience and love are both marvelous feelings, so there is little difficulty in calling upon them to help you.

. . . Once installed, nothing can disturb it except the most delicate of matter; dust, a piece of paper, an enthusiastic finger. Again we must remember that a slip of paper in the wrong place—someone's desk or a portfolio—can now destroy mankind. It is not the main tensions we must fear, it is the little delicate relationships which we must control.[13]

The forces at work in these two artists' contemporaneous sculptures have been aptly described by critic Rosalind Krauss: "This merging of constructivism and surrealism produced in the work of Lassaw and Lippold objects that draw an analogy between technology and magic."[14]

The artists discussed here, namely Roszak, Ferber, Lipton, Lassaw, and Lippold, in addition to Smith, were the individuals most devoted to fused metal processes during and beyond the war years. Each explored a personal stylistic preference. Lassaw and Lippold emphasized linear structures, Lipton utilized enclosed volumes, Smith concentrated on plane and line, and Roszak and Ferber pursued organic shapes in an expressionistic manner. These sculptors' respective oeuvres paralleled the work of abstract expressionist painters in New York. Both technical spontaneity and formal conceptions informed two- and three-dimensional work. Artists were less tied to external reality and more assertive of internal signals and symbols of universal import.

Two other artists working at this time were Reuben Nakian and David Hare, both of whom are associated with the New York School. Unlike the sculptors already discussed, these artists were less attached to welding. They used this process for given groups of work, while adopting other materials and means for other phases of their respective careers.

REUBEN NAKIAN

Somewhat of a maverick, Reuben Nakian (1897–1986) stayed his own course during a long career, experimenting with various media throughout his life. His irascible and doggedly independent nature is demonstrated in a statement made to critic Michael Brenson in

1985, when he was eighty-five years old: "I look at this age as an age of zombies, esthetically. My work comes out of art history. It's a tradition. Art has to be a branch coming out of a tree. Most of the stuff being done now is just weeds coming out of the ground."[15]

Born in Flushing, New York, Nakian studied briefly at the Art Students League and at other academies, but his most important educational experience was as an assistant to the sculptor Paul Manship in his New York studio. After 1920 Nakian became friendly with Gaston Lachaise, who also had worked with Manship, and shared studio space with him. During that time he worked in marble and wood with figurative themes, especially

animals. In 1931 a Guggenheim Fellowship allowed him to go to France and Italy. He did not return brimming with modernist ideas, however. In the early thirties he gained a reputation creating highly realistic portraits of well-known contemporaries, among them Franklin Delano Roosevelt and Babe Ruth. Later in the decade he worked on the WPA Federal Arts Project and met Arshile Gorky and de Kooning. Through them he became acquainted with early abstract expressionist work. From 1936 to 1946 his style was decidedly expressionistic in tone. He worked then in clay and with plaster poured over a wire armature. Subsequently turning to pen and ink, bronze, and welded steel, he based much of his work on the heroic themes found in classical mythology.

In the fifties he abandoned rounded forms in favor of large sheet-metal constructions. Three survive, among them *The Rape of Lucrece,* 1955–58 (pl. 23).[16] This piece, constructed

of rods and plates, holds to heroic themes, but the format exhibits considerable differences from his earlier works. Constructivist in its juxtaposition of plane and line, the piece is pointed and angular as abstract elements intersect one another. It is an active work, characterized by movement and energy

Nakian soon turned back to the plaster and wire works. In spite of their more curvilinear character, these pieces compare with his welded work in their activation of space. His work in each medium was expressive and in keeping with fifties artists' search for ultimate themes.

DAVID HARE

Unpredictable and experimental, New Yorker David Hare (1917–1992) first studied chemistry before stints as a commercial artist, portrait painter, and photographer. In 1941 he began to work with "heatages," work made by heating and melting photographic negatives. This brought him into contact with André Breton, Miró, and other Surrealists. He was introduced to Breton by his cousin Kay Sage, herself a surrealist artist.

He began sculpting in 1944 and was immediately successful, gaining a solo show at Peggy Guggenheim's Art of This Century Gallery the same year. His figurative work was made first of wire and plaster and later of fragments of steel, iron, and bronze. Hare had no specific theoretical mission. Rather, he assimilated form in what appeared to be a subconscious state. In a sense, Hare was a "natural" Surrealist, as his work does not appear affected, strained, or inordinately pretentious. Instead of a dogmatic origin, Hare's sculpture seems to have just appeared out of the depths of his mind. Author Robert Goldwater observed:

Hare is not doctrinaire. He works with no set vocabulary of "subconscious" images, and with no dream

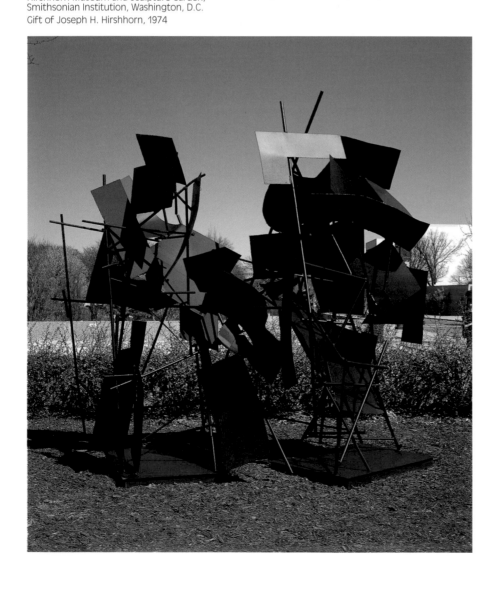

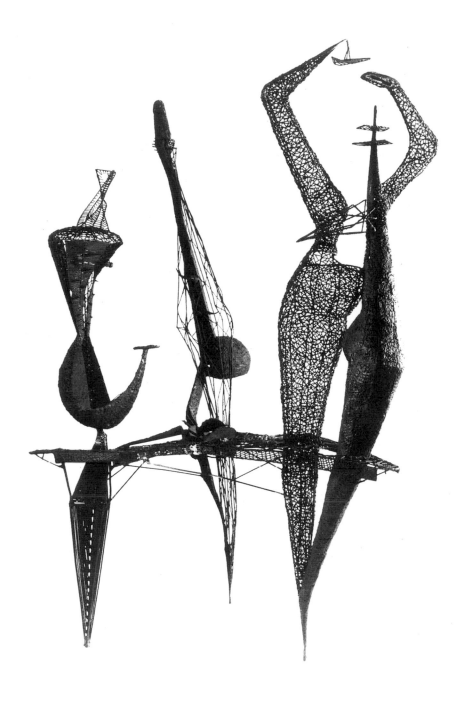

FIGURE 36
DAVID HARE
Dinner Table, 1950
welded steel
90 x 62½ x 47½ inches
Grey Art Gallery and Study Center, New York
University Art Collection
Gift of John Goodwin

diners, the interactions of conversations, and the interrelationships of individuals. Viewers are allowed to "fill in" this content because of Hare's masterly free associations of essentially unspecified form.

Eventually Hare made both paintings and sculptures. There was always a strangeness to his work that served his choice of subjects, which were human, insect, some other animal, or hybrids of these.

Although New York was a particularly powerful locus of artistic activity in the fifties, artists working elsewhere contributed their individual aesthetics to the art of welded sculpture. On the West Coast of this country were Claire Falkenstein and Bernard Rosenthal; Harold Cousins chose Europe for his home and work environment; working in Chicago were Joseph Goto and Richard Hunt.

symbols. Therefore his work (with the possible exception of some of his earliest pieces of 1944–45 whose smooth and polished surfaces have a surgical glow) is altogether without that breathless, vacuum-like, scrubbed cleanliness which is so much a part of some of the subtlest (Tanguy) and also some of the most banal (Dali) of the Surrealist creations. Nor does his oeuvre as a whole evolve within a closed and self-sufficient system. Hare is a stranger to both the poignant and the blatant extremes of Surrealist narcissism. . . . His whole purpose is to allow himself to wander freely through what he has called "the spaces of the mind," to work in such a way that the program of what he is doing is never a closed program, but always open to the apparent impulse.[17]

Hare began welding materials about 1950, sometimes creating life-size pieces. *Dinner Table,* 1950 (fig. 36), came at the beginning of his welded work and is quite remarkable in scale and imagery. One has only to think of the rigorously planned and executed and highly symbolic dinner table of Judy Chicago (now dismantled), which is emphatically feminist in content, or *Last Supper* by Marisol Escobar, a three-dimensional approach to Leonardo da Vinci's painting, to discern the more abstract approach of Hare. His work's large size serves to associate the viewer with the sculpture as it inhabits the same space on a similar scale. In addition to the table itself, the work suggests the presence of

CLAIRE FALKENSTEIN

A pioneering woman artist born in Oregon, Claire Falkenstein (1902–1997) was educated and produced early work in California before moving to France in 1950, during the heyday of welded metal sculpture and abstract expressionist painting. She was by then an accomplished artist, writer, and teacher. Preoccupied with wood in the 1940s, she began to experiment with transparent effects toward the end of that decade, working in Plexiglas and other media. For eight years Falkenstein lived in Paris, where she began to draw in space via brazing,

FIGURE 37
CLAIRE FALKENSTEIN
Vibration, 1964
welded copper
42 x 44 inches
Los Angeles County Museum of Art
Anonymous gift

soldering, and welding. She also had a studio in Rome and exhibited widely in Europe.[18] By melting copper tubing, wire, and sometimes glass, she gave her work a filigreed quality. Though her sculptures have an openness similar to that of Lassaw, she tackled spherical as opposed to straight and angular shapes. An example is *Vibration*, 1964 (fig. 37), made of welded copper. This work's curvilinear nature is emphasized by veins of copper running over and through it in intricate, irregular patterns. The piece is more open than closed, volumetric rather than solid, and linear instead of planar.

The intricacy of her work carries through in the gates she built in 1961 for Peggy Guggenheim in Venice, Italy (fig. 38), which consist of brazed, interwoven lines. The welded linear network provides a barrier that separates the entryway from the street yet offers a view inside. Set with pieces of glass, these gates convey a richly decorative effect and form a transition from outer world to inner garden. Returning to Venice, California, in 1963, Falkenstein continued to create sculptures that resembled thick natural growths.

BERNARD ROSENTHAL

More closely associated than Falkenstein with a West Coast school of artists, especially that of Los Angeles, is Bernard Rosenthal (b. 1912). Born in Illinois, Rosenthal was educated at the School of the Art Institute of Chicago and the Cranbrook Academy of Art in Bloomfield Hills, Michigan. After a period of working with the figure in wood and cast metal, about 1950 Rosenthal began to weld, inspired by such artists as Giacometti, Julio González, and Smith. Rosenthal's forte was architectural sculpture, for which he gained a considerable reputation in Los Angeles. Notoriety came with a large work, depicting a mother, father, and child, that he built for the city police building. This piece was deemed "un-American" due to its abstract form and was eventually melted down.

The Ark, 1958 (fig. 39), is illustrative of the directness of Rosenthal's approach to welding. With unconcealed hammered seams and welded joints, this work is rectilinear, yet its geometric qualities are softened by slightly curving lines and an irregular surface texture. Interlocking planes are positioned so as to create niches and prominences that project and recede in space. The artist's choice of title for this tabletlike form lends religiosity to this work, relating it to a sacred tabernacle or chest.

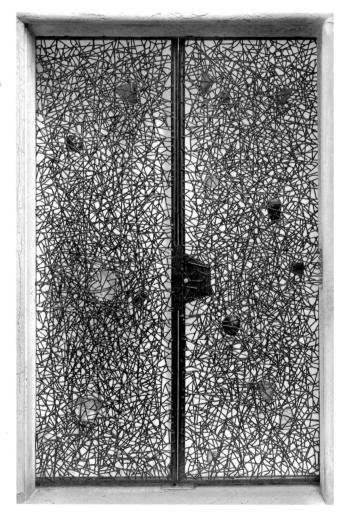

FIGURE 38
CLAIRE FALKENSTEIN
Entrance Gate to Palace, 1961
painted steel, steel tubes
108 x 35 inches (each side)
Peggy Guggenheim Collection, Venice
The Solomon R. Guggenheim Foundation

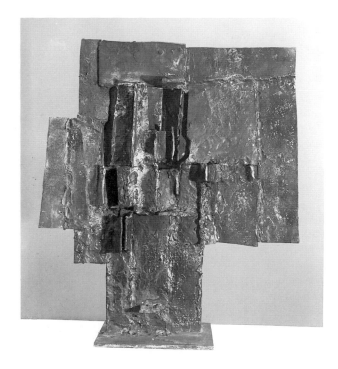

FIGURE 39
BERNARD ROSENTHAL
The Ark, 1958
brass
28 x 24 x 7¾ inches
The Museum of Modern Art, New York
Gift of Mr. and Mrs. Victor M. Carter

PLATE 24
HAROLD COUSINS
Plaiton Suspendu (Hanging Plaiton), 1958
steel, brass
62 x 17 x 14 inches
Collection of Danielle and Marc Cousins
Courtesy Michael Rosenfeld Gallery, New York

PLATE 25
HAROLD COUSINS
Plaiton Long-Standing, 1965–68
steel, brass
32 x 63 x 26 inches
Collection of Danielle and Marc Cousins
Courtesy Michael Rosenfeld Gallery, New York

HAROLD COUSINS

Like Falkenstein and Rosenthal, African American artist Harold Cousins (1916–1992) traveled to Europe; unlike them, he stayed. Born in Washington, D.C., Cousins served in the army from 1943 to 1945 and two years later studied with sculptor William Zorach at the Art Students League in New York. The next year he was in Paris assisting Ossip Zadkine, a sculptor who worked in a cubist mode.

His work of the early fifties, primarily in terra cotta, is blocky, solid, figurative, and expressive in character, indicating his training with Zorach and Zadkine. From about 1951 a series of clay and stone masks reflects Cousins's interest in non-Western art. Basically planar in form, these works often bear carved features, realizing a face, for example, through negative shapes. By 1952 Cousins was engaged in humorous figurations constructed of metal.

The fifties were also a time of travel, but he eventually settled in Paris.

In the mid-fifties Cousins's work was linear and planar in character, with one or the other element dominating. His use of line, unlike that of Lippold and Lassaw, is primarily upright but bent, with a horizontal counterpoint to the upright form. At this time he began work on his *Plaiton* series. The name combined

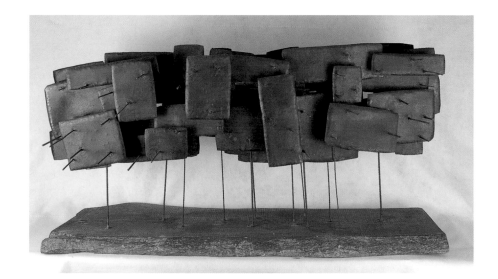

the words *plate* and *laiton,* French for "brass." The *Plaiton* sculptures are characterized by overlapping metal plates hammered to produce an overall relief texture. In certain instances, Cousins combined linear and planar elements. He continued working with these formats for the rest of his life.

One of Cousins's most interesting arrangements is suspended sculpture in which gravity is defied, as in *Plaiton Suspendu (Hanging Plaiton),* 1958 (pl. 24), in which horizontal and vertical planes are organized in an upright, relieflike mode. The work exhibits an important characteristic of Cousins's work: two-dimensional orientation that does not relinquish profile views. Hung in space, the work looks like an organism because of the informality of the composition and the irregular shapes of the metal planes. Cousins's work occupies an area between technology and nature, with its organic forms built of steel. His peculiar use of intersecting planes is unique among welding sculptors. Also, there is a sense of containment in Cousins's forms. Though they are organized in space, they tend to turn inward rather than out into the environment. Viewers must work around a sculpture that has no base. Its suspension, in effect, emphasizes the space around the work, including the space beneath it.

Plaiton Long-Standing, 1965–68 (pl. 25), is an instance of this artist's combination of planar and linear forms. Typically standing on supportive rods, the work seems perched as though on legs. It combines a horizontal top with a vertical bottom; openness below contrasts with fullness above. The work has a building-block quality, as if elements are set atop or adjacent to one another over time, forming a conglomerate. It might represent a group of figures or a crowd of people.

JOSEPH GOTO

Although he was born and raised in Hawaii, Joseph Goto (b. 1920) is associated with the Chicago School of artists. Goto went to the School of the Art Institute of Chicago in 1947. Chicago's Art Institute had considerable repute at the time, and the Chicago Arts Club, like the Museum of Modern Art in New York, was exhibiting modernist, surrealist, and expressionist work by Europeans. Certain galleries in Chicago were supportive of new work, and many active artists were students from the Art Institute or the Institute of Design (now part of the Illinois Institute of Technology). The former school emphasized expressionism, while the latter, founded by Moholy-Nagy, promulgated a more rigorous Bauhaus aesthetic. Additionally, a group of informally associated artists—Leon Golub, Ray Fink, John Karney, Hugo Weber, Abbott Pattison, and Nancy Spero—were part of a so-called Chicago School that rejected traditional imagery for a figurative style emphasizing the grotesque and even monstrous. Competition between the art scenes of New York and Chicago was intense.[19] Windy City artists chose a humanist course, incorporating figurative references into expressionist paintings and sculpture, while the New York City abstract expressionist movement was based on theory and abstract form. Goto shared with other Chicago artists an interest in Surrealism.

Goto had worked as an industrial welder. When he began to use the welding technique in a fine art context, he drew on the work of González for inspiration. His work at the beginning of the fifties was concerned with natural forms, primarily insects and plants, which he depicted in a rough, perfunctory manner. *Organic Form, I,* 1951 (fig. 40), suggestive of spikes and bristles, is indicative of this stylistic period. The combination of a streamlined design with a subject

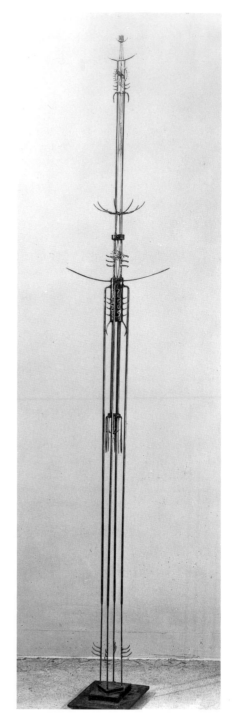

FIGURE 40
JOSEPH GOTO
Organic Form, I, 1951
steel, 2 parts
136¼ x 21¼ x 21 inches
The Museum of Modern Art, New York
Purchase
© Joseph Goto/Licensed by VAGA, New York, New York

drawn from nature results in a generalized hybrid, a creature culled from the imagination combining modern technology with organic forms.

RICHARD HUNT

Richard Hunt (b. 1935) is from Chicago and was educated at the School of the Art Institute. In the mid-fifties he saw work by González that inspired him to begin to solder and weld. Like Goto, he was struck by González's combinations of abstract organic forms. The dual influence of Goto and González is particularly apparent in Hunt's work of the mid- to late fifties. *Arachne*, 1956 (pl. 26), an important piece from this period, was purchased by the Museum of Modern Art in 1957, leading to greater recognition for Hunt, then in his early twenties. Nevertheless, *Arachne* is a mature piece illustrative of his unique blend of opposites. As the artist himself puts it:

One of the central themes in my work is the reconciliation of the organic and the industrial. I see my work as forming a kind of bridge between what we experience in nature and what we experience from the urban, industrial, technology-driven society we live in. I like to think that within the work that I approach most successfully there is a resolution of the tension between the sense of freedom one has in contemplating nature and the some-times restrictive, closed feeling engendered by the rigors of the city, the rigors of industrial environment. The theme of my work can be char-acterized as a fusion or harmoniza-tion of the vital tensions existing between dualities, such as organic and the geometric, the organic and the abstract, or the past and present, the traditional and contemporary.[20]

PLATE 26
RICHARD HUNT
Arachne, 1956
steel
30 x 24½ x 28¼ inches (including base)
The Museum of Modern Art, New York
Purchase

PLATE 27
RICHARD HUNT
Drawing in Space No. 2, 1977
steel
32⅜ x 34 x 33 inches
Neuberger Museum of Art, Purchase College,
State University of New York
Gift of Mr. and Mrs. Melvin Merians

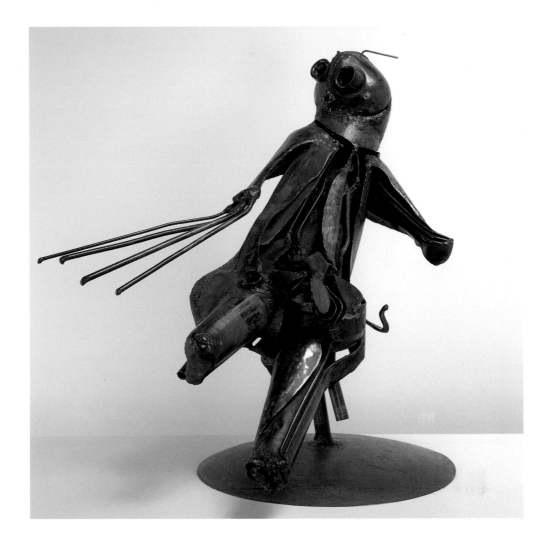

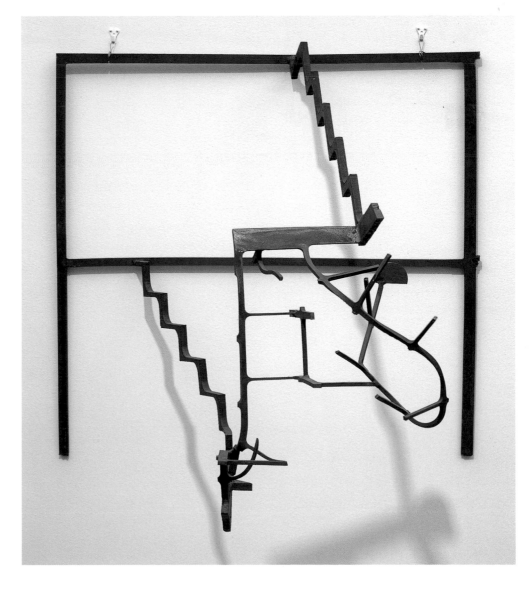

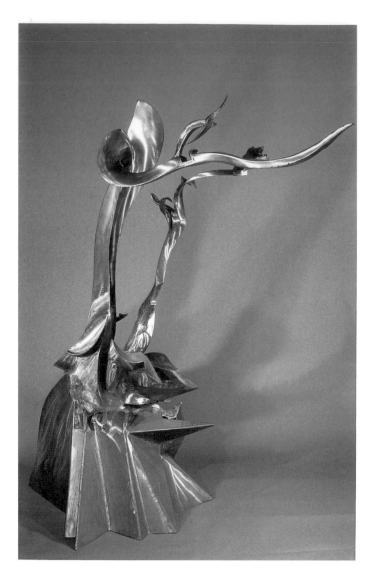

FIGURE 41
RICHARD HUNT
Growing Forward, 1996
bronze
108 x 40 x 30 inches
Collection of Geraldine Wicklander

Made of industrial parts, the image appears to have both man-made and natural elements, as if mutation had taken place. The past existence of juxtaposed fragments augments the sense of metamorphosis and transformed being.

After a stint in the United States Army (1959–60), Hunt returned to Chicago to pursue his work as a sculptor, continuing his exploration of the "hybrid" theme. From the sixties to the present, Hunt has been concerned with conveying movement in extended and directional compositions. *Drawing in Space No. 2,* 1977 (pl. 27), appears as a gestural construction. It is characterized by emphasis on line and geometric form, extending from the wall as an attenuated relief. It bridges two- and three-

dimensional space. Recent work has gravitated toward a sense of evolving movement that appears futurist in inspiration. Exemplary is *Growing Forward,* 1996 (fig. 41), with spiraling motion created by the extension of tendrils in space. This piece is also illustrative of Hunt's ongoing exploration of plant life, as forms gracefully branch from a central core. Comparison of this work with *Arachne,* completed forty years earlier, reveals a greater smoothness of surface in the later work as opposed to the raw, rough exterior of prior efforts. Also, in more recent sculptures there is less literal reference to insect life. Works of both periods suggest plant life, but his sculptures of the nineties do so in a more elegant, refined manner.

4 KINETIC ART AND ASSEMBLAGE

Offering the means to explore new avenues in three-dimensional art, welding has been a popular choice for those working in kinetic art. It provides the advantage of single connecting points or edges, making possible the creation of individual units that can extend into space, move, and make sounds. Many artists have incorporated a dadaist inclusion of manufactured items, futurist experiments with speed and noise, and constructivist concepts of movement in architecture. In Europe around the time of World War I, artists explored illusionistic and actual movement. At mid-century there was an outburst of such sculptural inquiry in both Europe and America, as artists used welding to extend the possibilities of sculpture.

NAUM GABO AND ANTOINE PEVSNER

Working with constructivist ideas in Moscow, the brothers Naum Gabo (1890–1977) and Antoine Pevsner (1886–1962) used plastics and metal to incorporate light and transparency as sculptural elements. In the early stages of their work, Gabo and Pevsner essentially translated Analytical Cubism into three-dimensional constructions, always working independently but in the same vein. Plane and void were the essential features of each of their work.

Head No. 2, 1916 (fig. 42), is an early example of Gabo's work with metal. Smooth and planar, the head seems robotlike in its dependence upon manufactured material. Gabo's study of mathematics and engineering in Munich was overshadowed by his newfound interest in the work of artists of Der Blaue Reiter, a loosely

FIGURE 42
NAUM GABO
Head No. 2, 1916
(enlarged version 1964)
Cor-ten steel
69 x 52¾ x 48¼ inches
Tate Gallery, London

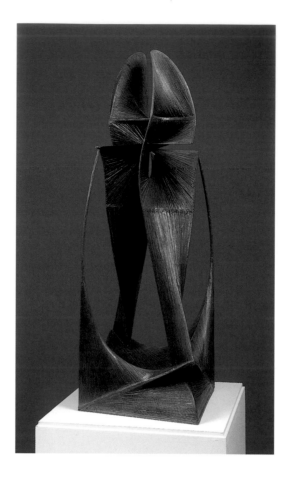

PLATE 28
ANTOINE PEVSNER
**Colonne jumelée
(Twinned Column), 1947**
brazed bronze rods
40½ x 14 x 14 inches
The Solomon R. Guggenheim Museum,
New York

LÁSZLÓ MOHOLY-NAGY

Herbert Read has aptly observed: "There was no limit to the ingenuity and inventiveness of Moholy-Nagy."[2] Born in Hungary, László Moholy-Nagy (1895–1946) studied law at the University of Budapest. Drafted into the Austro-Hungarian army, he was sent to Russia, where he suffered serious injuries, causing him to be sent home. Having discovered his ability to draw and sketch during his time as a soldier, he took classes in Budapest and read about art. Also, he joined a leftist group of writers and artists. Between 1918 and 1921 he invented his own version of a photogram, using familiar objects applied to slowly darkening paper, allowing him freedom to manipulate the objects. During this period he also made metal sculpture. *Nickel Construction*, 1921 (pl. 29), is an early example of his use of welding and exemplifies his inventiveness in

organized group of expressionist artists in Germany who sought to reflect spiritual realities in their art. Also, a trip to Paris made him familiar with revolutionary aesthetics elsewhere in Europe.

Pevsner devoted himself to painting until 1923. His subsequent sculpture was based on abstracted figurative motifs, a style in which the brothers worked independent of one another. During World War I the brothers lived in Norway, continuing to create art that was essentially constructivist and architectural in nature.[1] Gabo's *Head No. 2* is from this period. Returning to Russia in 1917, Gabo designed a number of sculptures as models for monuments, probably influenced by Vladimir Tatlin's constructivist aesthetic. Gabo then lived in Berlin and Paris, where in 1932 he took part in the Abstraction-Création group, which expounded a nonfigurative art. From 1936 to 1946 he was in London, where his impact was felt among local artists. He later became a United States citizen. Moving from

place to place, Gabo was an emissary of constructivist abstraction.

Pevsner, on the other hand, settled in Paris in the early twenties, remaining there the rest of his life. From early work in plastic, he turned to metal in the 1930s. His *Colonne jumelée (Twinned Column)*, 1947 (pl. 28), typifies his use of fused linear rods whose repeated lines set up rhythmic movements. Light reflected from the ridges of the lines heightens the impression of moving current.

Both artists employed contemporary materials in abstract ways to capture and capitalize on luminous reflections and refractions. In Gabo's and Pevsner's work, the transparency of plastic allows light to flow through space subtly delineated by plane and line. Their metalwork also fosters the play of light on surfaces. Resultant sensations of movement arise from the artists' manipulation of form and the viewers' position or movement around the piece.

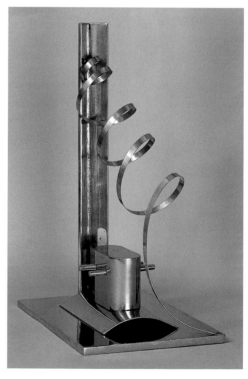

PLATE 29
LÁSZLÓ MOHOLY-NAGY
Nickel Construction, 1921
nickel-plated iron
14⅛ x 6⅞ x 9⅜ inches
The Museum of Modern Art, New York
Gift of Mrs. Sibyl Moholy-Nagy

finding appropriate means, in this case industrial, to achieve particular ends, here a constructivist format.

When leftist artists were no longer welcome in Hungary, he went to Vienna, then Berlin, arriving in 1920 and remaining until 1933. In the latter locale he learned about Berlin Dada and Russian Constructivism, meeting dadaist artist and writer Kurt Schwitters and becoming acquainted with the suprematist work of the Russian painter Kasimir Malevich and the Russian constructivist work of El Lissitzky. Experimental dadaist concepts influenced him in terms of his interest in collage, photomontage, and typography, and working in a constructivist mode confirmed his use of geometric forms. During this period he introduced the first of his *Light-Space Modulators,* which were constructivist in format and involved motion. Light trained on these moving sculptures produced shadow effects within the surrounding environment.

In 1923 Walter Gropius, founder of the Bauhaus school, invited Moholy-Nagy to teach at the Bauhaus in Weimar, Germany's most exciting art center of the time. When Gropius left the Bauhaus in 1928, Moholy-Nagy returned to Berlin. Political crises once again caused him to leave; he went first to Holland in 1934, then London in 1935, and finally Chicago in 1937. In America he became the director of a new Bauhaus school, which he named the Institute of Design. Here he influenced many artists by bringing European Bauhaus and constructivist concepts to America and through his own emphasis on experimentation in art.

Using manufactured materials, Moholy-Nagy realized sculptures that directed patterns of light and shadow. His primary interest was always illuminative effects, as demonstrated particularly by his *Light-Space Modulators* and as put forth in his book, *Vision in Motion.*[3] In a nutshell, his aim in art was to move the eye about with light. Photographer, sculptor, and painter, and involved in theater, film, and ballet, Moholy-Nagy created work in varied media that demonstrates his knack for giving visual form to moving light. He investigated numerous means of making motion an expressive feature, even utilizing motors.

JEAN TINGUELY

Born in Switzerland, Jean Tinguely (1925–1991) loved reading, especially biographies of Alexander the Great, Augustus Caesar, Napoleon Bonaparte, and Lord Byron. This enthusiasm for learning did not extend to school, however, and he often skipped classes. Regimentation and discipline did not suit his quixotic temperament, and later he was fired from his first job after tearing the time clock off the wall.

During the second half of the forties, Tinguely painted and experimented with constructed forms. He attended the Basel School of Arts and Crafts, where his teacher, Julia Ris, encouraged him to use movement as a means of making sculptures.[4] However, Tinguely soon fell in with a political group in Basel, which was then a center for refugees, and he gave up art for a time. He then met Swiss performance artist Daniel Spoerri, with whom he worked on creating a theater without actors, a project that drew Tinguely back into the art world. He went to Paris in 1952 to pursue his art.

In 1954 he began a series of small wire sculptures that he called *moulins à prières* (prayer wheels). Our example (fig. 43) is made up of circles and horizontal and vertical lines. The piece appears to consist primarily of space, like a three-dimensional diagram. This early soldered work led to experimentation with motors; he called his motorized works "meta-matics." Also of 1954

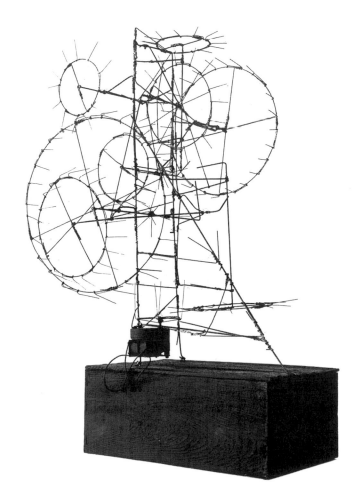

FIGURE 43
JEAN TINGUELY
**Moulin à prières
(Prayer Wheel),
1954**
steel wire, wood base,
electric motor
29½ x 21 x 14 inches
Museum of Fine Arts,
Houston
Museum purchase with
funds provided by D.
And J. De Menil

are "mobile-paintings," which were exhibited at the Galerie Denise René in Paris. These consisted of white geometrical shapes propelled by rubber band–driven wooden wheels. In 1955 he met experimental artist Yves Klein, and in the latter part of the fifties he and Klein had a joint exhibition—Klein's monochrome blue paintings were whirled around and "dematerialized" by Tinguely's machines. In 1959 he invented meta-matic drawing machines that produced drawings and distributed them among spectators. These meta-matics, in a sense, were the automat of their day, dispensing works of art. Satirizing the concept of the artist's hand and elevating the machine to the status of artist, Tinguely presented an ironic view of contemporaneous aesthetics.

In 1960 Tinguely made his first visit to New York, where he renewed his acquaintance with Marcel Duchamp, the champion of Dada and the Conceptual movement in art, and met Robert Rauschenberg and Jasper Johns, who were at the forefront of the New York avant-garde. On March 17 of that year he presented his first self-destroying machine, called *Homage to New York,* in the Museum of Modern Art's courtyard. This piece, a combination of sculpture and theater, became notorious. Ironically, it did not entirely succeed in destroying itself, much to the dismay of some. There was considerable social commentary involved: the idea of a city as inevitably doomed, the notion of a mechanism as destructive. When it did not destroy itself, the machine seemed to fail—a negative comment on its efficiency. But most of Tinguely's works were antimachine in the sense that they ridiculed any concept of streamlined efficiency, delivering scathing commentary on society's absorption with machines. This simultaneous use of machinery and critique of its mission was both interesting as an artistic concept and humorous. It was sculpture as social satire.

In the early sixties Tinguely began his *Baluba* series, made of junk, and commenced a long relationship with artist Niki de Saint-Phalle, with whom he lived from 1960 on. In 1962 he constructed *Study for an End of the World, No. 2,* which was filmed in the Nevada desert by NBC. Around this time he began working with de Saint-Phalle, Rauschenberg, and others who were experimenting with new forms of visual art, theater, and dance. Resulting works included a production of *The Construction of Boston* by the poet Kenneth Koch, produced in New York by dancer and choreographer Merce Cunningham. (Tinguely's contribution was a wall of cinderblocks across the stage.) With such partnerships Tinguely bridged continents, bringing his ideas about possible extensions of sculpture to this country. He also worked with de Saint-Phalle and Per Olaf Ultvedt in 1966 to make a huge temporary sculpture called *Hon* (*hon* means *she* in Swedish). This work, which was destroyed after three months, could be "visited" by entering and leaving through a vaginalike opening. Likewise, Tinguely's independent sculptures became monumental in scale at this time.

In subsequent years he created giant figurative machines composed of motorized water fountains and multimedia pieces consisting of found objects; also, he designed costumes for a Basel carnival. Theatrical and outrageous, he was a figure of enormous energy and creativity. Although welding was not the raison d'être of his work, it nevertheless allowed him to push the boundaries of sculpture into new territories with collaboration, interaction, and interdisciplinary projects.

HARRY BERTOIA

Born in Italy, Harry Bertoia (1915–1978) came to America at the age of fifteen. He was enrolled in a technical high school in Detroit, where he took classes in drawing, painting, jewelry making, and crafts. Later, a scholarship sent him to the Cranbrook Academy of Art in Bloomfield Hills, Michigan, where his classmates included Eero Saarinen and Charles Eames, who were to become famous industrial designers. The director of the academy, Eliel Saarinen, asked Bertoia to start a metalworking department there. At this time, Bertoia had been experimenting with printmaking and had sent some prints to the Guggenheim Museum in New York. He was surprised when Hilla von Rebay, then the museum's director, bought them for herself and for the museum.

In the forties Bertoia showed work at the Nierendorf Gallery in New York. In 1943 he was invited to California by Eames to help design a chair. He also worked on airplane parts for a company where Eames directed research and development. After the war he was employed by the Point Loma Naval Electronics Laboratory, where human movement was studied by means of stroboscopic photography. His labor in this scientific setting encouraged an interest in repetition as a device to suggest motion. At the same time he began to make surrealistic sculptures, recalling Joan Miró's forms but with a linear emphasis.

In 1950 he settled in Pennsylvania, where he designed furniture for a progressive company that emphasized good design in its products and hired talented artists. He simultaneously worked on his own sculpture. From this time on, Bertoia received a number of architectural commissions and made smaller scale sculpture as well.

Construction, 1959 (pl. 30), is a relatively early work, showing a dependence on line that is a major aspect of Bertoia's work. This linear quality entered into earlier drawings and prints that featured forms suggestive of rays and galaxies. Some of the prints emphasize movement via flat planes, predicting another facet of Bertoia's oeuvre. The fan of lines in *Construction*

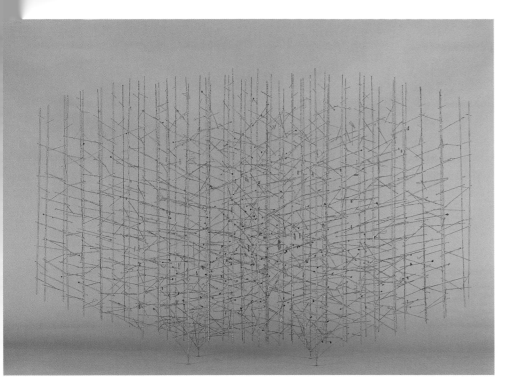

PLATE 30 (left)
HARRY BERTOIA
Construction, 1959
copper, steel
45 x 67½ x 8 inches
Neuberger Museum of Art, Purchase College,
State University of New York
Gift of Roy R. Neuberger

FIGURE 44
HARRY BERTOIA
Altar screen for the Massachusetts Institute of Technology Chapel, 1955
welded metals
24 x 12 x 3 feet
Courtesy The MIT Museum, Cambridge

FIGURE 45
HARRY BERTOIA
fountain dandelion, c. 1963
welded metal
76 inches diameter
Fischer Brothers Real Estate, New York

suggests rays, both in physical configuration and as light reflected from metallic surfaces. These elements move slightly with air currents, enhancing a sense of flickering illumination. The acetylene torch was crucial in such works, which required the cutting, melting, and attachment of metal.

Bertoia's work has been compared with natural phenomena—a dandelion gone to seed or the sun's rays. His obsessive duplication of lines or planes parallels the formation of such structures in nature. Though his work is precise and geometric, an organic feeling is enhanced by the flow of light over form. Further, works such as his 1955 altar screen (fig. 44) incorporate a spiritual quality. This work, constructed with modern technical means, is appropriately located at the Massachusetts Institute of Technology in Cambridge. Bertoia here utilized planes of metal suspended near a light source to convey the impression of a shower of luminosity signifying religious presence. Bertoia elaborated upon this idea to construct several other screens that are also basically frontal in orientation.

One of his fountains (fig. 45) features the play of water from spheres made of rods. A fine spray of water collects light and reflects it in a rainbow, producing an effervescent cloud of mist around the sculpture. Located on a busy street in New York, the work provides relief from architectural forms and the hubbub of human and automotive traffic.

In some of Bertoia's work, there is not only potential movement but also the possibility of sound as rods touch one another. His welded work realizes myriad kinetic possibilities while preserving a poetic, lyrical air.

GEORGE RICKEY

American artists also invented new means to convey movement with welding. In the case of George Rickey (b. 1907), welding was placed at the service of revealing natural currents of air. Using steel and geometric forms, he communicated the course of strong winds and the softest breezes.

Born in Indiana, Rickey moved with his family to Scotland at the age of six. He graduated from Balliol College, Oxford, with undergraduate and graduate degrees in history. He also studied at the Ruskin School of Drawing in Oxford and traveled in Germany in 1928, 1930, and 1934. From 1929 through 1930 he was in Paris studying at the Académie André Lhôte and the Académie Moderne. After teaching at the Groton School in Massachusetts, he lived in Paris for a year before moving back to this country in 1934.

Teaching stints continued to occupy Rickey in the late thirties and forties. During World War II he served in the United States Air Corps, where he made his first mobile. After the war he took graduate courses in art history at the Institute of Fine Arts, New York University. In the latter part of the 1940s he traveled to Europe again and made his first kinetic works in glass. From the next decade to the present, he has made individual smaller pieces and received a number of commissions for larger works.[5]

Rickey's work of the fifties consists of planes—circular, rectangular, or triangular—and lines. At times horizontal in orientation, at times vertical, his works always possess

a sense of asymmetrical balance. He wrote in 1956:

> Balance is a way of arriving at the placement of parts so that they are free to move. So I see balance as a means rather than an end, a way to control the posture of a completely free-hanging element.

> If I can balance it, I can control it. I began to study balance and freedom of movement at the same time, along with the effect of gravity. I also began very early to learn to control the natural period of movement of components.[6]

Natural movement preoccupied Rickey throughout his career. He put mankind's technology at the service of nature, evolving ways to allow steel parts to move by natural forces. This quest led him to welding:

> Quite early I recognized that, if the objects were going to fulfill my aspirations, they had to work, they couldn't be sketches of something that worked. They had to function in the way that I intended and they had to be made sufficiently well to demonstrate in themselves this order that I thought I was making. Whether I wanted it or not, I was stuck from the start with the need for a certain quality in production, and I had to produce it myself; I couldn't pass this on to someone else to make. Stainless steel was attractive to me. I tried other things. I tried plastic, I tried aluminum, I tried brass, and I came back to stainless steel as material which had a durable

finish and was also extremely strong. It had the qualities of steel—the stiffness and durability which I didn't find in aluminum. So I mastered bit by bit some of the technology of stainless steel. I didn't have anybody to teach me, I had to do it the hard way, myself. Then there was the problem of joining parts; the objects had to be made out of parts which I began to fashion myself out of salvaged stainless steel. These parts had to be joined in some fairly durable way. I soon abandoned lead solder. I tried silver solder, and then, for durability, I came to welding. I had to learn, which really meant teaching myself, the various techniques of welding. I bought a spot-welder which joins by heat and pressure in spots between two electrodes. Lippold gave me advice and information.[7]

In 1961 Rickey used heli-arc welding, a fast and economical method of joining heavy steel parts, to extend form greater distances into space. His sculptures' moving appendages became longer, more attenuated. In the early to mid-sixties he developed work consisting of more simplified elements. An example from 1966, *Four Planes Horizontal I (Five Positions)* (fig. 46), though

executed on a small scale, illustrates the economy of form adopted by Rickey at this time. Using only four planes closely situated at the same level, the artist established a constricted format for movement. These surfaces turn at their own speed, depending on passing air, thereby illustrating slight variations in atmospheric conditions. Lifting and falling forms create a sophisticated pattern. In a linear vein is his *Atropos 5,* 1974 (pl. 31). Rickey has moved between these two poles, linear and planar, throughout the course of his career. This larger work is composed of minimal, tall, pointed elements that swing

with the wind. Both pieces have a mechanical and organic quality as lines of steel are sent spinning by air currents. They slice through space, pointing the wind's path.

Rickey's work parts company with several of the artists with whom he may be compared, namely Alexander Calder, Richard Lippold, and David Smith. Like Calder, Rickey allows natural movement to enter the sculptural matrix. Here the similarity ends. Calder used curvilinear forms to represent organic shapes, like leaves, fronds, or petals, while Rickey's geometric planes and lines are neither derived from nor connected to plant life. His selection of bare stainless steel affords a play of natural light on surfaces, while Calder painted his forms. Both artists relied on the movement of air, but the possibility of various movements presented by Calder's mobiles differs from the simpler, more measured tempos of Rickey's sculptures.

While both Lippold and Rickey developed sculpture without mass, Lippold's metallic lines have a precise, crystalline quality and are structurally enclosed, while Rickey's rods flow freely in space. Indeed, space is a positive, capacious factor in both artists' work. Lippold's outline or definition of space is set, while Rickey's is open to fluctuations. Openness permeates the work of both artists, with Rickey's adding the physical flow of air through space. In Rickey's conception, space assumes a palpable existence with parts moving in space and time. His revelations of movement in sequence define interval and duration.

Rickey's work with planes, in comparison with Smith's, reveals a reliance on balance. Also, a tentative state of being is achieved through slight tiltings and angular orientations of form. On the other hand, Smith's work is upright and totemic. His figurations contrast with the nonobjective and minimalistic statements of Rickey. Smith conveys a sense of the strength and stability of steel, while Rickey portrays its

fluctuations in the face of natural elements. Smith's is stalwart; Rickey's is subject to chance and change.

BERNARD AND FRANÇOIS BASCHET

Interesting offshoots of kineticism were produced by several other artists who were associated with Rickey. He collected and wrote about the work of the Baschet brothers, who, working in France, introduced sound into sculpture. The work of Bernard (b. 1917) and François (b. 1920) Baschet has been described by the latter as follows:

My brother Bernard and I want to make a synthesis of the following three elements:

shapes
sounds
public participation

We make shapes and objects with which music can be produced manually—i.e., without electricity or electronics. Therefore anyone can play on them.

Beginnings in 1954 were difficult. Sacha Guitry said: "My wife wants dinner at 7. I want it at 8. We end up by eating at 7:30 and nobody is happy."

In our attempts to synthesize new form and new sound we encountered similar comments. Music people said "this is no music." Sculpture people said "this is no sculpture."

Things have improved. After our show at the Museum of Modern Art in New York which lasted four months it is easier for us to see the future.[8]

A prolific writer and an exponent of constructivist work, Rickey has expounded upon the Baschets in more than one instance. Describing François and his work, he wrote in 1965:

At 45, whimsical, soft-spoken French sculptor François Baschet has invented the deflatable guitar, musical typewriter and glass trombone. Now he is working on a whistling fountain and a public monument

that is moved by the varied weights of passing pedestrians. But Baschet's real bent is creating fantastic combinations of sculpture and sound that may well make tomorrow's music.

A full complement of Baschet's eerily beautiful brain-children is currently on view at New York's Museum of Modern Art. So seductive are the instruments that even some guards ignored the DO NOT TOUCH signs surrounding the "structures sonores" which seem an improbable blend of Calder and Stravinsky.[9]

In another context, Rickey expressed his admiration for the brothers' work:

It is fifteen years since the "Structure for Sound—Musical Instruments" exhibition of the Baschet brothers at the Modern Museum.

"Sculpture" is too general a word for these constructions and, at the same time, too limited. The Baschet machines are made not only for the eyes; their instruments are made not only for the ears; only the unmovable could remain unamused or unbemused in the Baschet world.[10]

Once part of Rickey's own collection, *Structure Sonore,* 1969 (pl. 32), by François Baschet, is one of a number of works intended to produce music, each a musical instrument requiring the participation of a viewer. Both brothers delved into the scientific fields of vibration, resonance, and acoustics. In so doing, they created work that involves viewers' visual, aural, and tactile senses. Like Tinguely's work, Baschet sculptures engage the audience. Tinguely and the Baschets created work with participatory aspects. Unlike the work of Tinguely, however, the Baschets emphasize research in sound and sound as sculptural content.

LIN EMERY

Another artist who works in a constructivist mode and is associated with Rickey is the American Lin Emery (b. 1928), who introduced water into her kinetic works. Born in New York, Emery studied at the Sorbonne (1948–49) and served as an apprentice to Ossip Zadkine in Paris. Returning to America, she learned welding at the New York Sculpture Center and later moved to New Orleans, where she has lived since. In 1956 she met and became friends with Rickey, and in the sixties she began making her own kinetic work.

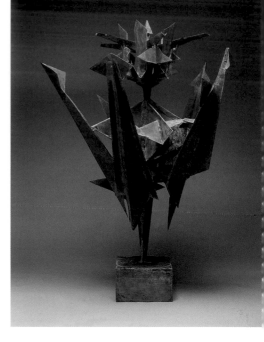

PLATE 33
LIN EMERY
Cripriflora Mobilia, 1962
brazed copper, water pump
53 x 38 x 28 inches
New Orleans Museum of Art
© Lin Emery/Licensed by VAGA, New York, New York

As early as 1961 Emery began to work with moving sculpture that incorporated water. Her earliest attempts were geometric in form, such as rods welded together to form crystalline structures. Exemplary is *Cripriflora Mobilia,* 1962 (pl. 33), which stands upright with water pouring from the top. The structure acts as a foil to the water as art is blended with nature. Occasionally she has powered her sculptures with motors and naturally moving air. Some sculptures include artificial lights and some incorporate sounds, operating like xylophones. Working on large-scale public commissions as well as smaller, more intimate pieces, she has continued to investigate a broad range of kinetic potentials in welded sculpture.

PLATE 32
FRANÇOIS BASCHET
Structure Sonore, 1969
stainless steel
14½ x 14 x 8 inches
Neuberger Museum of Art, Purchase College, State University of New York
The George and Edith Rickey Collection of Constructivist Art

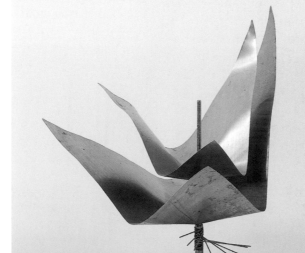

ASSEMBLAGE AND FOUND OBJECTS

Kinetic art was one artistic direction facilitated by welding. Correspondingly, this avenue extended the possibilities of welding. Welding has also aided the art of assemblage by offering the means of attaching manufactured metallic items.

As abstract expressionist painting moved from the fifties to the sixties, the preeminence of the flat surface was nudged aside by growing interest in assemblage and found-object work. An offshoot of collage or the attachment of man-made materials to the picture plane and of dadaist acceptance of found things in art, assemblage emphasizes incorporation of the external world of popular culture into the increasingly esoteric and internal realm of art. Artistic concentration on assemblage arose almost simultaneously with Pop art and gained recognition in the early sixties with several exhibitions in New York. One, at the Martha Jackson Gallery, was called *New Media—New Forms;* it included work by Johns, Rauschenberg, Claes Oldenburg, and Jim Dine. The Sidney Janis Gallery offered *The New Realists,* also with Oldenburg and Dine, along with Roy Lichtenstein, James Rosenquist, Andy Warhol, and Tom Wesselmann. In 1961 the Museum of Modern Art presented *Art of Assemblage.* Much of Pop art was commercially derived, hard-edged, cool, and associated with urban life. Assemblage, in contrast, was less sleek and more funky. Duchamp was a major influence in both trends with his insertion of ready-made objects and images into art, and Rauschenberg and Johns were directly associated with both movements.

After Abstract Expressionism, the notion of movement, style, or trend in art was *au courant,* and critics and writers scrambled to be the first to spot them. Often such categories proved misleading, as individual artists within movements often

worked in disparate styles. Jackson Pollock and Willem de Kooning, for example, painted in quite diverse manners with different results, while both are labeled Abstract Expressionists. Likewise, in terms of style it is difficult to classify Rauschenberg with Warhol or Johns with Lichtenstein, all often defined as Pop artists. Hearing the same names identified with each category over time, we have grown accustomed to the groupings, however unlikely. In a one-on-one comparison, though, there are gaps in the logic of grouping together certain artists. Naturally, such categorization has made marketing easier, as new trends have arisen with the speed and frequency of new fashions.

Assemblage cut across the territories of "movements" so that Rauschenberg and Johns could be grouped under this term or under Pop. Also, assemblagists might use a recognizable object or brand label in their work but be more concerned with the intersection of forms than with commercial reference.

As Pontus Hulten pointed out in his book on Tinguely, when artists forsook reality as a basis and guide for their work, a standard of judgment was relinquished.[11] Art was no longer measured by its correspondence with our accepted perception of a natural or a man-made world. With the invention of abstraction, the artist selected form as dictated by his or her individual response— temperament, mood, opinion, politics, and so forth. Like an "original creator," the artist could conceive from nothing. Dadaist introduction of chance as an operative and surrealist advocacy of the subconscious allowed absolution from total responsibility to external stimuli. The artist became a vessel and vehicle as well as an authoritarian god.

This new freedom empowered artists like David Smith to examine an idea in a series of works rather than just one—a cube could be positioned on top of another, to the side, or at an angle to form a group of related works. Tinguely could construct machines that worked

out their own destiny. Viewers were able to take part in this dialogue of possibilities. Assemblage and found-object art, rooted in the cubist collage and the dadaist ready-made, further demolished barriers. Artists chose not only abstract form, but also concrete objects to include in their work. They began to incorporate materials and objects encountered by chance. Surrealism, with its advocacy of subconscious associations of unlike objects, with histories and connections of their own, created juxtapositions evoking new feelings and meanings. The world outside entered art in the form of previously non-art objects bearing a past and viewers' own associations with them.

Several artists working prior to and alongside sculptors who welded were active as assemblagists. Notable among them was Joseph Cornell, who created personal worlds in boxes. Schwitters was important for his use of "junk," and Rauschenberg must be noted for his adventurous use of pillows, stuffed animals, tires, and various other items. Artists produced individual statements and communications by bringing mundane and disparate objects together. Welding proved to be a suitable tool for melding together different objects and their former associations. Four important exponents of welding for this purpose were Richard Stankiewicz, John Chamberlain, Lee Bontecou, and Mark di Suvero.

RICHARD STANKIEWICZ

Coincidentally, Richard Stankiewicz (1922–1983) went to the same Cass Technical High School in Detroit that Bertoia had attended (he had moved with his family to Detroit from Philadelphia, where he was born). There he took mechanical drafting, engineering, art, and

music. Afterward he worked in a tool-and-die shop and subsequently served during World War II as a U.S. Navy radio operator in the Pacific. Becoming acquainted with the organicism of Morris Graves and Mark Tobey of the Northwest School of abstraction, he began carving sculpture out of bone and other natural materials. He also took up painting.

Moving to New York in 1948, Stankiewicz studied at the Hans Hofmann School of Fine Arts. Like Emery and Harold Cousins, he traveled to Paris and worked with Zadkine. Back in New York he shared a studio with sculptor Jean Follet, and from 1951 to 1958 he founded and helped run the Hansa Gallery, an early artists' cooperative. Throughout the fifties and into the sixties he supported himself as a patent and mechanical draftsman. Representatives of the American architect and inventor Buckminster Fuller were among his customers. He moved to the Massachusetts countryside in 1962, the same year that he participated in a panel on "junk sculpture" at New York's Guggenheim Museum.[12] From 1959 through 1965 he showed in New York with the Stable Gallery. After he left this venue, his work was not shown again until 1971, when he was with Zabriskie Gallery.

In Grace Glueck's judgment, "If he didn't quite invent junk sculpture, Richard Stankiewicz was certainly its prime manipulator."[13] His first encounter with junk metal was in 1951, in his studio courtyard. It was as serendipitous as his later work:

My glance happened to fall on the rusty iron things lying where I had thrown them, in the slanting sunlight at the base of the wall. I felt, with a real shock—not out of fear but of recognition—that they were staring at me. Their sense of presence, of life, was almost overpowering.[14]

According to Glueck, he purchased a welding outfit and instruction book and completed a piece later that day.

An aspect inherent in Stankiewicz's work is its acceptance of the worn-out, the thrown away, the object that has outlived its usefulness. Recovered into art, it assumes a new being. Stankiewicz accepted rust, corrosion, broken and bent forms—and fragments of objects' former lives—into his congregations. A permeating factor in his work is humor. Essentially abstract in form, his peculiar combinations of remnants, their positions and assumed attitudes, result in amusing, often satirical configurations. Part of the fun results from identification of the former function of a particular part. For example, a bedspring, a boiler, nuts, or bolts assume droll postures in their new positions.

Stankiewicz's sculpture of the early fifties is linear in form, made from wire coated with plaster in various thicknesses. Open, curvilinear, nongeometric forms dominate, and insects sometimes provided inspiration.[15] In *Untitled,* 1951, he placed buttons up a slender central "stalk." The addition and placement of these fasteners allows the imagination to fill in "shirt," as though this creature were dressed like a human. The formation at bottom suggests a many-legged spider, while the top might be a broken daddy longlegs. There is some resemblance to the characters found in Miró's work, but instead of being constructed from abstract forms, Stankiewicz's creatures are concocted from manufactured objects with their concomitant associations.

Kabuki Dancer, 1954 (pl. 34), is one of several pieces he did in the mid-fifties suggesting personages. Association of parts that connote beings can be traced to Pablo Picasso's *Bull's Head* of 1943 (Musée Picasso, Paris), fashioned from a bicycle seat and handlebars. A kabuki dancer is conjured through Stankiewicz's adjoining of arched and repeated forms. There is a sense of formality, of ritualistically patterned dance in this formation around a central, upright rod. The sculpture accentuates the archness,

the conscious affectation, and the artificiality of the dance and its practitioner.

In *Instruction,* 1957 (pl. 35), a large cylindrical shape, studded with smaller cylinders, topped with nuts and bolts, and brandishing a "tablet," stands before a lower cylinder set on its side with hanging wires. Obeisance is suggested by the latter form's diminished stature. Standing erect before the "pupil," the "teacher" presents a lesson. A rigidity is established by the greater and lesser units.

The fantastic quality of Stankiewicz's work of this period is by turns grotesque, chimerical, bizarre, and curious. Through associating recognizable and familiar mechanisms, he entices the viewer into his fabulous world. Instead of physical participation, the imagination is activated. As it stretches to fill in gaps, the mind is engaged by the sculpture.

Stankiewicz's work of the late fifties and into the sixties juxtaposes intricate formations with simple ones, as in *Beach Sitter,* 1958 (pl. 36). This tight, compact form differs from earlier, more open pieces. Later in the decade, influenced by special circumstances, he began working in a more geometrically abstract manner. On vacation in Australia in 1969, he was offered an exhibition and a factory from which he could pick parts. The factory had only I-beams, steel tubing, and other standard industrial shapes. To realize the show, he worked with these materials.[16] The result was work based on intersecting and inter-related cylindrical and rectangular forms. He continued to work in this vein into the seventies, as in untitled works of circa 1969 (fig. 47) and circa 1972 (pl. 37). Also from the seventies is a series of wall reliefs primarily consisting of rectilinear or circular forms outlining interacting interior shapes. Within a rectangular or circular frame, Stankiewicz introduced a variety of internal diagonal junctures. Framed like a painting or a tondo, these works look like welded pictures.

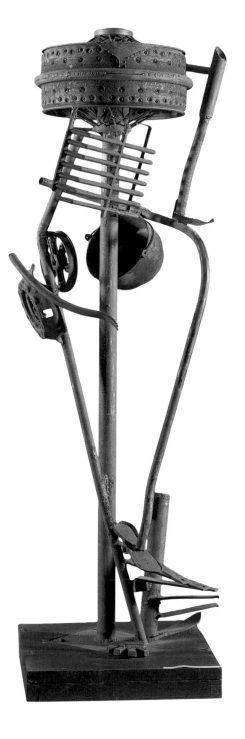

PLATE 35
RICHARD STANKIEWICZ
Instruction, 1957
welded scrap iron, steel
12½ x 13¼ x 8⅝ inches
The Museum of Modern
Art, New York
Philip Johnson Fund

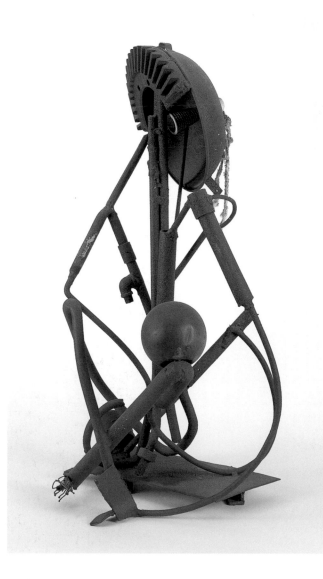

PLATE 36
RICHARD STANKIEWICZ
Beach Sitter,
1958
steel, found objects
37½ x 21¾ x 15¾
inches
Collection of Blanche
and Bud Blank

PLATE 34
RICHARD STANKIEWICZ
Kabuki Dancer, 1954
cast iron, steel on wood base
84 x 25 x 26 inches
Whitney Museum of American Art, New York
Purchase, with funds from the Friends of the
Whitney Museum of American Art

FIGURE 47
RICHARD STANKIEWICZ
untitled, ca. 1969
steel
19½ x 26 x 14 inches
Courtesy Zabriskie Gallery,
New York

PLATE 37
RICHARD STANKIEWICZ
untitled, ca. 1972
steel
30 x 40 x 26 inches
Collection of Edward Albee

Although the Australian work is comparatively large, most of Stankiewicz's sculptures are smaller. Intimate and personal, his work is unobtrusive and unpretentious, meant to activate one's fancy.

JOHN CHAMBERLAIN

John Chamberlain was born in Indiana in 1927 and grew up in Chicago. Like Stankiewicz, he did a stint with the U.S. Navy, after which he studied hairdressing in Chicago through the GI Bill. In 1951–52 he attended the School of the Art Institute of Chicago and then worked as a hairdresser and makeup artist. A turning point occurred in 1955 when he went to study at Black Mountain College in North Carolina. There he was influenced by poetry classes, equating word syllables with the visual parts of sculpture.[17]

In the mid-fifties Chamberlain began constructing welded sculpture that was inspired by Joseph Goto, whom he knew in Chicago, and indebted to Smith.[18] These were upright and linear in character, often with lines looping about a central accumula-tion of metal. In 1957 he moved to New York. Once while visiting Larry Rivers in Southampton he decided to make a sculpture. Looking for materials, he found an old Ford. Stripping the fenders, he crushed them and strung them together with wire. Then he drove over the work a few times. Called *Shortstop,* 1957 (pl. 38), the sculpture is his first statement using crushed automobile parts.[19] While his previous work is characterized by looping lines seemingly drawn in space, *Shortstop* emphasizes broad planes of metal suggesting volumetric enclosure. With this work the artist accepted the accidental effects of compression. A new emphasis on volume led toward the body of sculpture for which he is best known, separating his manner of working with welded steel from that of Smith by virtue of Chamberlain's emphasis on enclosed space via elaborated curvilinear formations.

Within two years, Chamberlain came to work solely with crushed car components. From 1959 to 1963 he used found surfaces, including those already covered with paint. One such is an untitled piece from circa 1962 (fig. 48), a gestural work characterized by fluid movement. Both color and shape presented ready-made forms for him to incorporate into his own aesthetic. Later, he began to paint the works himself. This is an important shift, particularly in light of Chamberlain's often-stated association with Abstract Expressionism. *Untitled, 1963* (fig. 49), of painted and chrome-plated steel, exemplifies this new turn in his work. Here his choice of colors is more subtle than those selected from spray-painted automobiles. By coloring parts himself, he took control of an element of form significant to his work, becoming better able to define space with curving surfaces that jut out from an imagined center or core. This work, utilizing warm tones, might be compared to de Kooning's *Gotham News,* ca. 1955 (pl. 39), which also uses colored planes moving in and out of space. In both, edges accentuate linear trajectories. Chamberlain's

occupancy of a three-dimensional area depends on the formation of parts apparently emerging from an invisible center. Though the painter's ground is flat and the sculptor works in the round, the results are similar spatial thrusts of plane, hue, and line.

Chamberlain parted company with contemporary welders through his use of colorful, curvilinear surfaces that encompass as well as protrude into space. The result is painterly but also sculptural in the sense of defining volume. One source of Chamberlain's strength is this position between artistic disciplines. Moreover, through his use of pigment and bent shapes, his work simultaneously suggests softness and malleability as well as metallic hardness. Flowing waves of sheet metal contradict the rigidity usually associated with this material. Elucidating Chamberlain's relationship with popular culture is a comparison with *Crusader* by Seymour Lipton (fig. 32). Both artists are concerned with volumetric forms, but Lipton's surface effects relate to traditional bronze, while Chamberlain introduces industrially and personally painted forms in bright colors.

In 1966 Chamberlain switched to urethane foam in a series of works that were literally soft and vulnerable. By tying and squeezing the

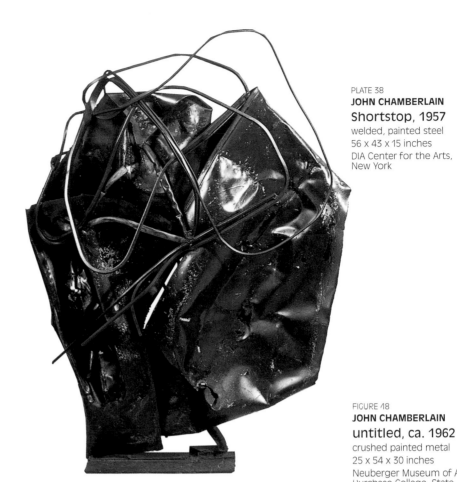

PLATE 38
JOHN CHAMBERLAIN
Shortstop, 1957
welded, painted steel
56 x 43 x 15 inches
DIA Center for the Arts,
New York

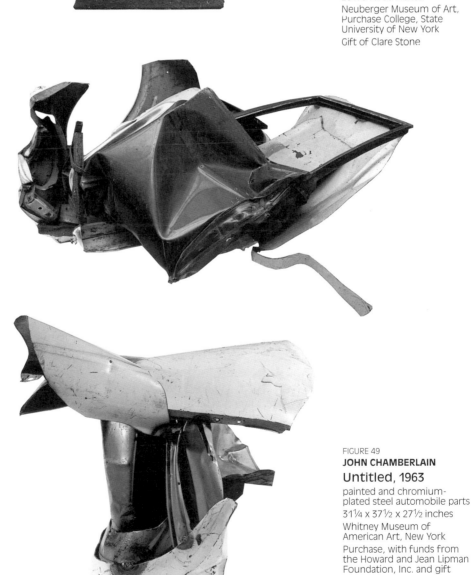

FIGURE 48
JOHN CHAMBERLAIN
untitled, ca. 1962
crushed painted metal
25 x 54 x 30 inches
Neuberger Museum of Art,
Purchase College, State
University of New York
Gift of Clare Stone

FIGURE 49
JOHN CHAMBERLAIN
Untitled, 1963
painted and chromium-
plated steel automobile parts
31¼ x 37½ x 27½ inches
Whitney Museum of
American Art, New York
Purchase, with funds from
the Howard and Jean Lipman
Foundation, Inc. and gift

PLATE 39
WILLEM DE KOONING
Gotham News, ca. 1955
oil on canvas
69 x 79 inches
Albright-Knox Art Gallery, Buffalo
Gift of Seymour H. Knox

foam, he continued to work with his trademark content of compression and expansion. A year later he adopted galvanized steel that was fabricated into boxes and then compacted and oriented at an angle by the artist. He then utilized synthetic polymer resin and aluminum foil. These media have in common monochromatic tendencies varied by reflected and absorbed light, forming shadows and gradations. By the seventies Chamberlain had returned to painted and chrome-plated steel, and during the following decade he varied the format of his work to include sculptures that spread horizontally and those that are painted with complex patterns, drips, and abstractions. In work from the latter period there is a greater breaking up or faceting of form, with elaborate and structurally intricate results.

Chamberlain's work is energetic, dynamic, and bombastic, exploring the value of chance—and even madness—in art. He wrote:

It is the risk of obtaining unprecedented information, even within a given madness, that is the key to art. Art is never boring and never presumptuous, and it doesn't deal in a state of fear. There are no crowbars. It's based on the sharing of a madness that you do not think peculiar at all. Where others suppress it, you have unleashed it, and you do it in such a way that you establish a liaison between your madness and other people. The socially redeeming factor is absolutely evident. Many times, when I've seen an artist's work, my reaction has been, "Oh, so you think so too!" The artist had revealed his madness to me and it was something I might have suppressed. I was relieved to know that someone refused to suppress it, and was astute enough, at some point, to make an object that revealed it to someone else. That is a very high point, a point of one of the greatest feelings of love. Without fear or crowbars. Art is one of the great gifts. It ranks right up there with gardening and sex. Art has a lot to do with feeling. I'm sorry to be so blunt.[20]

This statement not only reflects on the nature and significance of art but also indicates Chamberlain's straightforward and honest personality. His "plain talk" also indicates private struggles as an artist employing chance effects, experimenting with a variety of materials, and ruminating on what art is and what artists do. There is conscious action but also acquiescence to unbridled spontaneity.

In Chamberlain's attitude and that of other artists emerging in the fifties, there is a Bohemian braggadocio tempered by humility. Perhaps bearing the mark of the outset of an era characterized by nonconformity and a challenging of the status quo, artists likewise rebelled against precise definition of their art. For them, madness and randomness held new possibilities for meaning.

LEE BONTECOU

Though of the same generation, Lee Bontecou (b. 1931) has not enjoyed as much recognition as Chamberlain and many others. The abstract expressionist movement and the rise of New York as a primary artistic center mostly concerned the work of white male artists, thus impeding the reputations of women active at that time and continuing as a factor today. Bontecou's welded metal and fabric works have gained some admiration, but her subsequent, less abstract work in plastics has proven less acceptable. Like Chamberlain, she shifted gears in terms of materials, but her change has not curried favor. Chamberlain's change in material did not include a change in form. Bontecou, on the other hand, changed both media and imagery.

Born in Providence, Rhode Island, Bontecou summered with her family in Nova Scotia, where she was surrounded by the sea and forest. Her father, a hunter and camper, made the first all-aluminum canoe. Her mother did wartime work in a factory, wiring together submarine parts.[21] With this familial background, it seems not unnatural that Bontecou would come to produce welded-steel sculptures. She studied at Bradford Junior College in Boston and from 1952 to 1955 with William Zorach at the Art Students League in New York.

In 1959 she began a series of steel and canvas sculptures, and a year later she began to show with the Leo Castelli Gallery in New York. Exhibitions of her canvas assemblages were held in 1960, 1962, and 1966. The steel and canvas series has both organic and geometric allusions, resulting in a frightening hybrid of man-made and natural qualities, as though one had penetrated and interlocked with the other. Carter Ratcliff writes:

In describing Bontecou's steel and canvas constructions, mechanical and biological allusions suggest themselves before artistic ones— for these works are fabricated, not sculpted or painted in a traditional sense. One sees the "skeletons" of buildings and boats, the "flesh" of sails and tents. There are the shapes of turbines and jet motors, of a lighter-than-air masonry and of metal plate construction. On the biological side, skeletons and flesh are returned to their animal origins. One sees carapaces, shells, exposed membranes—animal tissues. The animal embryo develops by a process of layering and folding, whereas a plant keeps cell clusters in a permanently embryonic state, meristems from which stems and branches grow throughout the plant's life. One needn't know this to sense it in the distinctively animal—not vegetable— quality of Bontecou's folded, nestled, layered forms. Hence the powerful specificity of the openings they reveal—eyes, mouths, vaginas.[22]

There are closings as well as openings, parts that lock together like gears or zippers, and others that gape at viewers. All of these factors are present in Untitled, 1961 (pl. 40), a work that is characteristically frontal, confronting its viewers in a rough, uneven manner. Ends of wires used to attach canvas to steel

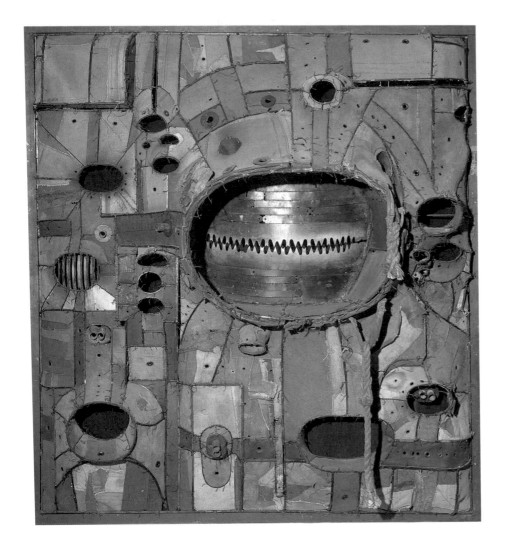

PLATE 40
LEE BONTECOU
Untitled, 1961
welded steel, canvas, wire, rope
72⅝ x 66 x 25⁷⁄₁₆ inches
Whitney Museum of American Art, New York

are exposed, and the canvas itself appears sullied with smoky blacks. Although Bontecou's earlier fabrications in this series included symmetrically composed works, such as *Untitled, 1960* (pl. 41), an asymmetrical arrangement of parts in the 1961 work completes a sense of direct process and its expression. The strength and beauty of the welded-canvas works lies in the stark juxtaposition of manufactured and natural elements. They are works of great power and vision that capture and hold observers with their strong statement of the duality of our modern existence.

In the sixties Bontecou made drawings and prints with pencil and soot and printer's ink that constitute expressionistic statements in two-dimensional formats. In 1967, however, she gave up the bio-mechanical reliefs, drawings, and prints for vacuum-formed plastic renditions of flowers and sea creatures, which related to her long-term study of nature in drawings. In this work she dealt more with transparency than with opacity and with a fully three-dimensional rather than a relief mode.

Her later work is not as disquieting as the earlier welded pieces; rather, it is fanciful and poetic and does not fit in with the work of contemporaneous artists. Bontecou's later sculpture has not found a niche, perhaps because of her sex and/or a lack of contemporary context.

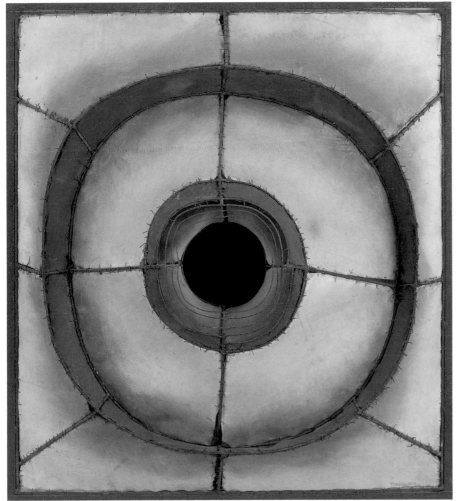

PLATE 41
LEE BONTECOU
Untitled, 1960
welded steel, leather, copper wire, canvas, pigment
39⅛ x 35⅛ x 8⅞ inches
Collection of Blanche and Bud Blank

MARK DI SUVERO

Born in Shanghai, China, Mark di Suvero (b. 1933) graduated from the University of California, Berkeley, with a degree in philosophy before going to New York. Influenced by the sculptor Gabriel Kohn, who worked in wood, di Suvero's first sculptures were in this material. For his first show at New York's Green Gallery in 1960, he made large constructions of found wooden parts. *Hankchampion,* 1960 (fig. 50), is an important piece from this period, illustrating di Suvero's connections with Abstract Expressionism, especially the work of painter Franz Kline.[23] The thrusting trajectories of di Suvero's wooden beams compare with the stark black thrusts in Kline's paintings.

Although best known for his assemblages of wood or steel parts, accompanied at first by chains and tires, di Suvero created a body of welded work and also used welding for partial construction of larger works. *Monet Arch,* 1968 (fig. 51), exemplifies work completed solely with this technique. Almost twenty-five years later he created *Homage to Louis Pasteur,* 1991 (pl. 42), again using the welding technique only. Together these works are typical of di Suvero's ruggedly direct style in their thrust of forms in opposing, diagonal directions. These pieces demonstrate his interest in creating physical lines of varying dimensions, from thick to thin. Tension is created by stress and counterstress, by trajectory and gravity, and by the push and pull of literal and physical lines of force. In essence, di Suvero presents us with an abstract depiction of the energy, rawness, and dynamism of urban existence.

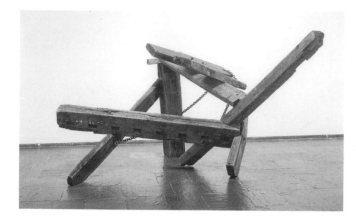

FIGURE 50
MARK DI SUVERO
Hankchampion,
1960
wood, chains
(9 wooden pieces)
overall: 77½ x 149 x 105 inches
Whitney Museum of American Art, New York
Gift of Mr. and Mrs. Robert C. Scull

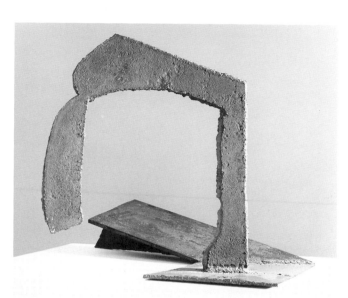

FIGURE 51
MARK DI SUVERO
Monet Arch, 1968
welded metal, paint
22 x 28½ x 28½ inches
Estate of Richard Bellamy/Oil and Steel Gallery, Long Island City, N.Y.

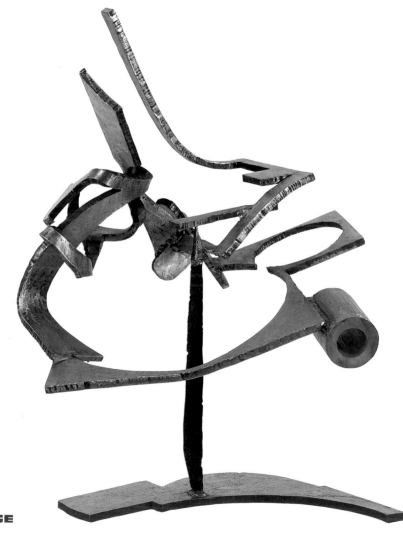

PLATE 42
MARK DI SUVERO
Homage to Louis Pasteur, 1991
stainless steel
33¼ x 28½ x 19¾ inches
Private collection

5 ENGLISH AND EUROPEAN WELDERS

The evolution of kinetic and assemblage art occurred concurrently with the flourishing of American artists' productivity with welded sculpture. Not unexpectedly, England joined America as a leader in terms of artists' interest in welding, for it, like this country, had emphasized the advance of technology since the time of the Industrial Revolution. Just as David Smith and other artists provided leadership in New York, Anthony Caro and his compatriots in London evolved their own center of activity. The approach of English welders, though influenced by Smith, was also imbued with the heritage of Henry Moore and Barbara Hepworth. Moreover, the cultural climate in England, especially London in the fifties, was in some ways a bit more radical than in this country.

ENGLISH SCULPTURE IN THE FIFTIES AND SIXTIES

Post–World War II English sculpture was dominated by Moore and Hepworth and the artists surrounding them. Moore's development of monumental bronze works, based on the abstracted human figure, served as both a touchstone and a point of departure for succeeding English artists. Hepworth, a friend of Moore and influenced by him, moved away from the representational subjects of Moore in her sculpture and focused on the counterplay between mass and space. In the early fifties English sculpture moved in two primary directions. In the first, exemplified by the work of Moore, modeled and cast forms were totemic in character and largely influenced by Parisian Surrealism, while a more constructivist approach gained ground

among younger artists, such as Ben Nicholson and Victor Pasmore. The first approach entailed traditional methodology and media, while the latter relied more on industrial materials and techniques.

London's Institute of Contemporary Arts, formed in 1948, was a seat of artistic and intellectual activity in the fifties, sponsoring exhibitions, lectures, discussions, films, and recitals. Herbert Read, Lawrence Alloway, David Sylvester, Will Grohmann, and Alfred H. Barr, Jr., were among speakers there. In 1953 the institute sponsored a controversial international sculpture competition for a monument to the Unknown Political Prisoner. The resignation of a Soviet juror, along with rumors that an American government agency had sponsored the competition, aroused suspicions that this art event was merely another example of cold war provocation. Reg Butler's winning maquette was smashed, and it and other entries were both scathingly

criticized and vigorously praised in the press.

Reactions were also aroused by several public outdoor exhibitions sponsored in part by the Arts Council of Great Britain. The council sent work by eight sculptors under age forty to the 1952 Venice Biennale. International critical acclaim for this exhibition heightened the stature of contemporary British art, while controversy continued to rage in England over its merits and relevance.

In spite of controversy, English sculptors proceeded to explore the possibilities afforded by new techniques and materials. Forerunners such as Butler, Lynn Chadwick, Hubert Dalwood, Eduardo Paolozzi, Leslie Thornton, William Turnbull, Robert Adams, and Kenneth Martin worked with welding among other processes. Of them, Chadwick, Butler, Dalwood, Paolozzi, and Thornton were most rooted in a lingering figurative tradition, while Turnbull, Adams, and Martin evolved more constructivist styles. Caro bridged the two modes and went further, moving into abstraction and removing any lingering figurative references.

Caro was without doubt a dominant force at Saint Martin's School of Art in London, where he taught in the 1950s and 1960s, but there was another important artistic center in London at the time—the Sculpture School of the Royal College of Art. Both institutions became important centers in the 1960s for individual contributions in sculpture as England became, for a time, a focus of inventive, popular, and fashionable demonstrations of modernism in art as well as music.

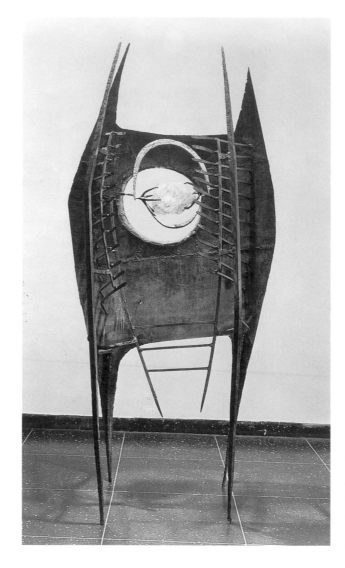

FIGURE 52
LYNN CHADWICK
Inner Eye, 1952
wrought iron with glass cullet
90½ x 42½ x 30¼ inches
The Museum of Modern Art, New York
A. Conger Goodyear Fund

LYNN CHADWICK

Welded and forged metal combined with glass were common in sculpture by Lynn Chadwick (b. 1914) in the early fifties. A work such as *Inner Eye,* 1952 (fig. 52), exemplifies Chadwick's opening up of form and delineation of space via flat planes and lines. Skeletal in shape, the work surrounds a center space. This puncturing of form is suggestive of work by Moore. Chadwick's sculpture, however, has a weightlessness that departs from a preference for massive form in the Michelangelo-Rodin convention, held to by sculptors like Moore. Chadwick's linear and planar elements are tempered by traces of verticality and anthropomorphism.

It is interesting that Chadwick, before becoming a sculptor, was trained as an architect and worked

as a draftsman in an architectural firm. His first forays in three-dimensional form are open, linear, and planar, with an organic flavor and symbolic meaning.

Chadwick worked with sheet metal and welding, often choosing to cut or forge shapes. In terms of surface effects, his work is similar to that of several American welders of the time, such as Herbert Ferber and Ibram Lassaw. *Inner Eye,* for example, might be compared to Ferber's *House (The Staircase)* (pl. 18) in that both works present open structures. However, the first, which relates to a human eye, could be described as having a hole in it, while Ferber's piece with its architectural content appears more like a framework. There is a verticality to Chadwick's work that is denied by the "roof" on Ferber's piece. Further, a spirituality is manifested in Chadwick's

choice of reflective, refractive glass as a material extension of the optical metaphor. In spite of these differences, the two artists share a predisposition for mottled surfaces that lend an aggressive, lively tone to an inanimate, fabricated material. Chadwick's later work has smoother, more highly polished surfaces and facetings.

REG BUTLER

Reg Butler (1913–1981) was also trained as an architect and practiced the discipline until 1950. In addition, he worked as a blacksmith during the war (1941–45) before becoming a sculptor in the late forties. He worked at first with hand-forged metal, using bars that could be twisted and bent. His technique lent itself to smooth, attenuated forms that he assembled into figurative shapes. The textural traces of the "bead," or molten metal between surfaces inherent in welding, do not appear in this work.

Butler's winning entry in the competition for a monument to the Unknown Political Prisoner (fig. 53) received as much derisive commentary as it did favorable reviews from critics and press, and the monument was never built.[1] The model of forged and welded steel featured an abstract, open, and upright sculpture planned to be set outdoors. For larger work actually constructed, such as *Manipulator*, 1954 (fig. 54), Butler combined forging and welding techniques to achieve structural stability for the vertical, open structures he favored.

Self-taught as an artist, Butler was an articulate writer and established a reputation as a teacher and theoretician.

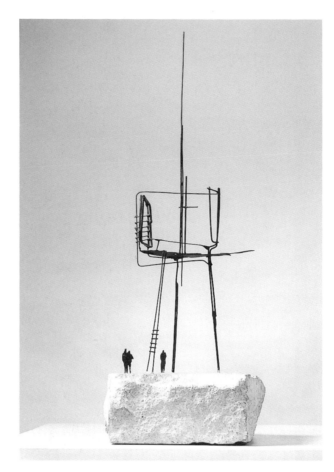

FIGURE 53
REG BUTLER
The Unknown Political Prisoner, *final maquette*, **1951–52**
stone, bronze, paint
174 x 80 x 64 inches
Tate Gallery, London
Lent by Mrs. Rosemary Butler, 1986

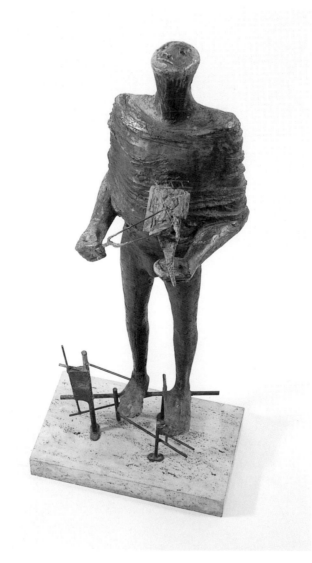

FIGURE 54
REG BUTLER
Manipulator, 1954
bronze
65¼ x 22 x 16½ inches
Albright-Knox Art Gallery, Buffalo
Charles Clifton Fund

LESLIE THORNTON

After studying at the Leeds College of Art and the Royal College of Art in London, Leslie Thornton (b. 1925) had his first one-person show in 1957. His subsequent work consisted of constructions of welded iron, steel, and brass rods that are often angular and jagged in form. In a sense they appear to be quick, linear sketches in space, like notations drawn to capture a visual moment. *Puppets,* 1957 (fig. 55), is typically figurative, with Thornton's peculiar content of anxiety and apprehension. In many ways his work depicts a modern lifestyle—movement amid the pressures and tensions of multiple tasks and demands. The puppets here seem caught up in life's currents, pawns of larger forces.

HUBERT DALWOOD

In the early forties Hubert Dalwood (1924–1976) served as an engineer apprentice to the British Aeroplane Company and later served in the Royal Navy before becoming an artist. He primarily used spherical shapes to realize objects of mysterious presence and import such as *Large Object,* 1959 (fig. 56), which looks like a head lying on its side. Subtle surface manipulations suggest features worn down with age.

This piece was made in a period important to English sculpture, as the country became known for abstracted, figurative forms exuding postwar angst and foreshadowing of a futuristic blend of nature and man-made elements.

EDUARDO PAOLOZZI

British artist Eduardo Paolozzi (b. 1924) lived in Paris in the late forties. There he met modern masters such as Alberto Giacometti. Other influences were Surrealism, Dada, and Jean Dubuffet's Art Brut—art produced by people outside the established art world, such as children and the mentally ill. After two years in Paris, Paolozzi returned to London to teach textile design at the Central School of Art and Design. In 1950 he founded the Independent Group, a small and

FIGURE 55
LESLIE THORNTON
Puppets, 1957
bronze
39½ x 18¼ x 11¼ inches
Neuberger Museum of Art, Purchase College, State University of New York
Gift of Roy R. Neuberger

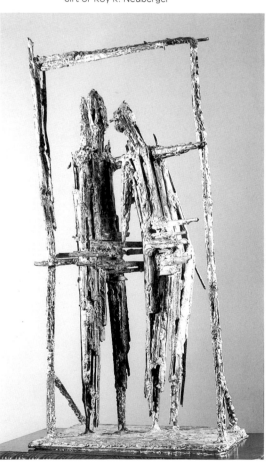

FIGURE 56
HUBERT DALWOOD
Large Object, 1959
cast aluminum, welded
28⅞ x 34⅛ x 27⅞ inches
The Museum of Modern Art, New York
Gift of G. David Thompson

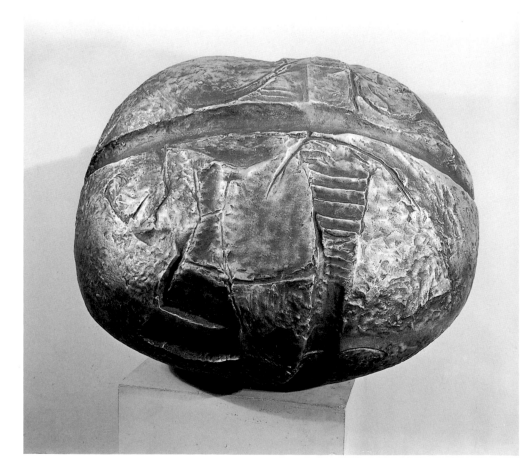

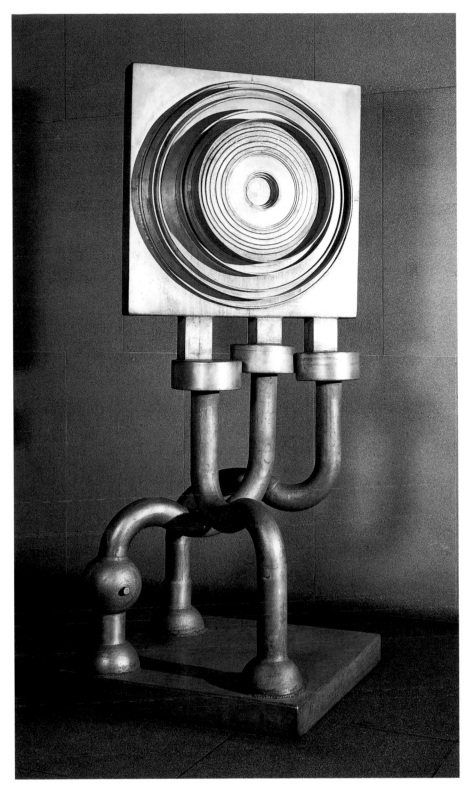

PLATE 43
EDUARDO PAOLOZZI
Lotus, 1964
welded aluminum
89⅛ x 36⅜ x 36⅛ inches
The Museum of Modern Art, New York
Gift of G. David Thompson

industrial. Like creatures from science fiction, his bronze sculptures of the fifties appear as precarious vestiges of destruction. Made of cast mechanisms, these totemic forms cross boundaries between the human and the mechanical as Paolozzi drew a spectral quality from metal. *Lotus,* 1964 (pl. 43), is illustrative of Paolozzi's second developmental stage, wherein he stacked geometric shapes to create a robotic form. Smoother in texture and seemingly lighter in weight than the sculptures from the fifties, this work is architectonic in overall appearance and gadgetlike in detail.

WILLIAM TURNBULL

Although the work of William Turnbull (b. 1922) was for a time anthropomorphic in character, particularly influenced by Dubuffet, that of his earlier and late phases is more geometric. The early work was indebted to Giacometti, whom he had met in Paris. Born in Dundee, Scotland, Turnbull settled in London in the forties and attended the Slade School of Art. Eager to learn of new Parisian developments in art, he visited Paris in 1947, returning the next year to live for two years. Paolozzi had moved there a year earlier, and they visited people and places together.

Turnbull's work of the fifties was based on head and mask themes, and he eventually created upright figurative forms that are totemic in character. In the latter part of this decade, he turned to stacking simple but organic elements, while he continued to pursue a parallel course in painting that was more advanced at this time in terms of its abstraction and rejection of motif. By the sixties Turnbull had turned to a smoother, sleeker phase. Works of this decade stretch into and activate space. A case in point is *Two Ways,* 1966 (pl. 44), which demonstrates

informal organization operating within the Institute of Contemporary Arts. Among its members were Lawrence Alloway, Reyner Banham, and Richard Hamilton. English Pop art was to grow out of this group. Indeed, at the group's first meeting

Paolozzi lectured on the relevance of advertising, comics, and mass media imagery to current art. Six years later Paolozzi participated in the significant *This Is Tomorrow* exhibition, focusing on elements of popular culture, held at the Whitechapel Art Gallery in London. Within the next decade his own work incorporated emergent industrial techniques and material.

Paolozzi's mature work brings intersections of the organic with the

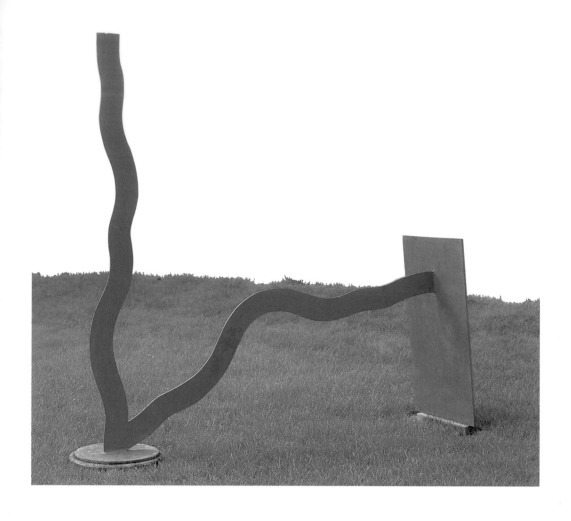

his use of a wavy, linear form that breaks the strict horizontal/vertical/diagonal focus of other artists. Subsequently consisting of geometric units, Turnbull's sculpture turned in a minimalist direction in the 1970s, when he also began to paint in the manner of the American Color Field artists.

ROBERT ADAMS

In the late forties Robert Adams (1917–1984), under the influence of Picasso, taught himself to weld. His first show came in 1947. Two years later he taught at London's Central School of Art and Design, where his associate was Victor Pasmore, noted for his abstract relief painting, and during this period he went first to Paris and then New York. In both places he met exponents of modernism. In the late fifties and sixties he completed several large-scale welded and painted steel sculptures. *Balanced Forms,* 1963 (pl. 45), is illustrative of the dynamic poise that typifies his work of this period. Undoubtedly, public commissions contributed to his use of intersecting planes set at idiosyncratic angles to one another. Later in his life he turned to circular and curvilinear shapes and sometimes to carved stone.

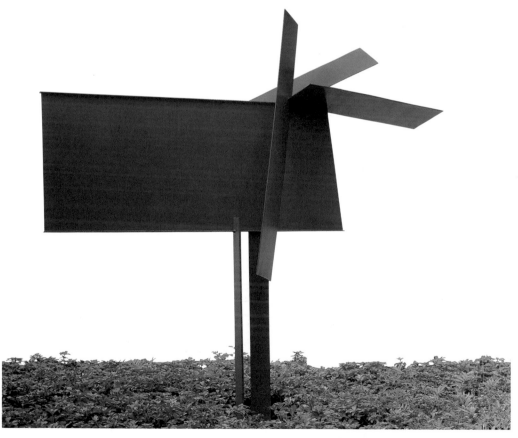

PLATE 44 (top)
WILLIAM TURNBULL
Two Ways, 1966
painted steel
86 x 94 x 22 inches
Collection of Gilbert and Doreen Bassin

PLATE 45 (above)
ROBERT ADAMS
Balanced Forms, 1963
painted steel
101 x 101 x 18 inches
Collection of Gilbert and Doreen Bassin

KENNETH MARTIN

With Pasmore, Kenneth Martin (1905–1984) and his wife, artist Mary Martin, represented a strictly constructivist trend in England. A painter before becoming a sculptor, Martin fashioned geometric structures beginning in 1951. Especially important is a series of works called

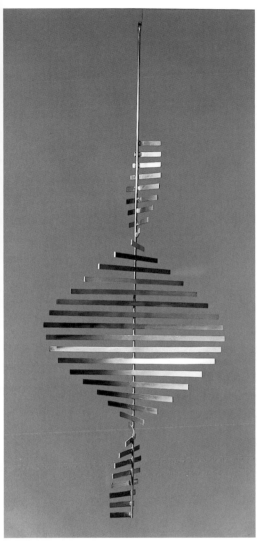

ANTHONY CARO

Both the figurative and constructive modes in English sculpture of the fifties provided background for the work of Anthony Caro (b. 1924) as he leaped from a phase devoted to the human body to a nonobjective format. Caro's earliest work, in the mid- to late fifties, is expressionistic in character. Exemplary is *Woman Waking Up*, 1955 (fig. 58). Prior to this period, Caro had served as an assistant to Moore. Nevertheless, other than his use of the figure, Caro's work departs from that of Moore, especially in terms of surface treatment. Compared with smooth-surfaced contemporaneous work by Moore, such as *Upright Motive No. 1: Glenkiln Cross*, 1955–56 (fig. 59), the exterior of Caro's work is rugged and craggy. Also, Caro's massive, bulky sculptures of the time were possibly influenced by Dubuffet, whose 1955 show at London's Institute of Contemporary Arts impressed Caro as well as many other English artists.[3] There is also a similarity to the massiveness present in Pablo Picasso's classical and surrealistic phases. Weight and the pull of gravity are emphasized in this work by Caro, presaging his

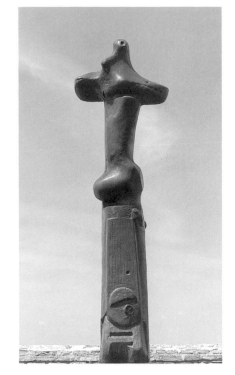

the *Screw Mobiles*. These are made from brass strips brazed onto a central rod in a spiraling formation. One such sculpture of 1953 (fig. 57) exemplifies the simple, geometric sequence of forms, with movement of light setting up a rhythmic play of reflections. Unfolding from their cores, these works present the visual manifestation of mathematical logic. One of these—within a larger structure provided by Mary Martin and the architect John Weeks—appeared in the 1956 *This Is Tomorrow* exhibition at the Whitechapel Art Gallery.[2]

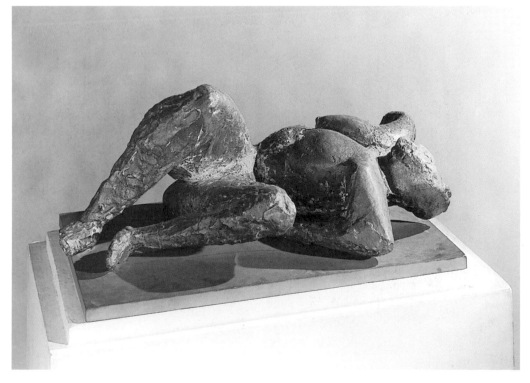

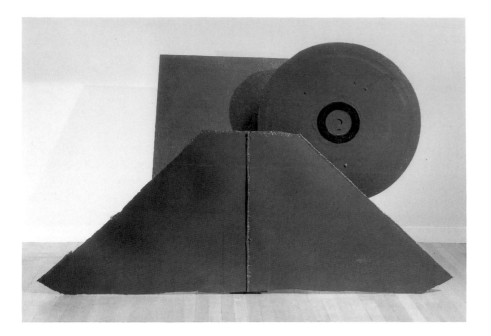

FIGURE 60
ANTHONY CARO
Twenty-four Hours, 1960
painted steel
540 x 872 x 327 inches
Tate Gallery, London
© Anthony Caro/Licensed by VAGA, New York, New York

later predilection for horizontality. Moreover, there is a specific gestural quality of form represented in the active verbs of such titles as *Man Holding His Foot* or *Woman Waking Up* that departs from Moore's generalized and majestic nomenclatures, such as *Upright Motive No. 1: Glenkiln Cross.* The mundane actions of Caro's figures are distinct from the impressive nobility of Moore's entities. By the time of *Woman Waking Up,* the artist was already thirty years old. Maturity, after a five-year gestation period, was to bring an abrupt shift to abstraction.

A significant event of 1959 was the artist's meeting with the abstract expressionist theorist and advocate Clement Greenberg. Greenberg had already penned *The New Sculpture* (1948), outlining his tenets for three-dimensional work based on reduction and abstraction of form. In essence, according to Greenberg, the separateness of sculpture from reality defined it as art. Later the same year, Caro went to the United States where he met Greenberg again and encountered Smith and the American painter Kenneth Noland. These contacts resulted in his turning away from figuration toward nonobjective art, as demonstrated in *Twenty-four Hours,* 1960 (fig. 60), his first mature excursion, at the age of thirty-six, into abstract sculpture.

Although Caro was influenced by Smith, his work was different in terms of surface treatment and use of ready-made parts such as I-beams. For example, Caro's early *Twenty-four Hours* can be compared with Smith's *Tanktotem VII* (fig. 27). Such a correlation reveals the simpler architectonics of Caro's approach. Also, his work looks raw in contrast to the polished surfaces and multiple forms present in Smith's sculpture. Distinctive is Caro's incorporation of a painted target shape in *Twenty-four Hours,* resembling a format in Color Field painting, especially that of Noland. This freely rendered shape and Caro's use of pigmentation are presented in a frontal orientation. Greenberg once owned this work, which epitomizes his doctrine of art as a separately identifiable and independent object. By contrast, Smith's work is more vertical, suggesting the figure. A hallmark of Caro's work, identifiable this early in his career, is an interest in sculpture that spreads laterally across territory. Although Smith occasionally used color to qualify surfaces, Caro's choice and use of color is more vivid and smooth and sometimes encompasses a sculpture's entire exterior.

From this time on, Caro was to explore the arrangement of geometric planes in space. Works of 1960–61 appear to be a series of overlapping and interrelated facades. The flatness and frontal orientation of this work betray the influence of Smith, Greenberg, and certain Color Field painters. This short phase was superseded by work that spreads out to establish directional emphases. Lack of centrifugal focus marked further evolution of Caro's individual aesthetic.

The brightly painted *Early One Morning,* 1962 (pl. 46), represents a lighter, more open phase of Caro's oeuvre in which he utilized plane and line to compose a work that entails perspective in the form of a "background" plane from and to which activity extends and returns. The airiness of this work relates to a European constructivist rejection of mass in favor of delineation of space. In work of this time, Caro rejected frontality as well as verticality, both often found in Smith's sculpture.

Over the next two years Caro concentrated on sculpture that is long and low-lying, utilizing the ground or floor as reference in work that is below eye level. Lateral extension makes the sculpture appear to defy gravity. An improvisational technique is emphasized by a repetition of right-angled planes, poised precariously in what seems an accidental or capricious manner. Continuity is provided by the artist's utilization of a monochromatic hue that lifts the work's mood. A feeling of lightness and spontaneity contrasts with conventional sculptural ponderousness. Within this decade Caro incorporated his signature use of I-beams augmented by cylindrical poles. One form balanced against another continues to energize and enliven each piece. Constructivism and its forerunner Cubism are the basis of such Caro compositions.

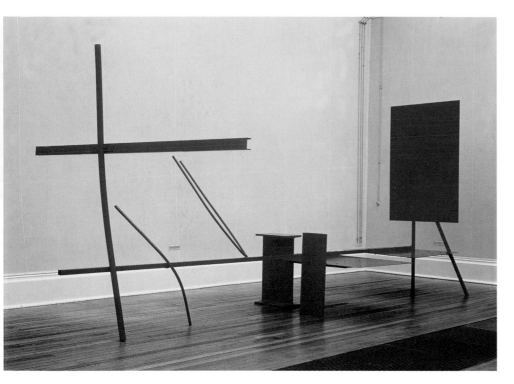

PLATE 46
ANTHONY CARO
Early One Morning, 1962
painted steel
114 x 244 x 132 inches
Tate Gallery, London
© Anthony Caro/Licensed by VAGA, New York, New York

In addition to the horizontality and improvised formation of Caro's work, the uniqueness of his contribution is an emphasis on placement of sculpture in literal space and his positioning of forms relative to the ground or floor. Previously, sculpture was placed on a pedestal, shelf, or in relief on a wall. In each instance, the work is set apart from viewers as though it were exalted. Generally, this work was also vertical in emphasis, moving away from its support. Caro, however, placed sculpture directly in the audience's environment. The immediacy of his work occurs as space is defined and invigorated. There is not a frontal emphasis; rather, the viewer must walk around the works, thereby emphasizing a kinesthetic experience. Instead of impacting from a distance, his works demand proximity, interaction, and viewer movement.

From 1966–67 Caro also utilized planar screens and arched or bent elements to lead the spectator visually around a work. As Museum of Modern Art curator William Rubin observed:

The eye, as it follows the contours of a Caro sculpture, speeds up, slows down, is blocked by an impenetrable screen, penetrates a perforated screen, is confused by divergent paths, interrupted by a traversing form, led to a dead end, pleased or deceived. The eye, in its progress, has enacted a bodily experience—taking an obstacle course, if you will—but just as validly it has enacted the mind apprehending a situation and coming to grips with it. The visual itinerary has recapitulated the processes of thought.[4]

In viewing Caro's work, one becomes voyeur and voyager on an aesthetic excursion.

When Smith died in 1965, Caro bought his stock of metal and had it shipped to England.[5] Thus, throughout the sixties, there remained some relationship with Smith, if only in Caro's use of Smith's materials. In a metaphorical gesture, Caro simultaneously incorporated the American artist's materials while establishing his artistic independence.

Moving into the 1970s, Caro executed "table" sculptures, employing forms that jut beyond the tabletop or dangle over the edge, suggesting Paul Cézanne's still-life arrangements, which spill over a tilted edge. With this work Caro played with the notion of sculptural base. He did not use it to set apart or emphasize his artwork. Rather, he incorporated the base's parameters and dimensions

into his sculptural aesthetic. The "table" supports but also acts as a foil for cantilevered shapes.

In his larger works of the 1970s, Caro utilized broader planes of steel. Typically, the parts lean on, abut, and support one another to become sculptures that are poised informally and incidentally in space. Kinesthetic feelings of leaning, touching, balancing, overlapping, and adjoining encourage a sense of illusory and potential motion, as if the piece could be disassembled and rearranged. A trip to Italy to work in Veduggio exposed Caro to Renaissance sculpture. He was especially interested in Donatello, whose work he saw as evolving in space with the viewer's eye movement and body position.[6] The verticality entering his work of the period may result from the influence of Italian figurative sculpture. In sculptures like *Veduggio Sun,* 1972–73 (fig. 61), however, a lateral direction is retained, as Caro's work continues to consist of a series of spatial relationships between interconnected planes and lines. Work of this time

FIGURE 61
ANTHONY CARO
Veduggio Sun, 1972–73
steel
100 x 117 x 54 inches
Dallas Museum of Art
Mr. and Mrs. Edward S. Marcus Fund
© Anthony Caro/Licensed by VAGA, New York, New York

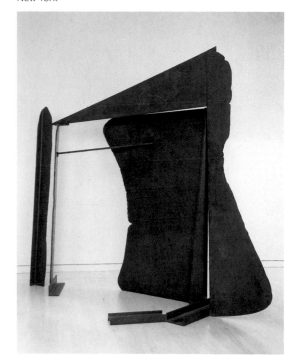

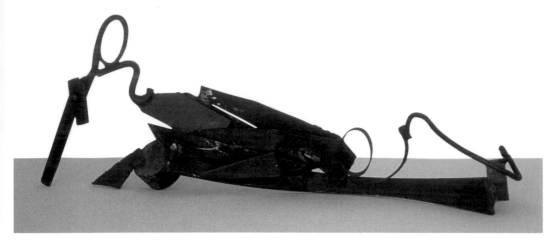

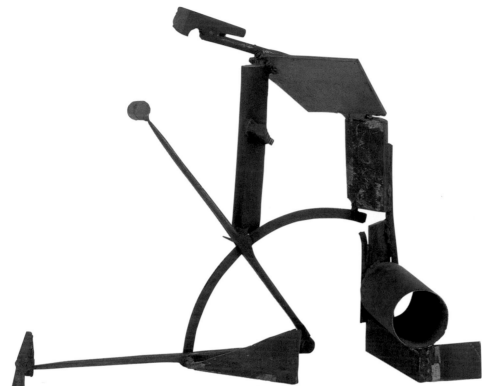

drawings that outline forces within an established arena. There is a cagelike quality that admits penetration but stymies spatial extension.

Into the 1980s Caro made a number of relatively small works of welded and cast bronze. Unlike the table-tops, these did not appear to defy gravity, nor did they ignore a support's edges. Caro also utilized steel objects from marine docks to fashion a number of large works that examine the relationship between flat plane and its use in enclosing space.

An important event in this artist's work of the mid- to late eighties was a trip to Greece in 1985. Not surprisingly, he was struck by sculpture and its relationship to architecture:

The light and the temples sited in their landscape made me see Greek art in a completely different way from studying photographs; the art and the history belong together. For me the most wonderful are the archaic sculptures, and also the pediments and metopes of Olympia. Instead of the separate sharded parts, that I knew from my studies, I now saw the sculptures more as they were originally conceived— sensual rolling forms and figures contained and even forced into strict architectural shapes. The contrast of the volumetric moving forms is set against the crisp and geometric.[7]

After this trip, Caro's work assimilated the concept of rounded human forms set within an architectural construct. The pediment of

is unique in its disregard for strict geometricism. Rather, *Veduggio Sun*'s large sheet of steel has irregular, curved, and ragged edges. The natural color of rusted steel offers great tonal range, and the retention of accidental marks and scuffs gives the steel a malleable, impressionistic feeling. Caro's prior inclination toward overall painted, intensely colorful surfaces has vanished in favor of a new proclivity for a more irregular and natural treatment. An atmospheric sense replaces the hard, mechanical precision of solid color. Additionally, this work seems more internal or inward-turning than the aggressive spatial invasiveness of previous pieces. It has a more painterly quality even though pigmentation is absent. Tonal

nuances occur out of the material itself and the artist's processes.

The sawhorse framework was used by Caro in sculpture of these years, followed by more complex arrangements of slabs, tubes, and cylinders. *Writing Piece "Whence,"* 1978 (pl. 47), and *Writing Piece "Such,"* 1979 (pl. 48), represent a continuation of the tabletop work with the addition of curvilinear motifs. Stretching laterally, stacked and overlapping planes anchor circles and arcs. Sidelong emphasis dominates these works. Reference to writing occurs in curving, linear forms and in the general movement of the pieces. In the later *Emma* series, Caro explored an open framework of linear steel parts. This series appears as spatial

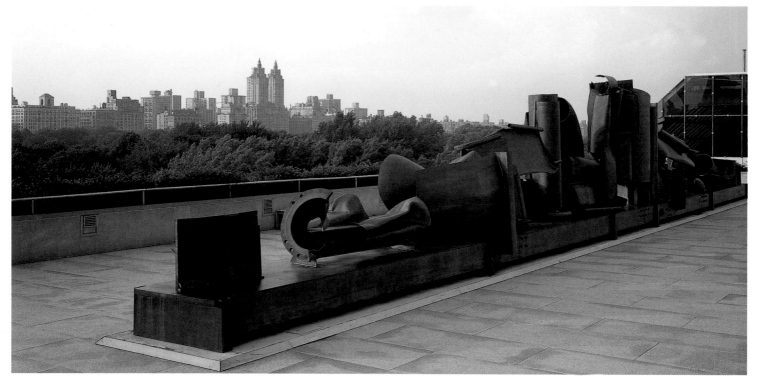

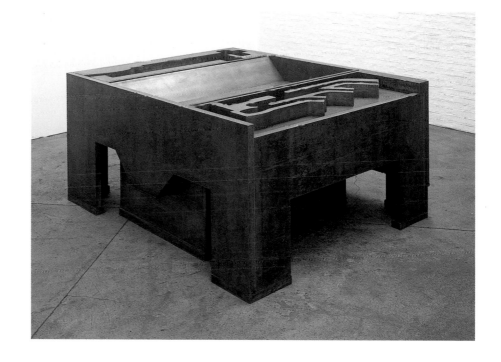

PLATE 49
ANTHONY CARO
After Olympia, 1987
steel
129½ x 913½ x 68¼ inches
EPAD, La Défense, Paris
© Anthony Caro/Licensed by VAGA, New York, New York

PLATE 50
ANTHONY CARO
Night and Dreams, 1990–91
waxed steel
41 x 88 x 74 inches
Annely Juda Fine Art, London
© Anthony Caro/Licensed by VAGA, New York, New York

the Temple of Zeus at Olympia was particularly influential. Caro's *After Olympia,* 1987 (pl. 49), is his monument to Greek sculpture. Using the extended triangle as a containing silhouette, he filled the space with curving and bent forms as well as flat planes in imitation of classical architectural juxtaposition of round and flat. This large work not only pays homage to its source but shows Caro's own examination of the combination of volume and plane. Though this work and others, inspired by Greek examples, make reference to figurative motifs, Caro remains within a modernist aesthetic. The work exists more as a play of geometric shapes than the classical Greek absorption with the body realized in multiple positions. *After Olympia* is Caro's interpreta-

tion of the classical rooted in his commitment to abstraction.

Preoccupying Caro in the nineties have been large-scale works in painted steel and smaller pieces in bronze and brass, cast and welded. In larger and smaller scale, he has worked with the notion of enclosure, of metal encompassing a space. For some pieces a round shape is employed, while others utilize rectangles. An example of the latter is *Night and Dreams,* 1990–91 (pl. 50). Here sculpture

stands like a table resting on legs over another geometric form. On top are smaller configurations reminiscent of hieroglyphs. The work states relationships between positive and negative space, horizontal extension, and simultaneous recognition of and interplay among the senses of top and bottom, under and over. Suggestions of a framework defining volume and form in relief are inherent in this work, which seems to be a benchmark in the artist's oeuvre.

Caro, then, evolved a constructivist aesthetic in sculpture that often paralleled painting, especially in his use of flat plane and line and his insistence on visual qualities. Tactility and weight are eschewed in favor of smooth, refined surfaces. Lateral movement and direction are part of Caro's approach to sculpture, as he has defied conventional verticality, massiveness, and distancing of sculpture from viewer.

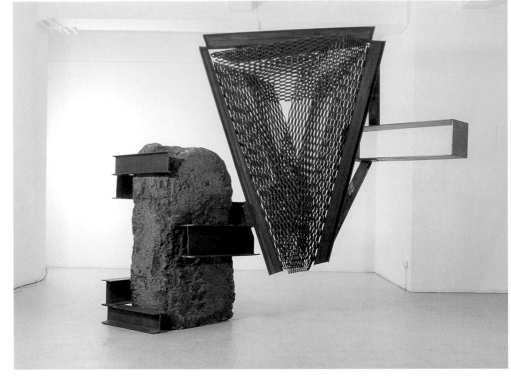

BEYOND CARO

In 1959, when Caro made his break from traditional materials, techniques, and philosophies, he was teaching at Saint Martin's School of Art in London. His students included David Annesley, Phillip King, Timothy Scott, William Tucker, and Isaac Witkin. Apparently, Caro was a teacher open to new ideas, as earth artist Richard Long and performance artists Gilbert and George were also in his classes. According to a former student, "he made anything seem possible."[8] His students experimented vigorously, especially with new materials such as steel, fiberglass, plastic, glass, plywood, and aluminum tubing. They also utilized color in work that was eccentric, playful, and reflective.

Younger sculptors around Caro, namely King, Scott, Annesley, and Tucker, responded to his emphasis on abstraction while parting company with him in terms of approach. American abstract painting was of interest to these younger artists, as was the organic abstraction of Constantin Brancusi. Experimenting with metal and other media, these sculptors stressed delineation and occupancy of space in works that evoked visual as well as material responses.

PHILLIP KING

Phillip King (b. 1934) assisted both Moore and Paolozzi after a year of study at Saint Martin's, where he subsequently taught. Working in part with steel in the early sixties, he adopted a conical shape that reappears throughout the course of his oeuvre. Simple and direct, this early work was also somewhat fanciful in form. Curved planes defining volume and expressing movement characterized his work at this time. Another untitled work of 1974 (pl. 51) possesses a more rugged character, though retaining a feeling for lateral motion. Cantilevered out from a concrete mass, perforated steel provides a contrasting transparency and lightness.

DAVID ANNESLEY

A painter and sculptor, David Annesley (b. 1937) was also part of the Saint Martin's group. In the sixties he achieved lyricism in steel sculpture through the use of color and curvilinear shapes. Noland's work influenced Annesley, especially

in using paint to verify flat surfaces. A later work, *Return Journey,* 1994 (pl. 52), indicates Annesley's continuing concern with color as it augments sculpture. The pastel hues of this work reflect a preference for tertiary tones.

WILLIAM TUCKER

William Tucker (b. 1935) studied history at Oxford University and sculpture in London at the Central School of Art and Design and Saint Martin's School of Art. His association with Caro at the latter institution influenced, to a degree, his direction in art. Tucker is not only a sculptor but an important writer on this discipline as well. His book, *The Language of Sculpture,* published in 1974, relieved contemporary sculpture from the burden of the past. He wrote of the postwar period as a "time when the idea of construction was revived to give

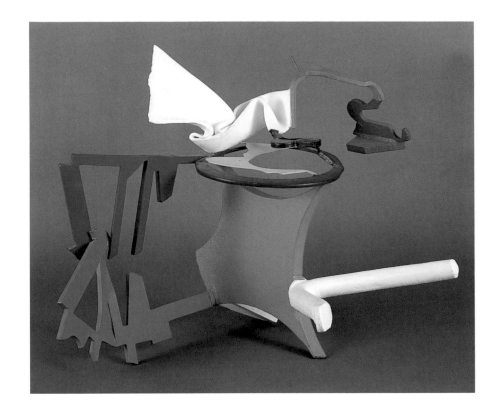

PLATE 52
DAVID ANNESLEY
Return Journey, 1994
painted steel
36 x 48 x 30 inches
Collection of Linda and Stuart Barovick

life to a dying tradition of modeling, when form was sacrificed to texture and autonomy of structure to a cheap and melodramatic imagery."[9] His interest at the time was in a purified sculptural structure as demonstrated by his work *The Mirror,* 1979 (pl. 53).

In 1975 Tucker organized an exhibition, *The Condition of Sculpture,* at the Hayward Gallery in London. The show emphasized the constructed format present in the work of several sculptors, including Tucker himself, Phillip King, Robert Murray, Timothy Scott, Richard Serra, Mark di Suvero, and Jackie Winsor. Eventually, Tucker gravitated toward the use of fiberglass, and since settling in New York in 1978, he has created a body of work that consists of organic cast bronze sculptures.

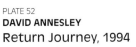

ISAAC WITKIN

Born in South Africa, Isaac Witkin (b. 1936) went to study art in England, where he became involved with the Saint Martin's group. Caught up in a creative atmosphere of exploration and innovation, Witkin first worked with self-contained sculptural shapes. By the late sixties he had turned to open forms that seemed to defy gravity, thus exploiting steel's property of tensile strength, as in *Angola II,* 1968

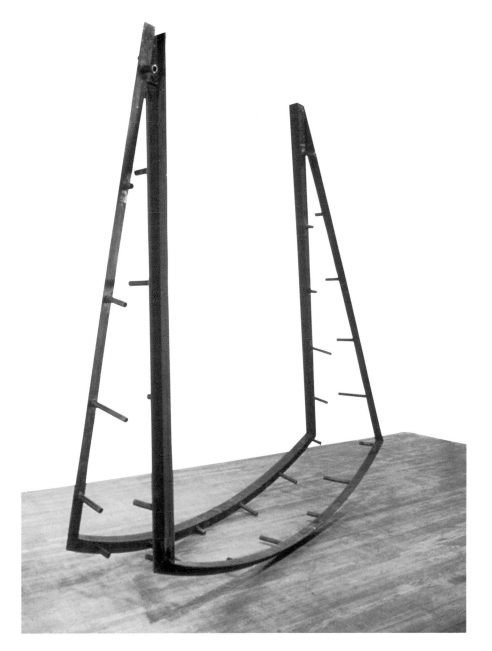

PLATE 53
WILLIAM TUCKER
The Mirror, 1979
steel
126 inches high
Courtesy of the artist and McKee Gallery, New York

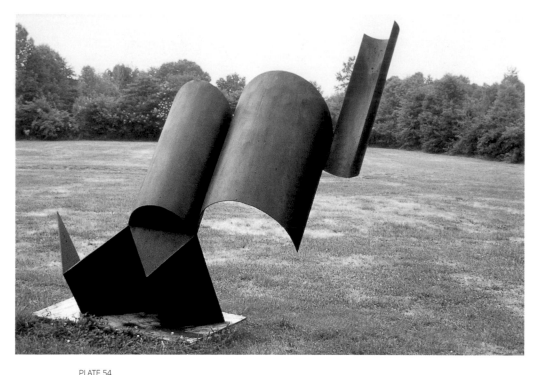

scale than the large welded-steel pieces that he continued to conceive largely for outdoor locations. Works both large and small are gravity-defying compositions showing Witkin's ability to alternate between geometric combinations and organic amalgamations.[10]

PLATE 54
ISAAC WITKIN

Angola II, 1968

varnished steel
100 x 96 x 46 inches
Courtesy of the artist and Locks Gallery, Philadelphia

(pl. 54). One factor in this change may have been his move to the United States, where he has resided since 1965.

By the late 1970s Witkin had expanded his sculptural vocabulary by melting and casting metal to realize work that is gestural and organic in character. Often, bronze sections would be welded together in work that has a flowing, animated feeling. These works are smaller in

EUROPEAN WELDERS

Interest in welded sculpture extended beyond America and Britain. The technique spread to other countries as the necessary technology and materials became widely available. Already discussed are artists who used welding as a means to introduce kineticism into their work, including Naum Gabo, Antoine Pevsner, László Moholy-Nagy, Jean Tinguely, Harry Bertoia, and the Baschets. There were other Europeans who adapted welding as a means of expressing diverse personal directions, ranging from suggestive, figurative motifs to pure abstraction. Several of them are highlighted here.

PLATE 55
PIETRO CONSAGRA

Carmine Garden, 1966

steel
48 x 57⅛ x 9½ inches
Neuberger Museum of Art, Purchase College, State University of New York
Gift of Jacques Kaplan

PIETRO CONSAGRA

Italian sculptor Pietro Consagra (b. 1920) is an abstractionist. He has worked with metal to create sculpture as independent objects and as architectural constructs. His *Carmine Garden*, 1966 (pl. 55), indicates his structural approach, which typically presents a planar form qualified by small additions. The slightly undulating form of the work subtly suggests organic growth like that in a garden.

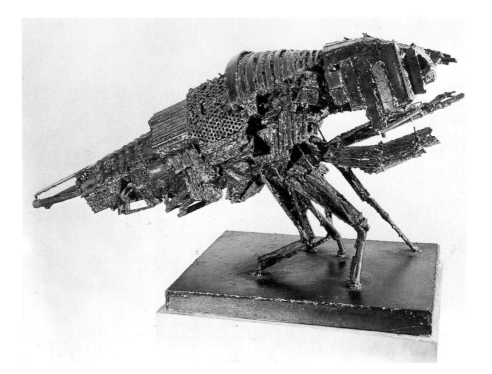

FIGURE 63
CÉSAR (BALDACCINI)
Galactic Insect, 1956
welded iron
19⅞ x 37 x 14½ inches (including base)
The Museum of Modern Art, New York
Gift of G. David Thompson

The results are active, even aggressive. *Galactic Insect,* 1956 (fig. 63), is an example of his work in welded iron. The title itself suggests the otherworldly character of this threatening creature. Part biological and otherwise mechanical, this body appears as though it might have a home elsewhere in the galaxy.

ROBERT MÜLLER

Born in Switzerland, Robert Müller (b. 1920) moved to Paris, where he studied with Germaine Richier. He created complex pieces with scrap metal, such as *Ex-Voto,* 1957 (fig. 62). Utilizing spiky, vertical forms, his work has figurative connotations and a sense of circular movement. Whether they are outlining or occupying space, forms lead the eye around Müller's active, vital work. Organs, plants, and insects are suggested. After the fifties his work assumed a simpler, clearer form.

LUDVIK DURCHANEK

Born in Vienna, Ludvik Durchanek (b. 1902) studied at the Art Students League in New York and the Worcester Art Museum in Massachusetts. His *Soliloquy,* 1959 (pl. 56), in hammered nickel and silver, illustrates his use of metal not just to portray the figure but to portray a mood. Unlike those of Consagra, Müller, and César, Durchanek's is not a formal approach. His work is more like that of Theodore J. Roszak or Seymour Lipton in portraying an emotional state. The figure, executed in relatively simple planes, leans slightly, conveying a sense of vulnerability. Arms folded close to the chest, the enlarged and emphasized eyes and the somber mouth aid in conveying a sense of aloneness. Both poignancy and dignity are

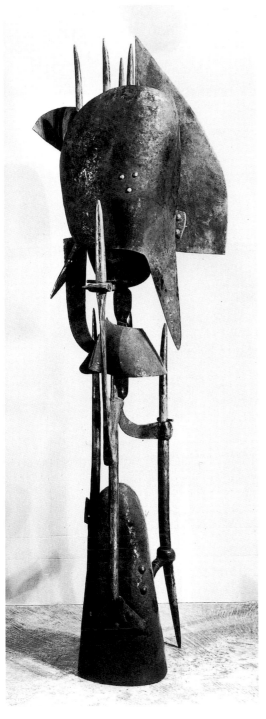

FIGURE 62
ROBERT MÜLLER
Ex-Voto, 1957
forged and welded iron
83⅞ x 13⅞ x 14¾ inches
The Museum of Modern Art, New York
Philip Johnson Fund

CÉSAR

Also influenced by Richier, the French artist César (Baldaccini) (1921–1998) used discarded sections of automobiles as "compressions" and as parts of figurative sculptures.

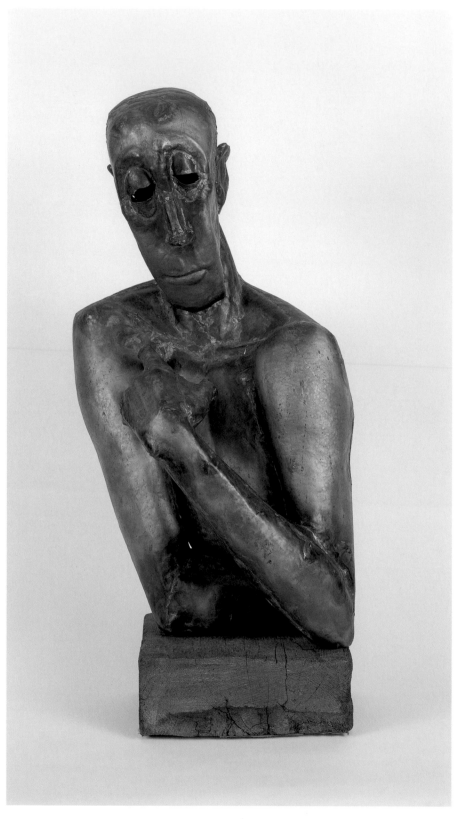

PLATE 56
LUDVIK DURCHANEK
Soliloquy, 1959
hammered nickel and silver
27¾ x 16 x 13½ inches
Neuberger Museum of Art, Purchase College, State University of New York
Gift of Roy R. Neuberger

communicated through the artist's choice of forms and their position. Movement is also present in the diagonal orientation of the torso and head.

ACHIM PAHLE

Born in Darmstadt, Germany, Achim Pahle (b. 1927), like Smith, tackled the unusual subject of landscape in sculpture. Pahle's *Hand Hollow Landscape,* 1984 (pl. 57), demonstrates the range of possibilities with welding. Like Smith's *Hudson River Landscape* (pl. 11), Pahle's format is basically frontal. Unlike Smith, this artist has not opened up form. Rather, he presents landscape as a modulated, but basically flat, plane. The results are a richness of surface texture and a sense of vista viewed as a planar proposition.

REINHOUD

The Belgian artist Reinhoud (d'Haese) (b. 1928) was associated with the highly experimental group of artists called CoBrA—for the first letters of the cities (Copenhagen, Brussels, and Amsterdam) from which the primary forces in the group came. Reinhoud's work of the fifties was figurative and expressive in form, paralleling the work of his contemporaries, such as Pierre Alechinsky, Karel Appel, and others.[11] With Alechinsky, he made a composite mural for the Stedelijk Museum in Amsterdam that included a painting by the former and a sculpture by Reinhoud— "a three-dimensional monster amidst painted monsters."[12]

Early in his career Reinhoud did commercial work, repairing a variety

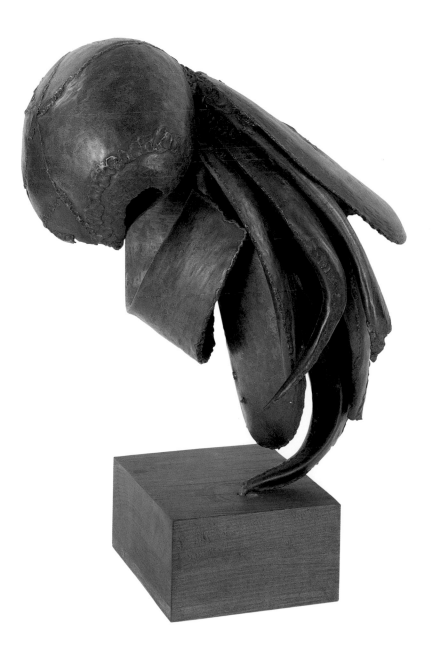

PLATE 57
ACHIM PAHLE
Hand Hollow Landscape, 1984
welded mild steel
14¾ x 19½ x 1 inches
Neuberger Museum of Art, Purchase College,
State University of New York
The George and Edith Rickey Collection of
Constructivist Art

PLATE 58
REINHOUD (D'HAESE)
Bird, 1960
bronze
17 x 9 x 13 inches
Neuberger Museum of Art, Purchase College,
State University of New York
Gift of Roy R. Neuberger

of metal objects, such as cars and boilers. His work as a sculptor increased in the late fifties. For a time he lived in Brabant, a city close to where Hieronymus Bosch had worked centuries before. Noted for his distortion of the human form into creatures of recognizable though fantastic proportions, Bosch may have had some influence on Reinhoud. Moving to France in 1959, he became increasingly solitary and absorbed in his work. *Bird,* 1960 (pl. 58), which appears, like Bosch's work, to be a composite of the human, insect, bird, and animal worlds, exemplifies his output of the time.

6 FORMALISM AND FABRICATION

There have been two especially influential developments affecting art in this century. Global communications have spread information rapidly via magazines, newspapers, and now the Internet. An artist in Estonia can closely follow what a colleague is doing in Newfoundland. The second factor is the tendency of art, like business and trade, to gravitate toward a single hub. In the second half of this century, New York has become that focus. Artists have come to New York from all over the planet in order to market their work, seeking coverage in periodicals and newspapers, exposure in powerful galleries and influential museums, and sales to collector-advocates. Today there is less emphasis on geographical phenomena, such as the School of Paris, since New York has become an artistic melting pot.

In the visual arts, there has been a strong emphasis on simplified structure as Minimalism succeeded Pop art and assemblage in being the latest trend. Pop's objectivity, however, carried over into the minimalist aesthetic. The former's hard-edged forms and use of contemporary techniques and media were retained by Minimalists, as was an emphasis on the autonomy and anonymity of the art object. Minimalist sculpture was intended to have a physical manifestation in space, but without emotional or personal appeal. The artist's personality was eliminated as a factor in the art; the presence of the artist's hand was no longer evident.

Instead, artists sought out commercial fabricators to construct objects from their mental images, drawings, and specifications. Factory fabrication not only allowed artists access to technology without their needing specific training, for some artists it also factored out the notion of a handmade entity. This new manner of working circumvented technical ability as an artistic criterion. Milgo-Buskin in Brooklyn, a company established to form and bend metal, began working with artists as well as industry in the mid-sixties. The expertise offered by this company attracted artists interested in sophisticated means to achieve large-scale work. Also in the mid-sixties, Lippincott Inc., a sculptural fabricator located in North Haven, Connecticut, began to fabricate work for such sculptors as Robert Murray, Barnett Newman, Robert Morris, Clement Meadmore, Louise Nevelson, and James Rosati. Such firms offered not only technical expertise but the means to achieve work that looks factory built and architectural. The monumentally scaled work produced in a factory setting appears akin to the sleekness of modern architecture. Often placed in urban settings, this form of sculpture fits in with smooth-walled, right-angled buildings.

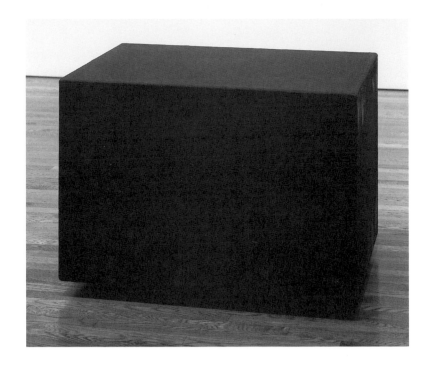

FIGURE 64
TONY SMITH
Black Box, 1962–67
hot-rolled steel
22¼ x 33 x 25 inches
National Gallery of Canada, Ottawa

MINIMAL ART

Welding lends itself to fabrication in art, as many artists have found, because of its industrial background. In fact, fabricators have helped some artists to realize work that they might not have been able to make themselves. The smooth seams desired by Minimalists were more readily available through the fabricator. Also, without the artist's active participation, the resultant piece could assume a more anonymous quality. It would reveal less of the artist's personality.

TONY SMITH

In the forties Tony Smith (1912–1980) was friendly with leaders of Abstract Expressionism, namely Newman, Mark Rothko, and Jackson Pollock. Born in New Jersey, he was trained as an architect and worked with Frank Lloyd Wright. In the forties and fifties he designed homes for the art dealer Betty Parsons and the painter Theodore Stamos, as well as a studio for Cleve Gray, also a painter. In the fifties he made a series of painted works based on a grid and conceived via a modular system. Not until 1960 did Smith turn his attention to sculpture. His first one-person show at the Wadsworth Atheneum in Hartford, Connecticut, was in 1964, when he was fifty-two.

Smith's early works were based on cardboard maquettes. His first metal sculpture, *Black Box* (fig. 64), was fabricated in an edition of three over the period 1962 to 1967. The inspira-

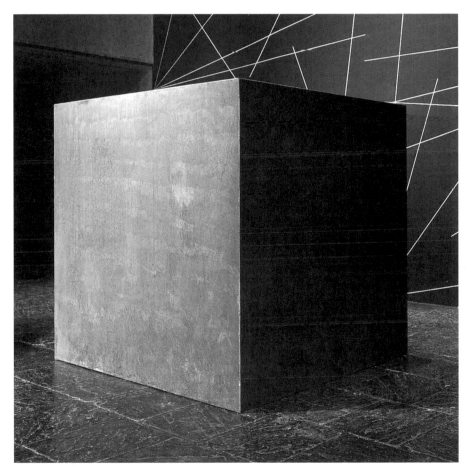

FIGURE 65
TONY SMITH
Die, 1962
steel
72⅜ x 72⅜ x 72⅜ inches
Whitney Museum of American Art, New York
Purchase, with funds from the Louis and Bessie Adler Foundation, Inc., James Block, The Sondra and Charles Gilman, Jr. Foundation, Inc., Penny and Mike Winton, and the Painting and Sculpture Committee

tion for this matter-of-fact work was an index-card box on the desk of a colleague at Hunter College in New York, where Smith was teaching at the time. Smith had assigned his students to enlarge basic, found shapes and decided he would try it himself.[1] With the larger *Die,* also an edition of three, 1962–67 (fig. 65), Smith established simplified form as his sculptural statement. Newman

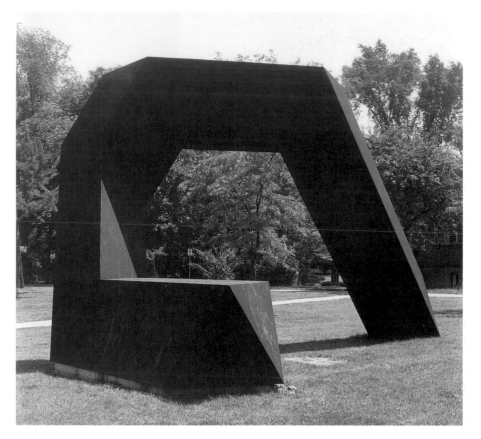

FIGURE 66
TONY SMITH
Cigarette, 1961–68
Cor-ten steel
180 x 216 x 312 inches
Albright-Knox Art Gallery, Buffalo
Gift of the Seymour H. Knox Foundation, Inc.

Known primarily for his association with Abstract Expressionism, New Yorker Barnett Newman (1905–1970) was both a painter and a theorist who later in his career created several sculptures. Newman's use in painting of vertical bands fore-shadows the simple shapes of his three-dimensional work and forms a bridge between the New York abstractionists and the Color Field painters of Washington, D.C. Both groups, in their persistent affirmation of painting as its own reference, presented concepts crucial to later minimalist theories. The relationship between abstract expressionist insistence on flat

FIGURE 67
BARNETT NEWMAN
Here III, 1965–66
stainless steel, Cor-ten steel
110 x 8 x 3 inches
Whitney Museum of American Art, New York
Gift of an anonymous donor

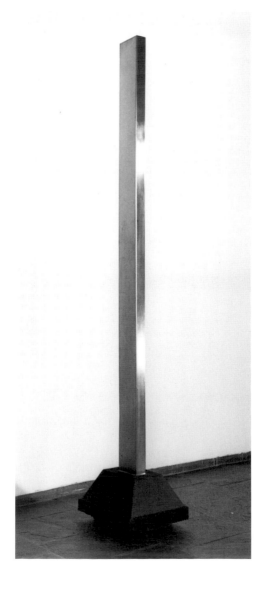

systematic ways. You have to take each plane as it comes and find out in what way it will join the other planes. There isn't even any regularity of height.[3]

identified this work as sculpture, even though Smith himself was not sure of its nature.[2] This type of work both launched his career as a sculptor and set a precedent for the reductive impulses of subsequent minimalist artists.

Smith's development was based on an interest in mathematical systems to achieve nonrelational structures. He utilized five regular geometric solids but was especially interested in the tetrahedron and octahedron as modular units. Working from paper, then plywood mockups, he realized configurations that have an active, directional movement of asymmetrical shapes. Essentially, Smith's approach was casual in process and irregular in final form. He said:

Each piece is unique. I use angles that are derived from different solids. When they go together, they do not follow any internal system. They are parts that I know will go together from their different solids, and I assemble them, you might say, in capricious ways rather than

According to critic Sam Hunter, Smith saw a content in his work beyond that of aesthetics. He is said to have compared his sculptures to primitivist art and early architecture, such as menhirs, Indian mounds, and diagrammatic plans for Near Eastern structures.[4] Early works such as *Die* do have the quality of early monuments or markers. Later works, like *Cigarette,* 1961–68 (fig. 66), illustrate his use of geometric units to produce twisting, turning, monumental shapes in space. In spite of its mathematical basis, this work has an idiosyncratic flavor, the dynamic, artistic product of individual imagination.

Smith continued to realize wood and steel versions of his small maquettes until the time of his death. His manner of working—from diminutive models to large-scale fabricated objects—was important to subsequent artists and to the evolution of minimalist art. Especially relevant to Minimalism was his statement of sculpture as an independent, physical object in space that refers only to itself.

surfaces and the reality of both canvas and pigment can be thought of as precursory to Minimalism.

Newman's sculptures of the sixties reiterate his attenuated, vertical, rectangular bars, as seen in *Here III*, 1965–66 (fig. 67). This work appears as a sign or marker of spiritual import, like a cross. Perhaps an indicator of the artist's philosophical and religious investigations, the work seems to manifest an unrelenting conviction. Like Smith, Newman used minimal forms, believing in their ultimate meaning. This is different from minimalist practitioners such as Donald Judd and Morris, whose work referred only to its existence as a physical object in space without deeper significance.

DONALD JUDD

The writer and sculptor Donald Judd (1928–1994), in describing his own approach, helped to establish minimalist values:

I wanted work that didn't involve incredible assumptions about everything. I couldn't begin to think about the order of the universe or, the nature of American society. I didn't want work that was general or universal in the usual sense. I didn't want it to claim too much. Obviously the means and the structure couldn't be separate, and couldn't even be thought of as two things joined. Neither word meant anything.

A shape, a volume, a colour, a surface is something itself. It shouldn't be concealed as a part of a fairly different whole. The shapes and materials shouldn't be altered by their context. One or four boxes in a row, any single thing or such a series, is local order, just an arrangement, barely order at all, the series is mine, someone's and clearly not some larger order. It has nothing to do with either order or disorder in general. Both are matters of fact.[5]

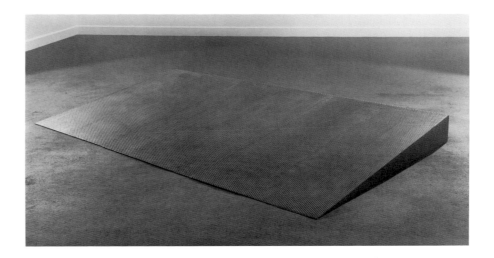

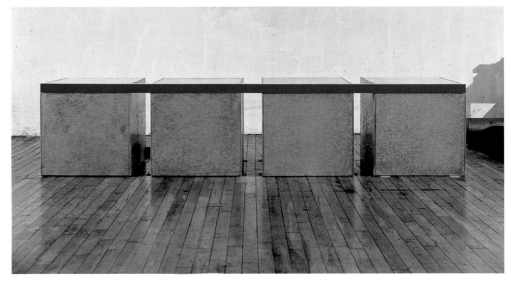

FIGURE 68 (top)
DONALD JUDD
Untitled, 1965
perforated steel
8 x 120 x 66 inches
Whitney Museum of American Art, New York
50th Anniversary Gift of Toiny and Leo Castelli
© Estate of Donald Judd/Licensed by VAGA,
New York, New York

PLATE 59 (above)
DONALD JUDD
Untitled, 1970–80
red lacquer, galvanized iron
30 x 141 x 30 inches
Courtesy Gagosian Gallery, New York
© Estate of Donald Judd/Licensed by VAGA,
New York, New York

Interestingly, Judd wrote this piece for an architectural journal, indicating his and other minimalist artists' identity with that discipline.

Like Smith, Judd was born in the Midwest (Missouri) and was a painter before becoming a sculptor. Rejecting the illusionistic and referential aspects of painting, Judd looked for a format entailing actual space and materials. His first three-dimensional pieces were exhibited at the Green Gallery, New York, in 1964. Working in Plexiglas and perforated steel, Judd completed a number of floor pieces, such as *Untitled*, 1965 (fig. 68). Characteristically, this work is matter-of-fact in terms of its simple structure and industrial materials and dimensions. Works by Judd, like those of Smith, are relatively large, forcing confrontation with viewers.

About the same time, Judd conceived of his wall reliefs in terms of serial imagery. Cubes and rectangles were mounted horizontally or vertically on the wall, as in *Untitled*, 1970–80 (pl. 59). Both units and intervals were equalized, producing a specific perceptual experience. This sequential presentation of forms established the peculiar blend of anonymity and identity characteristic of Judd's work and of Minimalism as a whole.

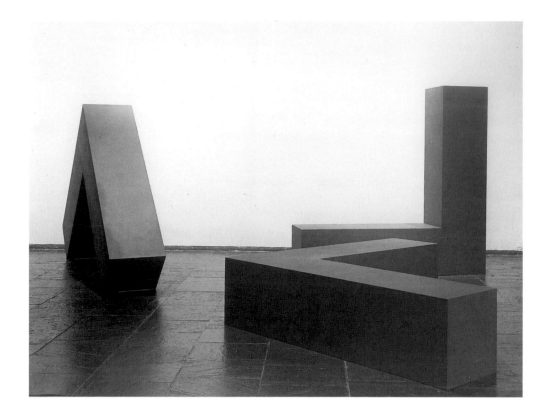

FIGURE 69
ROBERT MORRIS
Untitled (L-Beams), 1965
stainless steel
96 x 96 x 24 inches
Whitney Museum of American Art, New York
Gift of Howard and Jean Lipman

SOL LEWITT

Like Morris, Sol LeWitt (b. 1928) places no priorities on one form over another. His contribution to Minimalism is a repetition of basic shapes. Modular units, usually open cubes, form the basis for his sequential works. Begun in 1965, LeWitt's steel and baked enamel works stretch along the floor with the suggestion of endless continuation. *Open Modular Cube,* 1966 (fig. 70), demonstrates his concentration on frameworks that appear anonymous and neutral, like a mathematical formula. In spite of their neutrality, however, such work has become unmistakably connected with this artist. Even

ROBERT MORRIS

Although both were considered Minimalists in the mid-sixties (and both were born in Missouri), the approaches of Robert Morris (b. 1931) and Judd were quite different. Judd, a former painter, approached sculpture from a perceptual angle, while Morris's aesthetic was more conceptual. Duchamp's emphasis on concept as opposed to technical skill was particularly important to Morris. His sculpture of the time, in wood, fiberglass, and metal, was predicated on the self-sufficiency of the object and a rejection of the importance of formal relationships, much like Duchamp's introduction of the ready-made object. Morris also denied materials and geometry as necessary artistic ingredients. By leveling the relative significance of art's traditional factors, such as form, content, and media, Morris ironically distinguished the nonreferential object occupying a continuous space with that of the viewer.

A case in point is his *Untitled (L-Beams),* 1965 (fig. 69). The simple right angle has no symbolism or reference, as it represents only a joint common to industry and architecture. Though the work is large, it does not partake of the monumentality spoken of in connection with traditional, figurative forms of art. Instead, the work has a mundane, everyday casualness, as if it could occupy a vacant lot or construction site. Its circumstances, however, qualify it in an artistic context, just as Duchamp entitled a bicycle wheel or bottle rack to artistic existence.

FIGURE 70
SOL LEWITT
Open Modular Cube, 1966
painted aluminum
60 x 60 x 60 inches
Art Gallery of Ontario, Toronto

though the artist's hand is not present, his style has been defined by the production of similar works over a period of time. So rather than lacking identity, LeWitt's work considered as a body has a distinctive character.

This artist has also produced a number of site-specific wall paintings that qualify walls with a continuous web of lines. In both sculpture and painting, he emphasizes lines in geometric series of shapes seemingly capable of infinite repetition.

Born in Hartford, Connecticut, LeWitt lives and works in New York. In addition to his work in sculpture and painting, he has been active in the worlds of dance and film, always in a minimalist mode.

MINIMALIST VARIATIONS

Smith, Judd, and Morris are the artists most closely associated with Minimalism. Newman and LeWitt as well can be related to a minimalist aesthetic because of the stringent nature of the former's later three-dimensional work and the latter's rigid geometrical bases. Other artists working within a minimalist tradition in the sixties and seventies were not as insistent on simplified form. Instead, they produced work that presents variances on a purely minimalist aesthetic.

The distinctiveness of Minimalism exists in a disregard for formal relationships within the artwork. Instead, Minimalism introduced a repetition of simple units. The self-referential nature of minimalist work separated it from the sometimes more expansive sculpture of later artists. Retained from Minimalism were geometric form, abandonment of the pedestal, and consideration of sculpture as a separately identifiable object in space. Artists varying a minimalist stance opened examination of geometric forms to include optical effects, movement, and architectonic structures.

CHARLES GINNEVER

Charles Ginnever (b. 1931) is from California. His interest in sculpture began in childhood, when he visited the Golden Gate Exposition held in San Francisco in 1939. Several sculptors were represented, including Marino Marini, Aristide Maillol, and Ernst Barlach. Like many sculptors, Ginnever went to Paris in 1953 to study this art form. At the Académie de la Grande Chaumière, he studied with Ossip Zadkine, who, as a teacher, was a potent force in influencing young artists. Also in the class were Beverly Pepper and Richard Stankiewicz. In 1955 Ginnever went to the California School of Fine Arts (now the San Francisco Art Institute). In 1957 he and Mark di Suvero drove across the country to the East Coast. Dropping di Suvero off in New York, Ginnever went on to Cornell University in Ithaca, where he was a graduate instructor for the next two years. At that time he was working with railroad ties and steel and had been impressed by the open work of Alberto Giacometti, namely *The Palace at 4 A.M.* (fig. 19), and by Frederick Kiesler's *Galaxy,*

1951, and Reuben Nakian's *Rape of Lucrece* (pl. 23). Opened and constructed form characterized each of these and constituted the appeal for Ginnever. These influences supported Ginnever's own pursuit of spatial definition via line and plane. In New York by 1959, Ginnever began to use wooden beams in a post-and-beam method of construction (predating di Suvero's work in this vein). Shortly after he executed more complex sculptures with steel, wire, and enamel paint. Ginnever also ventured into performance art in the 1960s, producing what he called "sculpture dances."

Ginnever exhibited one sculpture at Park Place Gallery in New York, an artists cooperative. It was *Dante's Rig,* 1964 (pl. 60). Shown during the height of Minimalism, *Dante's Rig* offered another direction, namely one that emphasized illusion and dynamism. Also, *Dante's Rig* represented aspects of Ginnever's work

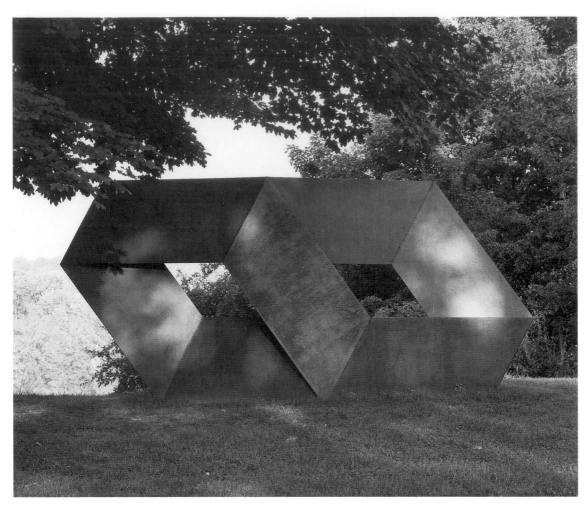

FIGURE 71
CHARLES GINNEVER
Fayette: For Charles and Medgar Evers, 1971
weathering steel
94½ x 202 x 18 inches
Storm King Art Center, Mountainville, N.Y.
Gift of the Ralph E. Ogden Foundation, Inc.

that would continue as he developed statements of perspectival illusion and optical effects. Usually thought of in terms of painting or two-dimensional work, optical illusions were made physical in the sculpture of Ginnever by the fact that viewers must walk around a work to realize all its aspects fully. As viewers do so, there is a continuing range of viewpoints, offering a variety of visions. *Fayette: For Charles and Medgar Evers,* 1971 (fig. 71), is one such illusion. Photographers would be hard-pressed to depict the changing apparitions of his work in one image.

THE PARK PLACE GROUP

Formation of the Park Place Group in the sixties, as well as the landmark exhibition *Primary Structures,* focusing on reductive form, held in 1966 at the Jewish Museum in New York, underscored a sculptural current toward elemental forms. Among artists included in *Primary Structures* were Murray, Pepper, Ronald Bladen, Lyman Kipp, David von Schlegell, and Peter Forakis. All of these artists displayed a predilection for basic structure as well as for industrial materials and techniques.

Like other artists using factory fabrication, Bladen worked on large-scale pieces usually first built in wood. He used diagonals, sometimes in the form of cantilevered units, placing structures on edge or tilted into space. The results are dynamic, imposing objects. Murray worked with planes that suggested volumes. Like Bladen, he preferred a single surface color.

Di Suvero (see chapter 4) and Forakis were founding members of the Park Place Gallery, in existence from 1962 through 1967. Members of the Park Place Group utilized a constructive method to achieve work that suggests energy. Thrusts and counterthrusts of form express dynamic forces related to an urban environment.

RONALD BLADEN

Ronald Bladen (1918–1988) was born in Vancouver, British Columbia, and studied painting at the California School of Fine Arts in San Francisco, a city in which he associated with the Beat poets of the day. At the end of the fifties he moved to New York and began to make wooden reliefs. He created his first freestanding sculpture in 1963. He rapidly developed his peculiar aesthetic of cantilevered and leaning forms that

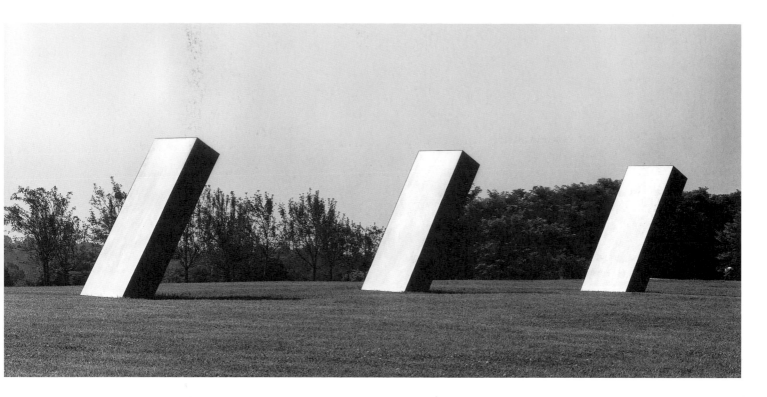

FIGURE 72
RONALD BLADEN
Three Elements, 1965
painted aluminum
108 x 48 x 120 inches
North Carolina Museum of Art, Raleigh

seem to acknowledge yet resist gravitational forces. Reductive and formalist, his work is also dynamic as it exhibits a tendency toward precarious balance. Fabricated structures, such as *Three Elements,* 1965 (fig. 72), illustrate the imposing, forceful presence of Bladen's work in metal. He often filled an entire exhibition space with a single work.

from preliminary drawings, he moves to thin cardboard or sheet aluminum models, ultimately working closely with fabricators at every stage.

In particular, Murray's work of the late sixties might consist of a large steel plane set on edge and joined with another at a corner. Such work, reflective of a variation on minimalist tenets, seems to twist or turn in space, making it appear less static than the pieces of Morris or Judd. At first limited to flat planes, Murray's sculptures of the early seventies featured folded and bent parts.

Later he varied this scheme to include subtly undulating surfaces. *Hillary,* 1983 (pl. 61), is indicative of his irregular, curving shapes. Sprayed on paint adds to the effect of flowing motion. Characteristically, the piece consists of strips of metal welded together and ground down. This process is revealed in the early stages of a maquette (fig. 73). His welds are concealed by grinding

FIGURE 73
ROBERT MURRAY
Hillary (maquette), 1983
aluminum
12 x 46 x 26 inches
Courtesy of the artist

ROBERT MURRAY

Born in Vancouver, British Columbia, Robert Murray (b. 1936) studied at the University of Saskatchewan School of Art. There students could participate in workshops held by Newman, Clement Greenberg, and others. Influenced by David Smith, Minimalism, and other artistic currents, he has concentrated on sculpture since moving to New York in 1960. Factory fabrication with industrial machinery, resulting in smooth, undifferentiated surfaces, has been a part of Murray's aesthetic from the start. Working

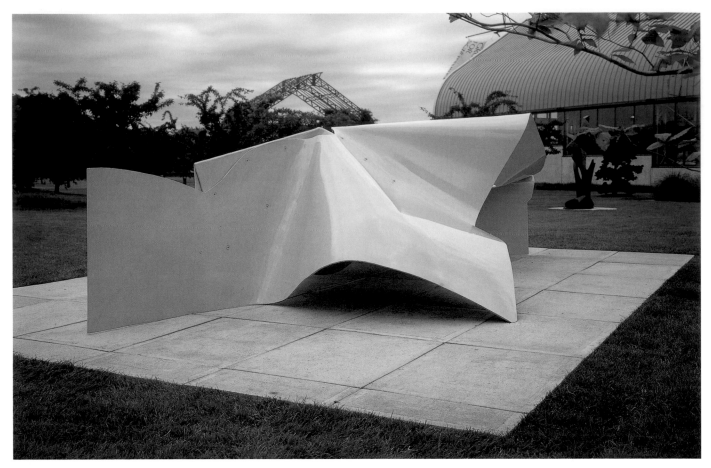

so that there are no straight lines or right angles; rather, the work undulates through space and is experienced as an unfolding entity. Plane and line are the primary elements in this work, yet it is romantically elegant rather than austere.

BEVERLY PEPPER

Born in New York, Beverly Pepper (b. 1924) studied at the Pratt Institute in Brooklyn, with Fernand Léger and André Lhôte in Paris, and at the Art Students League in New York. From 1949 to 1960 she was a painter, turning to welded sculpture only in 1961. She resumed her pursuit of painting in the 1980s, and recent exhibitions have been devoted to painting. She has divided her time between New York and Italy since 1951.

In the early sixties her works were irregular boxes with rough edges and textural surface. Color, often reddish orange, was used to accent interior space. Later in this decade she repeated open rectangles and cubes, suggesting a chain of movement. With these geometric forms and polished-steel exteriors, Pepper moved toward a minimalist focus.

Subsequently, she turned to columns, pyramids, and so-called altars, in works that suggest the influence of non-Western culture as well as that of Constantin Brancusi. *Model for Split Pyramid*, 1971 (pl. 62),

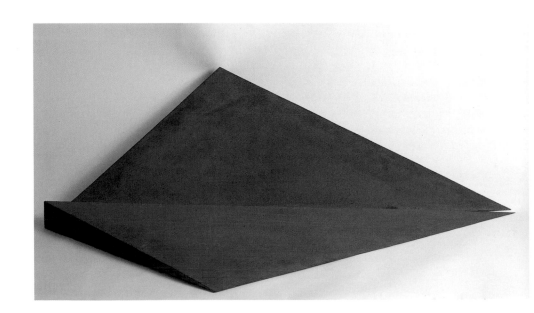

FIGURE 74
BEVERLY PEPPER
Taurus Portal, 1979
steel
24 inches high
Courtesy of the artist
© Beverly Pepper/Licensed by VAGA, New York, New York

an upright, totemic format. This method was also employed in wall reliefs emphasizing modulated surfaces. Light playing on these surfaces creates an impressionistic, atmospheric effect related to her return to painting.

LYMAN KIPP

Lyman Kipp (b. 1929) is from Dobbs Ferry, New York, not far from Manhattan. Like Pepper, he studied at the Pratt Institute. An early breakthrough for him came in 1954 with a one-person exhibition at the Betty Parsons Gallery in New York. At the time this gallery was important for exhibiting work by Pollock and Newman, among other prominent artists. Twelve years later he participated in the landmark *Primary Structures* show. By 1966 he had turned from wood sculpture to work in metal through commercial fabrication. Demonstrating a predilection for verticality, his work veered toward architectural structure and the minimalist aesthetic of impersonality. Characteristically, his sculpture consists of simplified rectangular shapes, the overall configuration sometimes reminiscent of columns. Utilizing post-and-lintel construction and strong primary colors, as well as the hues of the materials themselves, Kipp directs geometric shapes into architectonic formations.

His *Lockport,* 1977 (pl. 63), shows his typically vertical orientation of forms accented with secondary horizontals. Although his means are minimal, Kipp, like other artists

exhibits the blend of structural and spiritual elements in Pepper's work of that time. Here she has exploited the soft, rich surface of rusted Cor-ten steel to add to an enigmatic feeling. Her simple juxtaposition of triangular shapes is effective in suggesting the majesty and mystery of the pyramids. Pepper's *Taurus Portal,* 1979 (fig. 74), is reflective of Brancusi's use of simple shapes that evoke an animate quality. Totemic in nature, this work explores the evocative possibilities of basic forms. Pepper was particularly influenced by travel in Cambodia, where she

saw Khmer sculpture. She wrote: "In 1960 I walked into Angkor Wat a painter and I left a sculptor."[6]

Pepper parted company with other artists using a simplified format through her interest in a more subjective content. Rather than emphasizing form in an art for art's sake manner, she has plumbed feelings and memories from it. She is interested in the emotive possibilities of basic form.

In the 1980s Pepper used cast bronze for further explorations of

working in this vein, parted company with Judd and Morris by rejecting strictly rectangular enclosures for more idiosyncratic opened structures. The scale of Kipp's work, as well as its configuration, bears a relationship with architecture, yet his use of color and a diagonal thrust lend a dynamic, constructivist tone.

DAVID VON SCHLEGELL

Like several artists of this period, David von Schlegell (b. 1920) started out as a painter and became a sculptor in the early sixties. Born in St. Louis, he studied at the Art Students League in New York in the mid-forties and with his father. He did not give full attention to sculpture until the early sixties. Working primarily in Maine, he began to show his sculptures in New York in 1965. Using techniques he learned

FIGURE 75
DAVID VON SCHLEGELL
Untitled Steel Wedge #1, 1977
white-coated steel
16¾ x 90 x 115 inches
Yale University Art Gallery, New Haven
Gift of the artist

FIGURE 76
PETER FORAKIS
Port and Starboard List, 1966
stainless steel
60 x 108 x 123 inches
Courtesy Stoà Gallery and Publishing,
Petaluma, Calif.

JAMES ROSATI

Born in Washington, Pennsylvania, near Pittsburgh, James Rosati (1912–1988) was a violinist in his teens and played with the Pittsburgh Chamber Orchestra. He began to make sculptures in the early thirties. Moving to New York in 1943, he began to exhibit his works in the 1950s. His close friend was David Smith, and it was Rosati who delivered Smith's funerary eulogy in 1965. Up to 1954 Rosati worked in bronze and stone, after which he began to experiment with welding. An early welded example is *Interior Castle, Number 1,* 1959 (fig. 77), a work consisting of welded rectangular planes. Though this piece has an organic and anthropomorphic quality, he

as an aircraft construction engineer in the forties, von Schlegell works primarily in fabricated aluminum.

His *Untitled Steel Wedge #1,* 1977 (fig. 75), illustrates his turn away from minimalistic progressions and systems aesthetics toward large-scale works indicative of industrial sources. Characteristic is lateral extension into space, which activates the surrounding area. Shiny, reflective metal surfaces augment sensations of movement through atmosphere.

STRUCTURAL VARIATIONS

Artists working in the mid-sixties who were included in the *Primary Structures* exhibition and/or exhibited at the Park Place Gallery shared a deviation from doctrinaire Minimalism. They each manipulated basic forms to achieve more complex sculptures and often more emotive expressions. Several began as painters, perhaps explaining a predilection for illusionary effects. These artists did not form a group, but they shared in a spirit that presented alternatives to a concurrent minimalistic aesthetic.

There were other artists working at the time whose work participates in formalist directions, but who, however, did not show at Park Place and were not included in *Primary Structures.* Among them were Rosati, Meadmore, and James Metcalf.

PETER FORAKIS

A westerner born in Wyoming, Peter Forakis (b. 1927) studied and taught at the California School of Fine Arts, working first as a painter and then turning to sculpture about 1960. The tetrahedron was a favorite geometric construct he used in work of the sixties. *Port and Starboard List,* 1966 (fig. 76), is illustrative of his use of this form and its permutations. Using stainless steel tubes and sheets, his work is both planar and linear, open and closed.

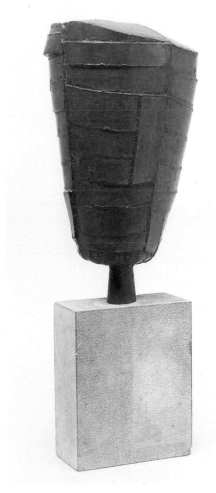

FIGURE 77
JAMES ROSATI
Interior Castle, Number 1, 1959
zinc on cement base
17½ x 10¾ x 9½ inches
Whitney Museum of American Art, New York
Purchase, with funds from the Friends of the
Whitney Museum of American Art

soon turned to a more formalistic aesthetic. He did not exhibit work from 1962 until 1969, when he had a one-person show at the Rose Museum at Brandeis University. Also in 1969 he began to work with Lippincott Inc. on the fabrication of his sculptures, instigating a turn to geometric forms.

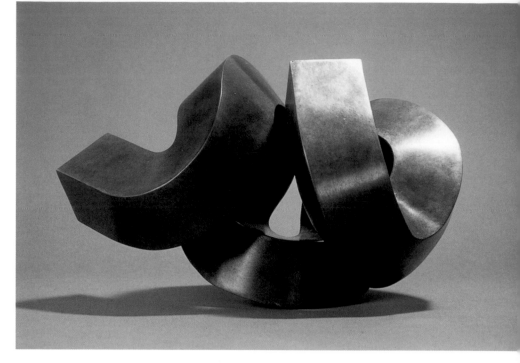

JAMES METCALF

Like Rosati, James Metcalf (b. 1925) can be viewed as a transitional figure between earlier emotive welded work and later formalism. Born in the United States, Metcalf was educated here and in London at the Central School of Art and Design, where he taught in 1954.

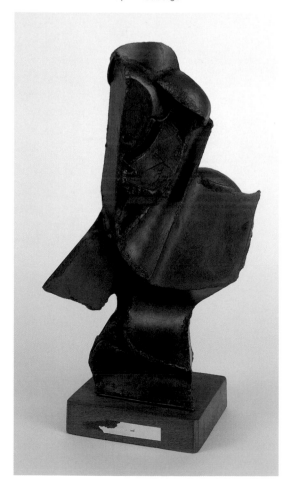

Subsequently, with the aid of a grant, he did research in ancient metalworking techniques. In 1956 he moved to Paris and had his first one-person show there in 1959. Two years later he began to exhibit in New York. An untitled work of 1960 (pl. 64) illustrates his use of curvilinear metal parts welded into a tight configuration suggesting intricate curvilinear motion. Seen from various angles, the sculpture seems to undulate. There is a sense of concentrated, focused energy in this small piece. Metcalf left Paris in 1967 to work in Santa Clara del Cobre, Mexico, where he established a new technique in forging metal, revitalizing this art form and injecting new life into an impoverished community.

CLEMENT MEADMORE

Another maverick in terms of classification is Clement Meadmore (b. 1929), whose work is minimal but either bent or curvilinear. Born in Australia, Meadmore first studied aircraft engineering but was already making sculptures in an industrial design course. In 1953 a trip to Belgium and a visit to the outdoor sculpture show at Middelheim Park

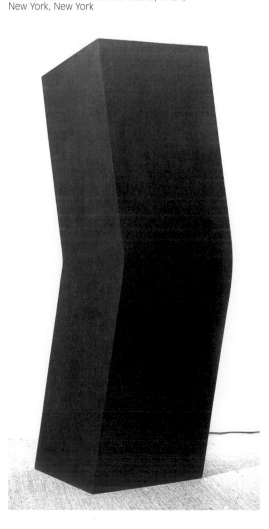

in Antwerp convinced him to purchase welding gear. His early work of the 1950s is both geometric and organic in form. Based on plane, line, and right-angled interchanges, the forms have an organic irregularity that suggests the artist's hand.

Arriving in New York in 1963, Meadmore almost immediately gravitated toward harder, smoother edges and seams. He introduced himself to Newman, whose work he admired, and embarked on a group of works that emphasize the juncture of basic forms. *Bent Column,* 1966 (fig. 78), reflects his present concerns and points toward future considerations. A large rectangle, the piece can compare with minimalist work of the time, but it varies in terms of its upright position and bent stance. The slight curvature adds movement, a factor eschewed in Minimalism. This work points in the direction of Meadmore's current work, which is rounded in form. *Round Midnight,* 1996 (pl. 65), exists as a tightly curled entity in space. Evidently capable of extension, the piece seems like a truncated fragment of a larger entity. Refined movement is enhanced by gleaming, smooth surfaces. Working from small models, Meadmore selects what he feels to be the most potent of his options for fabrication.

SEVENTIES PLURALISM

The so-called pluralistic era of the seventies acknowledged the existence of as many styles as there are artists. Pluralism also seemed to parallel populism in politics. Feminism was a factor in leveling notions about a hierarchy of media and techniques, and women as well as artists of color clamored for equal exposure and attention. Alternative spaces proliferated—perhaps in response to artists' work outside established venues. The possibilities of welding continued to expand,

stretched by artists' special desires and needs and by new artistic directions. Formalism continued to dominate, because of the nature of the process itself and because of the influence of earlier welders.

Into the seventies artists pursued unique paths that ranged from geometric to organic formalism. Using their own equipment more often than factory fabrication, artists had at their disposal a diverse range of artistic options.

PLATE 66
ALEXANDER LIBERMAN
Light Interceptor, 1965
steel
62 x 37¼ x 21½ inches
Neuberger Museum of Art, Purchase College, State University of New York
Gift of Howard Lipman

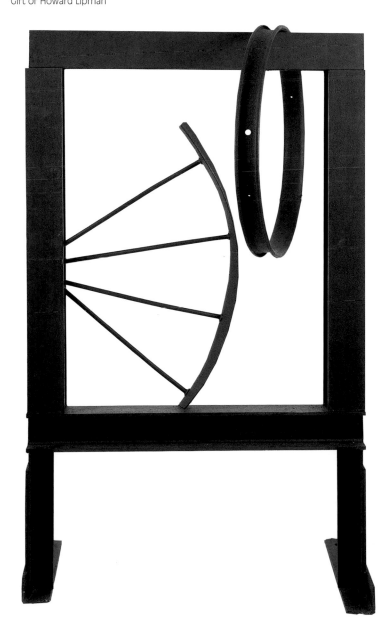

ALEXANDER LIBERMAN

Though of another generation, Alexander Liberman (1912–1999) came into his own as a sculptor in the sixties and seventies. Having been involved in painting since the thirties, Liberman came to the United States from the Soviet Union in 1941. In the forties he began a career as a magazine editor and art director. He became art director for Condé Nast Publications in New York in 1944 and from 1962 to 1994 was editorial director. In the fifties Liberman learned arc welding, and he soon had a one-person show at Betty Parsons Gallery. *Light Interceptor,* 1965 (pl. 66),

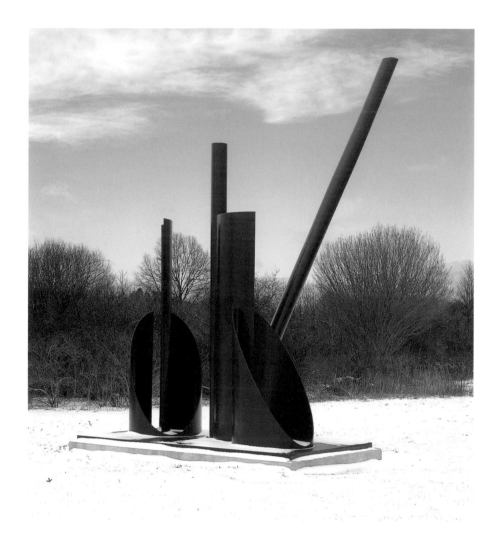

PLATE 67
ALEXANDER LIBERMAN
Odyssey, 1973
painted steel
288 x 168 x 96 inches
Neuberger Museum of Art, Purchase College,
State University of New York
Gift of the Friends of the Neuberger Museum
of Art and Roy R. Neuberger

demonstrates his interest in recti-
linear shapes tempered by arcs.
In its orientation and indication of
framed space, this sculpture inter-
sects painting.

Liberman began in the fifties to
work on a monumental scale,
often painting his sculptures.
Demonstrating this and later ten-
dencies is *Odyssey,* 1973 (pl. 67),
which exemplifies a mature phase in
Liberman's development. It includes
cylinders of varying thicknesses,
sometimes complemented by pla-
nar or linear elements. Liberman's
work seems to connect with archi-
tecture, a discipline he studied.

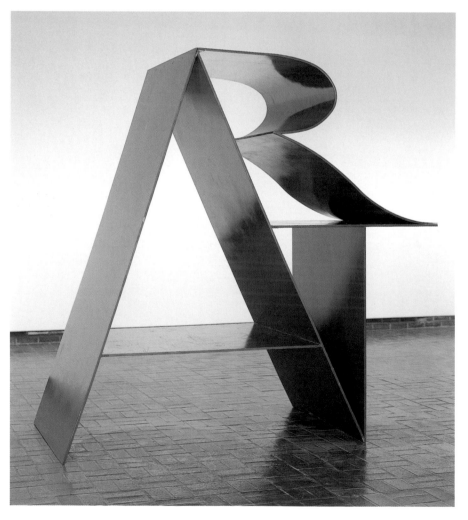

ROBERT INDIANA

There are also Pop artists who have
used the means of factory fabrica-
tion to achieve literary and figurative
forms. Robert Indiana (b. 1928), born
Robert Clark in New Castle, Indiana,
became known for his paintings of
words having particularly volatile
meanings in American society. The
most famous of these is the word
love, which was made into a paint-
ing, a sculpture, and eventually a
postage stamp. He selects terms
that have been so overused by
commercialism and mass media
technologies that they have become

PLATE 68
ROBERT INDIANA
ART, 1972
polychromed aluminum
84 x 86 x 42 inches
Neuberger Museum of Art, Purchase College,
State University of New York
Museum purchase through a matching grant
from the National Endowment for the Arts
and the Friends of the Neuberger Museum

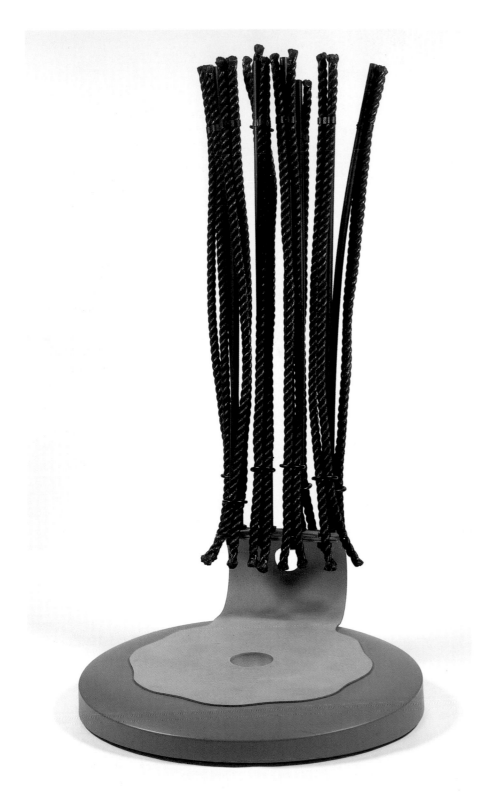

PLATE 69
CLAES OLDENBURG
Typewriter Eraser, 1970–75
rope, aluminum, fiberglass, steel
84 x 48 x 48 inches
Frederick R. Weisman Art Foundation,
Los Angeles

surrealistic and socially cogent. An enlarged hamburger or an enormous floppy fan communicates the importance of objects in daily life. Increasingly, Oldenburg has become involved in large public projects and has utilized fabrication to realize these and other pieces, such as *Typewriter Eraser,* 1970–75 (pl. 69). Typically, the artist has chosen an object common to the time— prior to the invention of liquid paper or computer deletions. The uncharacteristic bend in the eraser demonstrates the strength of steel in supporting a crumb-sweeping brush jutting up at a right angle to the eraser base. His magnification of the ordinary results in an object with humorous overtones.

PETER REGINATO

The work of Peter Reginato (b. 1945) is in a structuralist vein. Born in Dallas, Texas, Reginato studied at the San Francisco Art Institute before going to New York in 1966. At first engaged in poly-chromed plywood sculpture, he turned to fiberglass in 1968. With this material he introduced more color and texture into his work. In 1969 he began to make welded-steel sculptures in geometric, interlocking shapes, largely under the influence of Greenberg and a prevalent structuralist tendency in art. By the seventies, organic, playful shapes became more fre-quent, eventually constituting his trademark format.

virtually meaningless. Another such word is *ART,* which Indiana made into a sculpture in 1972 (pl. 68). Using bold colors and graphic forms, Indiana points out the impersonality of this word. It stands as a sign or announcement of conceptualization wherein an artist can designate what is or is not art. Indiana's work has a strong material presence and objectivity, relating it to Minimalism as well as Pop. In addition to being a word, his sculpture is also a structure.

CLAES OLDENBURG

An American born in Sweden, Claes Oldenburg (b. 1929) was once associated with Pop art. At first he fashioned manufactured food and other items ubiquitous in American society. Changing certain properties of objects became his signature gesture: light switches become soft and lettuce becomes hard in Oldenburg's universe, which is both

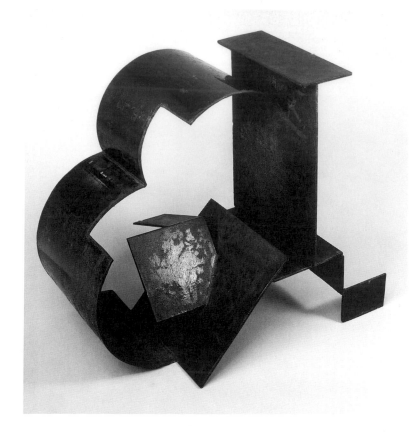

FIGURE 79
PETER REGINATO
The Diapason, 1970
steel
30 x 17 x 27 inches
Metropolitan Museum of Art, New York
Gift of Mr. and Mrs. Jason McCoy, 1979

The Diapason, 1970 (fig. 79), consists of the swirling lines, irregular planes, and organic leaf and plant forms characteristic of his work. This piece is painted in hot, bright colors; the artist sometimes splashes the pigment on in an abstract expressionist manner. Movement is present in many guises and modes: slow, fast, off center, leaning, balancing, and stretching. Though his work has no specific reference point, it is an amalgam of plantlike and anthropomorphic forms.

PLATE 70
MEL EDWARDS
Lynch Fragment, 1989
steel
16¼ x 8½ x 9½ inches
Collection of Blanche and
Bud Blank

PLATE 71
MEL EDWARDS
Dry Days, 1992
steel
21 x 12½ x 7 inches
Neuberger Museum of Art, Purchase College,
State University of New York
Gift of Mel Edwards

MEL EDWARDS

In his youth Mel Edwards (b. 1937) lived in Dayton, Ohio, and Houston, Texas. He was involved in art in high school, and this interest drew him to California. Edwards studied at Los Angeles City College (1955–57), the University of Southern California (1957), the Los Angeles Art Institute (1958), and finally earned a B.F.A. from USC in 1965. In college he was interested in painting, but after he graduated he learned the technique of welding. He lives in New York.

The *Lynch Fragments,* for which he is justifiably acknowledged, have a continuing history from the early sixties. This series has a direct connection with events of the time, including heated civil rights conflicts that involved rioting in Los Angeles and elsewhere. It also recalls the lynching of black people during the days of slavery. Pieces in the series suggest tightened knots or nooses. Also, there are cross and horseshoe images related to people's beliefs and superstitions. African art, espe-

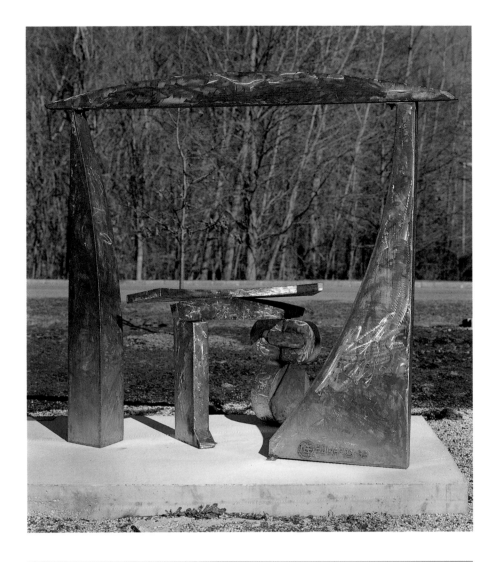

cially masks and implements, further influenced Edwards. Examples of this in his work of the 1990s are *Lynch Fragment,* 1989 (pl. 70), and *Dry Days,* 1992 (pl. 71), both of which have a tight, constricted feeling. As wall-mounted reliefs, these relatively small sculptures seem to contain unyielding cores of opposing forces. To become tied or tangled in a knot meant the threat of disablement and death, and steel chains and other objects incorporated by Edwards insinuate the violence of lynching.

In addition to this work, Edwards has pursued a series of larger sculptures that deal with relationships of geometric units. In *Gate of Ogun,* 1983 (pl. 72), space has been opened up and outlined using planes of steel that have been ground and polished in the textural and painterly manner of David Smith. In this work there is a sense of gravity's pull and welded steel's resistance.

LILA KATZEN

Like so many sculptors of this period, Lila Katzen (1932–1998) began as a painter, which she studied in New York, her place of birth. Switching to three dimensions, she had her first one-person show of sculpture in 1964. Maturing in the sixties, her work has been widely shown since. Consisting of flowing, curvilinear forms, Katzen's sculptures of the seventies are organic and related to human movement, especially dance. During the next decade she incorporated light into floor pieces, followed by the more

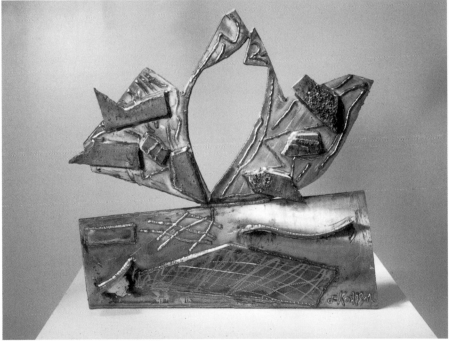

vertical orientation of welded work in the 1980s and 1990s. *The Voyage,* n.d. (pl. 73), is characteristic of later work in its combination of organic and geometric shapes. Linear and planar relief elements, along with a manipulation of surface textures, create a sensation of jewel-like effects as light dances over shiny and opaque forms. The work is both decorative and brutal, as the artist's raw, open presentation of elements culminates in a feeling of preciousness and power.

SIDNEY BUCHANAN

Sidney Buchanan (b. 1932), born in Wisconsin, lives and works in Omaha, Nebraska, away from major art markets. As early as the fifties he was devoted to welded-steel sculpture. Using found parts from scrap metal yards, Buchanan has created

a variety of formats ranging from relief sculpture to large-scale, three-dimensional works.

In the seventies Buchanan produced medium-scale pieces that look like surrealistically arranged furniture. A dresser (fig. 80), for example, might serve as a point of departure. A drawer emerges from a structure that assimilates and suggests vanity as a human personality trait. The drawer is "open" yet welded in place, turning function into a nonfunctioning artwork. His elaboration of a common and specific piece of furniture leads viewers into the realm of imagination and art. There is a dreamlike quality present in an object that presupposes moving parts but denies access.

Buchanan's ideal projects are large-scale and public, and he has created many that use subtly composed

geometric and curving elements. He has also created smaller outdoor pieces such as *Frazzel I,* 1981 (pl. 74). The title is suggestive of a frantic jumble of shapes emerging from a baselike entity. Tightly interwoven forms convey feelings of nervous actions. Buchanan's work reflects his use of abstraction in an architectural sense and in a human sense is reflective of emotional states.

LOUISE NEVELSON

That Louise Nevelson (1899–1988) was born late in the nineteenth century might catch one by surprise, since most artists reaching recognition as she did in the late fifties and sixties were younger at the time. This may have resulted from gender discrimination, the limited range of opportunities offered to women, or simply a maturation reached later in life when her work intersected in an ideal way with conditions and trends in the art world.

Nevelson was born in Russia but came to America with her family in 1905. She studied art in New York and Munich and also studied drama and modern dance and worked as a film extra. While her art owes a

FIGURE 81
LOUISE NEVELSON
Tropical Tree IV, 1972
direct welded painted aluminum
50 x 26 x 20 inches
Courtesy PaceWildenstein Gallery, New York

painted aluminum and steel. These works, realized at the Lippincott foundry, were similar to earlier works in wood because of their frontality and emphasis on assembly. Nevelson personally worked in the fabrication plant, adding elements to build individual sculptures. At the time she wrote, "I had never worked directly in metal before or, for that matter, in a foundry, but I am working near my capacity in an atmosphere of harmony."[7] She went on to describe her process:

I build up elements and tear them down and work until my eye is satisfied. When a maquette is enlarged, there are different considerations and I never merely enlarge. I rethink and add and change edges and thickness of forms—as well as adding new pieces. My works are always in process until they are installed and, even then, I've made changes.[8]

The flexibility and improvisational quality described here are a major trait in all of her work, whether in wood or steel.

Tropical Tree IV, 1972 (fig. 81), is a result of Nevelson's extemporaneous manner of working and demonstrates an interest in organic themes. This sculpture combines eccentric, planar shapes to suggest lush, wild growth. Curvilinear and straight edges are juxtaposed in an arrangement that is dramatically suggestive of plant life. An overall coating of black paint counters the organic forms while providing unity and a sense of mystery. Darkness associated with plant greenery gives the work an enigmatic mood. Also, this tone offers the possibility of shadow effects so important to all of this artist's work.

debt to Cubism, Constructivism, Dada, Surrealism, Assemblage, and Minimalism, it was her modular assemblages of blocklike components, first wood and later steel, that established her place in the art world.

Nevelson's role in the story of welded sculpture was played out in university settings. In 1969, when she was seventy, she was commis-

sioned by Princeton University to do her first monumental Cor-ten steel piece, *Atmosphere and Environment X.* Later she received more commissions for public pieces, and in 1977, in a dramatically large gallery at the Neuberger Museum of Art at Purchase College, State University of New York, Nevelson showed a substantial group of sculptures formed from

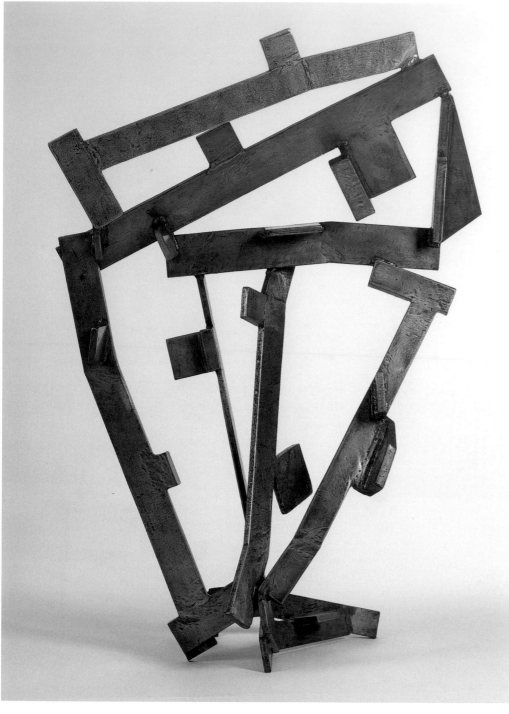

PLATE 75
JOEL PERLMAN
Shield, 1989
steel, bronze
48 x 23 x 16 inches
Courtesy of the artist

sixties. He returned to New York in the early seventies. Working in cast and welded bronze and later in welded steel, he has produced a body of work with a consistency and cogency of presentation.

Citing as influences David Smith, Herbert Ferber, and Richard Hunt, Perlman has pursued a constructivist course, welding straight-edged steel shapes to one another. His work belongs to the tradition of welded open work, an example being *Shield,* 1989 (pl. 75). Characteristically, his work is vertical in orientation and often architectonic in its relationship of rectangular forms. Employing an open center, his pieces defy gravitational pull on dense matter. Even as a student at Cornell, taking an adult-education course in welding because the college did not offer one for undergraduates, he experienced the wonder of welding:

All of a sudden I could do all of these amazing, magical things. A little weld will hold up an enormous amount of weight. I felt that I had been given this incredible power, and it is such a power that you have to be careful not to get caught up with the magic of it.[9]

JOEL PERLMAN

Born and raised in New York, Joel Perlman (b. 1943) received a B.F.A. from Cornell University, then studied for a time in the mid-sixties at the Central School of Art and Design in London. He later completed a master's degree at the University of California–Berkeley before returning to England to teach in the latter part of the

FLETCHER BENTON

On the West Coast, Fletcher Benton (b. 1931), a resident of San Francisco, gave up painting in the early sixties to produce kinetic works, first paintings, then sculptures moved by motors. In the 1970s he turned to welded-steel sculpture.

Untitled #5, 1989 (pl. 76), is illustrative of the capricious element in his mature work, which entails circles, squares, and curved elements, largely flat or shallow in dimension. The delicacy of his metal constructions is enhanced by their slow, rhythmic movements.

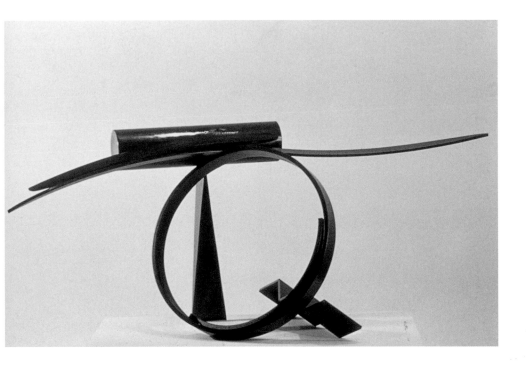

JOHN PAI

A Korean American, John Pai (b. 1937) was raised in Seoul; he arrived in the United States in 1952. Educated at the Pratt Institute, he eventually became a professor and head of the sculpture division there. Gravitating almost immediately to welding, Pai created work recalling that of his mentor, Theodore J. Roszak. Adopting the notion of the module in the mid-sixties, he noted a similarity between modular structure in art and that present in science, as in atoms, cells, or other basic components of life.[10] In other words, he rejected the anonymity and geometry of minimalist aesthetics for a more organic interpretation of the single, repeated unit. His *Passage*, 1973 (pl. 77), has a vast number of tiny repeated modules that set up a curvilinear motion, similar to that of a moving wave or wing in flight. Space is a major element in this work, which appears to be feathery light as it floats within its geometric steel cube. Other works by Pai, such as *Gahggoom*, 1993 (fig. 82), convey a ruffly, frilly sense of motion in space. An undulating motion denies the stiffness of metal. Consistent with such effects, Pai has expressed his feeling that "welding is a fluid process like painting with a sable brush."[11]

Pai has related his art to Australian "song lines," performances that the aborigines believe sustain the world's existence. The idea of the work as a part of a larger whole is more important to him than the individual object:

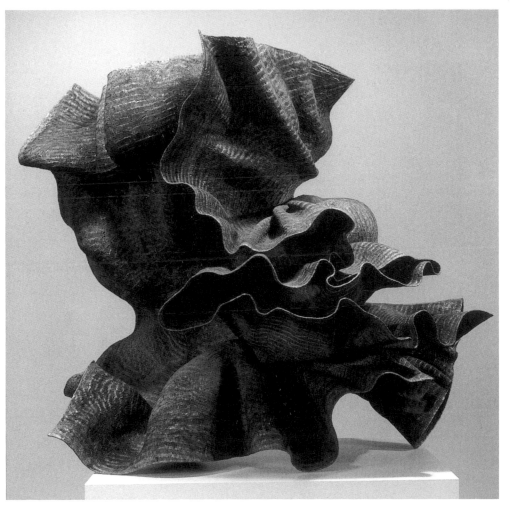

FIGURE 82
JOHN PAI
Gahggoom, 1993
steel
45 x 37 x 58 inches
Courtesy Sigma Gallery, Inc., New York

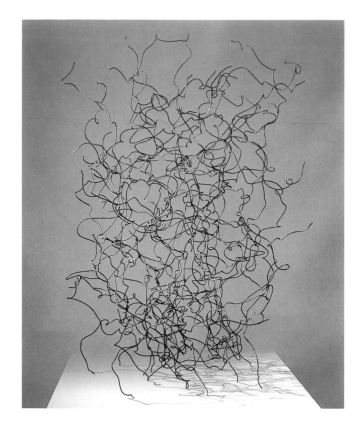

FIGURE 83
JOHN PAI
Entropy's Sirens, 1997
steel
48 x 32 x 32 inches
Courtesy Sigma Gallery, Inc., New York

... through art, you know that you are alive. You cannot remove yourself from life to being an artist ... you have to be a player, test yourself from moment to moment, make mistakes, feel doubts, jump into the middle of things. Ultimately, this process is more important than the result of making an object.[12]

This sense of ongoing process is exemplified by *Entropy's Sirens*, 1997 (fig. 83), in which metal lines appear to be moving in space.

ANN SPERRY

Ann Sperry (b. 1950), with Barbara Zucker, presented a paper on color in sculpture at an annual meeting of the College Art Association in 1980. The statement was important in exploding preconceived notions about sculpture. Sperry has, since the seventies, introduced painted surfaces into her welded work.

Born in the Bronx and now living in Manhattan, Sperry was a pupil of Roszak at Sarah Lawrence College. She has devoted herself to welding for some twenty years. In the seventies she completed a body of work painted pink. The notion of painting steel sculpture pink—a color usually associated with femininity—was a statement of women's power and strength. *Vessel I*, 1976 (pl. 78), is from this period and exemplifies Sperry's use of curving metal strips juxtaposed to a larger stabilizing element. Here, the strip relates to a bowl-like shape, enlivening and qualifying a simple circle.

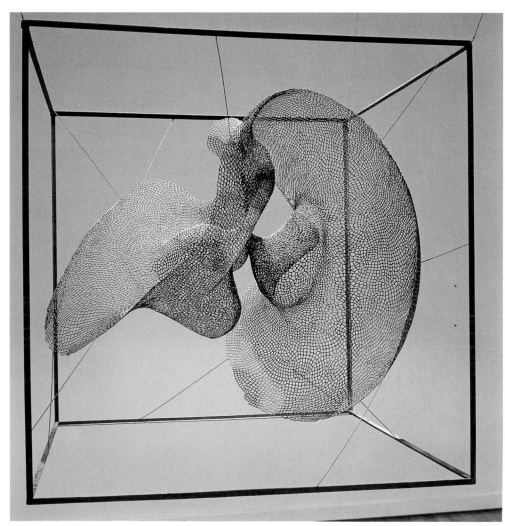

PLATE 77
JOHN PAI
Passage, 1973
steel
39 x 39 x 39 inches
Courtesy Sigma Gallery, Inc., New York

PLATE 78
ANN SPERRY
Vessel I, 1976
welded and painted steel
19 x 23 x 12½ inches
Courtesy of the artist

Continuing to work in series, Sperry was absorbed for some time in garden and floral shapes translated into work entailing deft touches of paint. Instead of coloring the whole form, she splashed and brushed pigment over certain portions. These painterly qualifications added tonality as well as hue, highlighting certain organic parts. Recently she has embarked on a group of works having to do with outer space, planets, and orbits. *Out There XXXV*, 1997 (fig. 84), suggests the universe as an orb. To a basic circular form the artist has added another element, indicating existence within an infinite chasm.

FRANK STELLA

Born in Massachusetts and educated at the Phillips Academy and Princeton, Frank Stella (b. 1936) created a series of pinstripe paintings that commanded the attention of the art world in the sixties, during a period of emphasis on minimalist structure. In paint Stella emphasized the flatness of his canvases and the relationships of parallel stripes to the perimeter of the work. Eventually Stella left the flat canvas plane entirely, opting for painted wall reliefs. From the mid-seventies on, his painted steel and mixed-media constructions are difficult to categorize as either painting or sculpture. Given Stella's previous work as a painter, subsequent work might be seen as three-dimensional manifestations of painting. On the other hand, work of this period exploits surface effects of certain media and exhibits a sense of substantial physical presence. Elements

FIGURE 84
ANN SPERRY
Out There XXXV, 1997
steel
36 x 36 x 12 inches
Courtesy of the artist

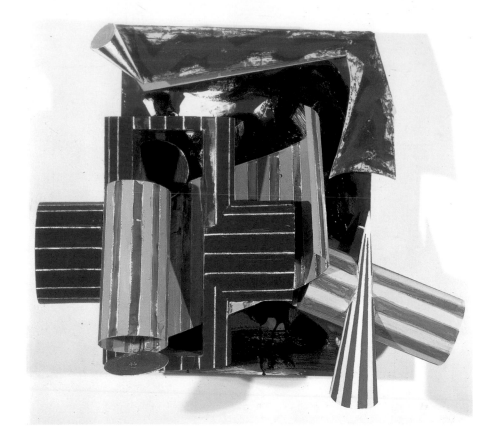

PLATE 79
FRANK STELLA
Maquette for Il Dimezzato, 1987
mixed media on aluminum
27½ x 34 x 16½ inches
Courtesy Greenberg Van Doren Gallery,
St. Louis

PLATE 80
ROBERT HUDSON
Double Time, 1963
painted metal
58¾ x 50 x 35 inches
Oakland Museum of California
Gift of the Women's Board of the Oakland
Museum Association

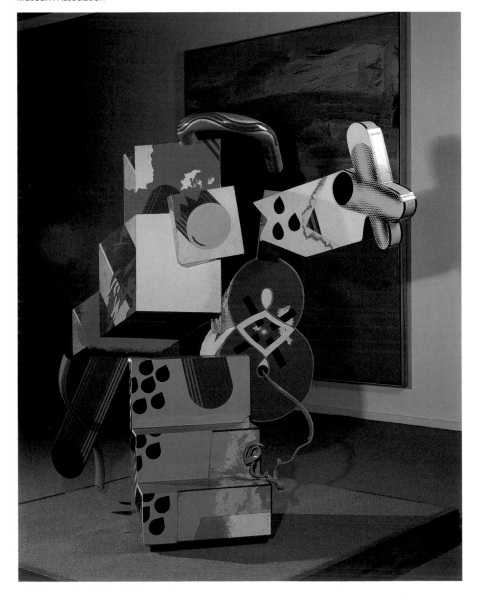

in a work such as the maquette for *Il Dimezzato,* 1987 (pl. 79), range from a substantial brushwork that is literally hard and rigid to strokes that are drawn or painted on the surface. A restless, energetic talent on the move, Stella has not stayed with painting on metal, yet his work in this vein adds to a sense of the breadth as well as depth of possibilities available using welded metal as form and as surface.

ROBERT HUDSON

Robert Hudson (b. 1938), born in Salt Lake City, received undergraduate and graduate degrees from the San Francisco Art Institute and has continued to live and work in the Bay Area. In the sixties he progressed from painting through leather sculpture to welding. Major influences in sculpture were David Smith, Roszak, and Wilfred Zogbaum. Hudson eventually channeled his forces into a combination

of assemblage and popular art. With painted metal, he created brightly colored works that seem almost psychedelic.[13] *Double Time,* 1963 (pl. 80), shows off his use of geometric patterns painted on organic shapes. In the next decade Hudson's work became more formalistic, with simplified forms arranged in sharply defined compositions.

Related to Hudson's direction were other Californians of the time, including William T. Wiley, William Geis, and Don Potts. Their work has a funkiness characteristic of West Coast art of the sixties and seventies.

JASON SELEY

Highly eccentric figurative work was the forte of Jason Seley (1919–1983), who was born in Newark, New Jersey. Early in the forties Zadkine played a role in Seley's progress as his teacher at the Art Students League in New York. In the latter part of the decade, Seley lived in Haiti, after which he toured Europe, visiting Henry Moore in England, and returning to the United States in 1950. At this time he became interested in found objects. Especially portentous was a short stay in a small town where his car was being fixed. His wife saw an automobile bumper and persuaded him to buy it. Seley recognized its anthropomorphic potential and began to use bumpers in his work beginning in 1958.[14] Thus began Seley's mature career using automobile bumpers to realize figurative imagery. Exemplary is *Baroque Portrait #3,* 1961 (fig. 85), a figure with the flowing forms of the historical Baroque period. Seley capitalized on the organic, curvilinear flow of bumper forms to create a sense of billowing elaboration in his work.

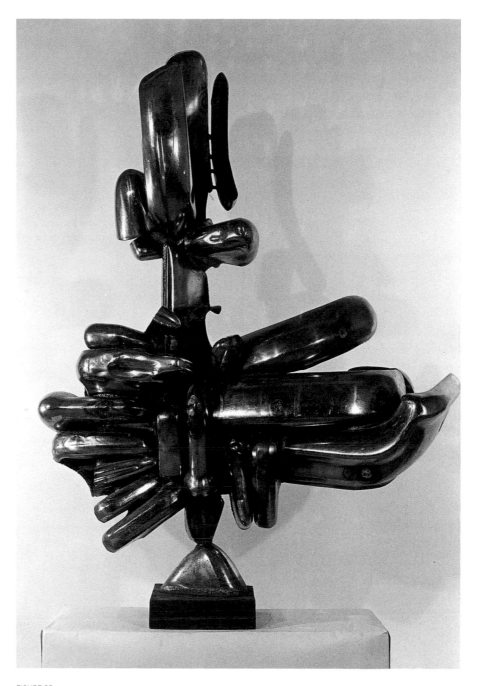

FIGURE 85
JASON SELEY
Baroque Portrait #3, 1961
chromium-plated steel
60½ x 44½ x 18 inches
Neuberger Museum of Art, Purchase College, State University of New York
Gift of Mr. Howard Lipman

7 MILLENNIAL METAL

As in technology, fashion, and other areas of American life in the final decades of this century, the consumer cult of the new has pervaded the art world. Emphasis has been placed on the private sector to support art as many arts organizations have suffered cutbacks, and some have closed because of governmental funding cuts. Still, many young artists continue to develop individual approaches to sculpture, and welded sculpture continues to proliferate.

Welded sculpture's continuity and advancement have been supported by facilities such as the Sculpture Center School in New York City and the Sculpture Center in Utica, New York. These organizations have provided the necessary facilities, including work space and equipment, that individuals might not otherwise be able to afford. Artists may pay rental fees, or they are provided with fellowships and residencies to help cover their costs. Places such as these have contributed to the ongoing vitality of welded sculpture.

End-of-the-millennium welders can be grouped in four categories according to the character of their work: figurative (Nancy Graves, Deborah Butterfield, Christy Rupp); fantastic (Judy Pfaff, Penny Kaplan, Jody Culkin, Jenny Lee, Wendy M. Ross); organic (Lee Tribe, Arthur Gibbons, Grace Knowlton, George Dudding, Kendall Buster, Arthur Mednick); and geometrically abstract (Dorothy Dehner, Helene Brandt, Jedd Novatt, Howard McCalebb, Jonathan M. Kirk).

NANCY GRAVES

Born in western Massachusetts and educated in art at Yale University, Nancy Graves (1940–1995) received a Fulbright grant for painting in 1964, enabling her to study in Paris and to visit other European nations. The next year she lived and worked in Florence, pursuing interests in anatomy and taxidermy. At this time she turned from two- to three-dimensional work, making the first of her life-size camel constructions. She also collaborated with Richard Serra on an assemblage incorporating live and stuffed animals. In 1966 she moved to New York, where she began the investigations into anthropology and archaeology that continued her camel and fossil sculptures. In 1969 she became the first woman to be given a one-person exhibition at the Whitney Museum of American Art, where she presented installations marked by archaeological and anthropological

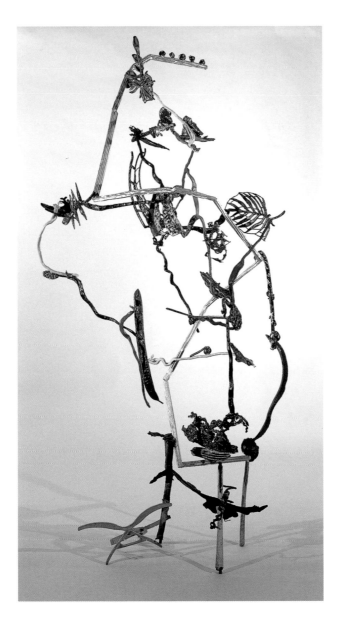

indicative of the accidents and incidents of nature. This work typifies Graves's unique association of elements, ranging from antique carvings to the re-creation of nature, based on study and experience of diverse cultures.

DEBORAH BUTTERFIELD

Deborah Butterfield (b. 1949), born and raised in California, was educated at the University of California at Davis. Beginning in the early 1970s Butterfield chose the horse as subject, making sculptures of mud, sticks, barbed wire, fencing, and corrugated metal. She claims her art "isn't about horses at all," however, and that she uses this form as a metaphor for herself.[2] First using clay and then burlap dipped in plaster draped over chicken wire, she fashioned other animals such as cows and reindeer to express universal feelings and experiences.

By 1976 Butterfield was using steel armatures as support for clay, plaster, and mud horses. Moving to Montana in 1977, she constructed moving and reclining animals. A breakthrough occurred two years later: she moved to an abandoned farm filled with fencing, scrap metal, and other found materials. At this time she gravitated toward welded horses, continuing her exploration of the horse's outer form and inner psyche:

As I was becoming more knowledgeable about horses, I was more aware of the internal, not only in terms of medicine and care, but emotions and intellect, learning to ride dressage (the execution by a trained horse of precision movements in response to barely perceptible signals from its rider), learning to propose new ideas to the horse, trying to get them to understand me and for me to understand them. I was dealing with interior space. For me to try to make a running horse . . . they do it much

overtones. For a short time in the seventies she returned to painting and made prints. In the latter half of the decade she began experimenting with bronze casting. Visits to India, Egypt, Peru, China, and Australia informed the iconography of her work in the eighties and nineties, when she executed numerous sculptures of painted and patinated welded bronze. Many of these include figurative motifs from nature and ancient and African motifs.

Graves placed David Smith among her sculptural forebears, though she used fabricators for her sculpture. According to critic Robert Hughes, her sculptures were "like Constructivism gone haywire."[1]

Color became significant in works that extend out into space, supported by slender spokes and rods. Somewhat like drawings in space, such works imitate natural growth systems through castings of natural and man-made parts assembled into an open network of organic shapes.

Rebus, 1984 (pl. 81), is made of bronze with polychrome patina, enamel, and stainless steel. The title appropriately indicates representation of a word or phrase by pictures or symbols. Characteristic is her rich array of objects and shapes, which give clues about content. Open like a constructivist work, the sculpture is nonetheless organic in character, with irregular curves and angles

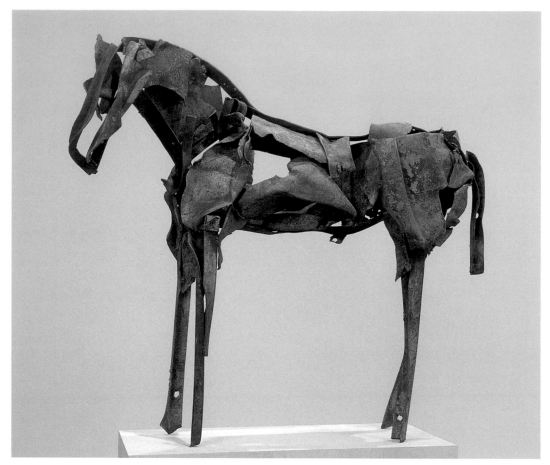

PLATE 82
DEBORAH BUTTERFIELD
Roman, 1993
found steel
39 x 47 x 21 inches
Collection of Catherine and
Bruno Manno

better. But the internal gesture, the state of being, was often agitated or quite lively. I tried to capture almost an X-ray vision photograph of that horse's state of being at any given moment. Isn't that what some of the aboriginal art is, X-ray vision?[3]

Roman, 1993 (pl. 82), demonstrates Butterfield's ability to capture the spirit of the horse, its internal as well as its external structure. Her analogy to aboriginal depictions of animals is unerring in that her structural interpretations reflect an internal being as well as an external frame-work. There is a dual sense of draw-ing and constructing in space as Butterfield updates a perennial artistic fascination with the horse as subject matter.

CHRISTY RUPP

Born in Rochester, New York, and currently living in New York City, Christy Rupp (b. 1949) works with figurative motifs with social and political content. Turning to the use of welded armature in the nineties, Rupp created single works and installations of multiple elements reflective of her concern for the environment. Originally interested in birds and rodents, Rupp had an installation at the infamous *Times Square Show* held in 1979 in New York, which consisted of rat images running along baseboards in a room. The piece's notions of infestation were perfect for the space, a derelict building in a blighted area of Manhattan. This installation was typical of Rupp's gravitation to alternative spaces such as Fashion Moda in the Bronx and ABC No Rio in New York's Lower East Side. She has continued to focus on environmental concerns, installing work at Documenta in Kassel, West Germany, and in New York's Dag Hammarskjold Plaza and Central Park.

Rupp's works involving welding are devoted to reptiles, shells, insects, and fish. She employs the technique to convey messages of social import. Welded structure forms a support for plastic bags filled with water, charred paper, plastic, and glass. *Ziplock Turtle,* 1992 (pl. 83), illustrates both Rupp's technical ability and her talent for upending conventions. The water inside the turtle reverses the usual

PLATE 83
CHRISTY RUPP
Ziplock Turtle, 1992
welded steel, water
18 x 13 x 3 inches
Courtesy of the artist

JUDY PFAFF

Judy Pfaff (b. 1946), is a British expatriate who lives in New York City. In 1979 she turned the Neuberger Museum of Art's Theater Gallery into an installation site. This early work is typical of Pfaff's environments of curvilinear, organic elements, surrounding and encompassing viewers. Sensations of tropical rain forest or underwater life are prevalent in this work—a physical manifestation of illusion and fancy. Since that time she has done a number of other installations as well as individual sculptures. From 1990, *Straw into Gold* (pl. 84) typifies this artist's construction of phantomlike apparitions in space. The enameled, tangled shapes float like smoke or a cloud, possibly a twister. The title has a fairy-tale connotation of raw material being transformed into precious material. This phantasmagoric work seems suspended, yet moving in space. It suggests the many orbs in a galaxy, each in action but part of a larger whole.

PLATE 84
JUDY PFAFF
Straw into Gold, 1990
steel wire, bedsprings
114 x 118 x 100 inches
Courtesy of the artist

PLATE 85
PENNY KAPLAN
Fallen Pyramid, 1978
steel
30 x 30 x 36 inches
Collection of the artist

presence of water around the creature. Filled bags inserted into a welded-steel support imitate the creature's characteristic mottled shell and shiny, damp surface, while the title of the piece asserts plastic's intrusive effects.

PENNY KAPLAN

A native New Yorker, Penny Kaplan studied radio, theater, and art history before taking up painting and eventually a five-year welding apprenticeship. She hit her stride in this medium in the eighties, securing commissions and creating installations in a number of northeastern sites. Kaplan's fantastic elements often lean toward ancient mysticism. Egyptian influence enters her work. In *Fallen Pyramid*, 1978 (pl. 85), ancient sources appear as a script on a relief surface. The dark tone of the work hints at a conundrum-like presence.

PLATE 86
JODY CULKIN
A Mighty Blow, 1994
knitted steel wool, steel, flocking
4 x 30 x 24 inches
Courtesy of the artist

JODY CULKIN

New Yorker Jody Culkin (b. 1952) likewise incorporates disparate media into her work. Her most recent sculptures are basically steel with some odd additions: elastic, flocking, zippers, fabric, steel wool. Often humorous or enigmatic, the content of her work arises from an association of title with shape. *A Mighty Blow,* 1994 (pl. 86), demonstrates her use of flocking, a technique associated with wallpaper, and shows her playful use of titles. We are to imagine a weapon possessed of extraordinary powers. Her association of steel wool and flocking forms an interesting contrast in metallic and fibrous textures, suggesting both masculinity and femininity.

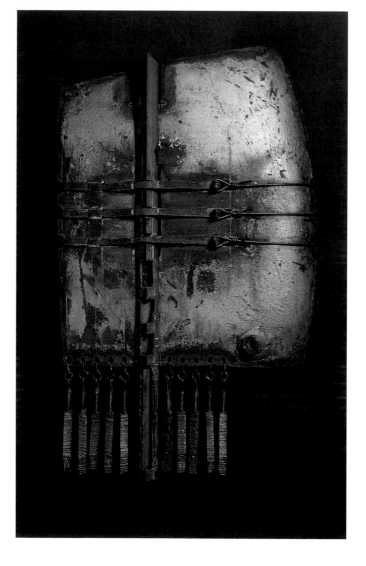

PLATE 87
JENNY LEE
Bride, 1988
steel
26 x 16½ x 6 inches
Courtesy Anita
Shapolsky Gallery,
New York

JENNY LEE

Jenny Lee (b. 1957) was born in Malaysia and came to New York in the late seventies. Trained in architecture, engineering, and fine art, she has exhibited her welded work since the late 1980s. Some of her armor- and masklike work has traces of her Chinese descent. Openings, clasps, ties, fringes, loops, and bindings add a decorative and structural sense. *Bridge,* 1987 (pl. 87), indicates Lee's use of curved planes and lines in work paradoxically suggesting both protection and torture, comfort and pain. Added color, scuffed surfaces, and rugged edges lend an ancient quality to her work.

WENDY M. ROSS

As in her *Quantum II*, 1997 (pl. 88), Wendy M. Ross (b. 1948), an artist born and based in Washington, D.C., welds steel punch-drops into sculptures that entail obsessive repetition. This work is geometric in the sense of forming a conceptual construct; it might be molecular, relating to a scientific hypothetical model. It also has the enigmatic feeling of a UFO. Ross has been a sculptor for twenty-five years, devoting most of her time to welded work.

LEE TRIBE

Born in England, Lee Tribe (b. 1945) attended Saint Martin's School of Art in 1970, when William Tucker, Phillip King, and Anthony Caro taught there. However, an important part of Tribe's education took place on London's docks, where he was apprenticed to a boilermaker as a plate welder. He arrived in New York in the late seventies. Tribe's

challenge in welding has been to find a personal aesthetic. He began by juxtaposing geometric and irregular forms in dynamic, flowing combinations of curvilinear movement. One example, *Marquis,* 1980 (fig. 86), is an association of forms suggesting those of Paul Klee. Open and primarily frontal, the piece demonstrates Tribe's early concern for delineation of space in a manner that is airy, organic, and whimsical, forming a correlation with nature.

Into the next decade his work vacillated between vertically oriented, open structures and tightly woven masses of steel parts. The latter works communicate aggression through a writhing, tortuous spiral upward from a lower mass. Masculine in character, the works seem to be about struggle as well as potency. Larger pieces are a blend of tangled and twisted forms maneuvered into a circular or elliptical shape. Interior space is simultaneously opened and surrounded by intertwined metal parts and rods. *Progeny Beast V,* 1992–94 (fig. 87), is a compact, seething form that continues the artist's interest in movement. In contrast to earlier achievements, this object occupies and activates space, rather than defining it.

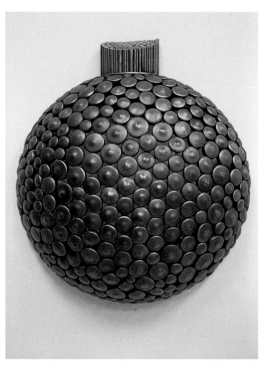

PLATE 88
WENDY M. ROSS
Quantum II, 1997
steel
14 x 12 x 4 inches
Courtesy of the artist

FIGURE 86
LEE TRIBE
Marquis, 1980
steel
49 x 53 x 27 inches
Collection of the artist

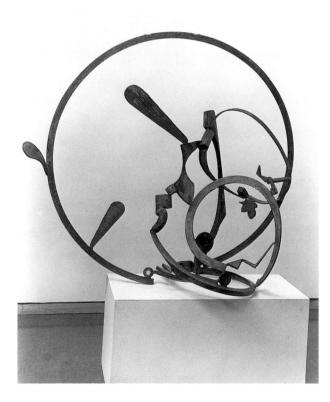

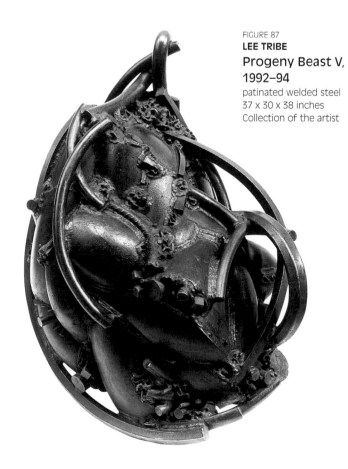

FIGURE 87
LEE TRIBE
Progeny Beast V,
1992–94
patinated welded steel
37 x 30 x 38 inches
Collection of the artist

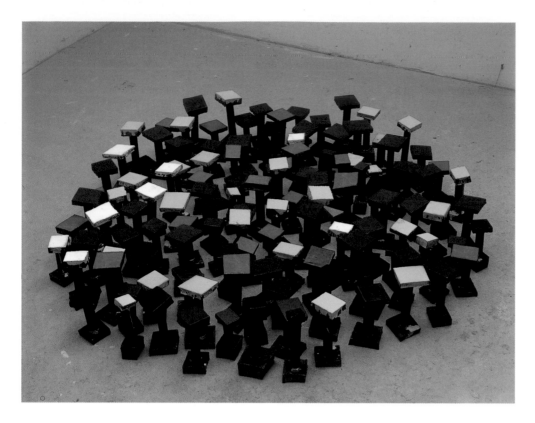

irregular steel plates. A recent work, *Counting*, 1996 (pl. 89), resembles clustered mushrooms poking through the soil, a colony of phallic symbols.

GRACE KNOWLTON

Grace Knowlton (b. 1932), a sculptor originally from Buffalo, New York, who now lives near New York City, has utilized a number of media in establishing a sense of enclosed, interior spaces. These include clay, cement, Design Cast, and most recently, welded metal. In whatever medium, exterior surface and internal nucleus are important to this artist. Even before she made welded globes, she was adding painted strokes and splashes to her orbs. Welding copper, steel, and found metal pieces, Knowlton created a series of spheres in the early nineties that combined the coloration and texture of metal with painted elements. *Untitled*, 1992 (pl. 90), is made from parts of an old stove. It evinces Knowlton's ability to instill an awkward, clumsy, yet sophisticated quality in an object that is tactilely and visually attractive.

PLATE 89
ARTHUR GIBBONS
Counting, 1996
steel, encaustic
8 x 60 x 60 inches
Courtesy of the artist

PLATE 90
GRACE KNOWLTON
Untitled, 1992
copper
48 inches diameter
Courtesy of the artist

ARTHUR GIBBONS

Born in Dayton, Ohio, Arthur Gibbons (b. 1947) lives and works in New York City. His welded sculptures of the eighties demonstrate his predilection for steel slabs, bent and cut into curvilinear, organic shapes that he juxtaposes vertically into abstracted plant forms. In the latter part of that decade he exhibited large, more somber works of intersecting, ragged-edged,

GEORGE DUDDING

George Dudding's *Six Costumes*, 1994 (pl. 91), executed in welded copper, signifies an interest in metaphorical associations of abstract sculpture with theater and music. An American born in Dortmund, West Germany, Dudding (b. 1953) now works in his Lower East Side Studio in New York. Working primarily with copper, he has examined hanging and extending forms. His work is largely linear, sometimes an outline, forming a vigorous diagram in space.

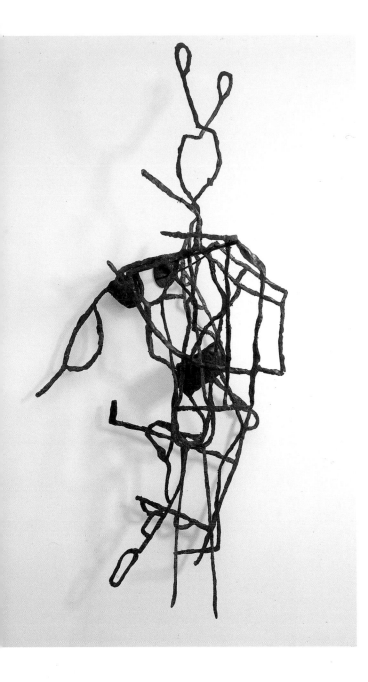

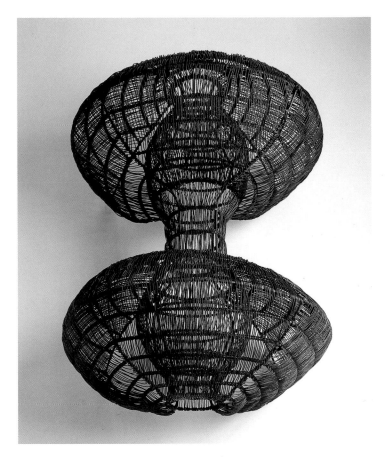

KENDALL BUSTER

ARTHUR MEDNICK

Kendall Buster (b. 1955), an artist born in Selma, Alabama, and now located in Washington, D.C., presents spacious webs that rest directly on the floor. Their bulbous shapes make them seem like inflated objects, at once light-weight, strong, and structurally tense. *Snare III,* 1996 (pl. 92), resembles a shell, cocoon, or hive—light in weight but stable and robust. Typically, it emphasizes the existence and power of interior space. As linear-based structures, her works connote diagrammed energy held in check.

A native of Philadelphia now residing in Brooklyn, Arthur Mednick (b. 1958) has created a body of work that is small and has a heraldic quality. His labor-intensive process involves cutting a simple shape in graduated sizes from sheet steel of varied thickness. He then stacks, welds, and burnishes them. *Groove #1,* 1997 (pl. 93), represents the simplicity and enigmatic quality of his work. The artist's effort as he painstakingly constructed the piece is quite apparent. As a result it takes on the characteristics of a talismanic object that has been touched many times in reverence.

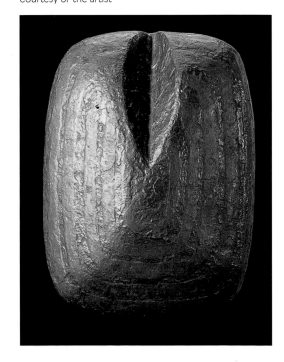

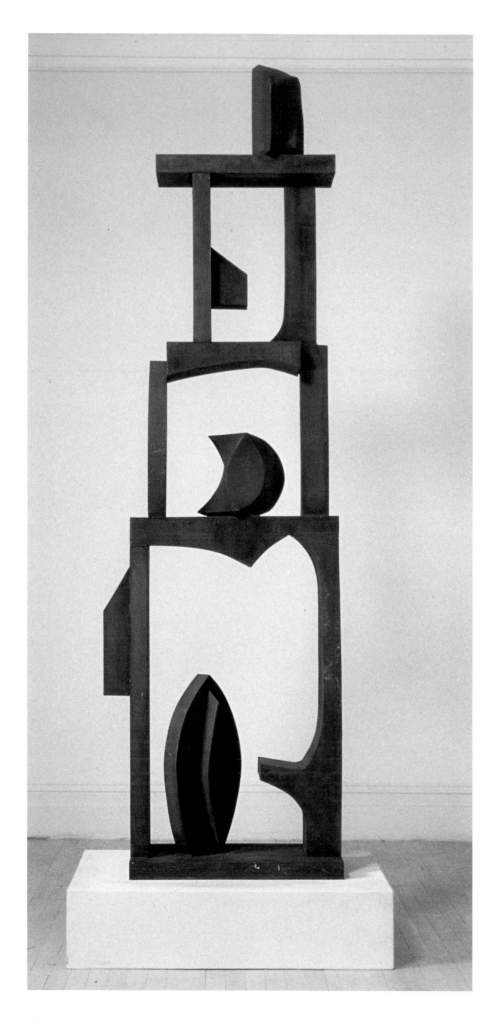

DOROTHY DEHNER

Born in Cleveland, Ohio, as early as the thirties Dorothy Dehner (1901–1994) had traveled to Paris, studied at the Art Students League in New York, and been influenced by John Graham. As a result Dehner was well aware of Cubism and African art. After their marriage in 1927, she and David Smith (see chapter 2) traveled in Europe and elsewhere, encountering surrealist work in Paris. By the time the two moved to Bolton Landing, Dehner was painting and drawing. After divorcing Smith in 1952, Dehner moved to New York, where she began to show her work and studied printmaking at Stanley Hayter's Atelier 17. At this time she began to create sculptures in wax, then moved on to bronze. Her work of the fifties and sixties has a mythical and hieroglyphic cast combined with a basic bent toward juxtaposition of horizontal and vertical elements.

In the 1980s she began to use factory fabrication to create steel sculptures related to earlier works, consisting of combinations of geometric planes. *Scaffold*, 1983 (pl. 94), exemplifies the vertical thrust of this work and its totemic associations. Though Dehner herself did not weld, she used fabrication to create a body of sensitively composed and emotionally evocative works.

HELENE BRANDT

Born in Philadelphia, Helene Brandt (b. 1936) was educated in New York at City College and Columbia University. She studied at Saint

PLATE 94
DOROTHY DEHNER
Scaffold, 1983
Cor-ten steel
72 inches high
Private collection

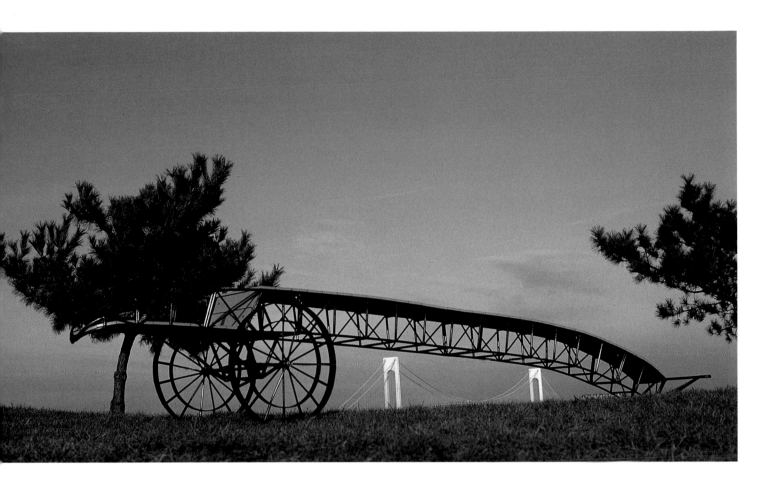

PLATE 95
HELENE BRANDT
The Portable Bridge, 1983
steel, wood
36 x 48 x 264 inches
Courtesy Steinbaum Krauss Gallery, New York

FIGURE 88
HELENE BRANDT
Hexahedrix, 1993
steel
16 x 15½ x 112½ inches
Courtesy Steinbaum Krauss Gallery, New York

Martin's School of Art in London in 1976. There she began to weld bicycle parts and other materials. Her work from 1979 to 1985 consists of skeletal cages based on her own body. After choosing a position, she would structure an encasement around it. A visit to Brandt's studio in Lower Manhattan can become a visual and kinesthetic experience. Climbing into one of her cages is an encounter with something between a carnival ride and a torture device. Welded-steel tubes form the structure that loosely encompasses the body.

Perhaps Brandt's most celebrated piece is *The Portable Bridge,* 1983 (pl. 95). Wheels bring a kinetic element into a sculpture that is powered by human energy. The piece appears architectural, like a bridge, yet the addition of wheels and a seat are vehicular. Brandt's recent work is occupied with optical illusion or the ability of sequential shapes to establish a perspective in space. *Hexahedrix,* 1993 (fig. 88), is an example of this work, which relates somewhat to the structural sequence of *The Portable Bridge.* The first bridge, however, is a physical object that can be moved, while *Hexahedrix* relates to optical effects found in painting. This direction holds untold possibilities for Brandt's future work.

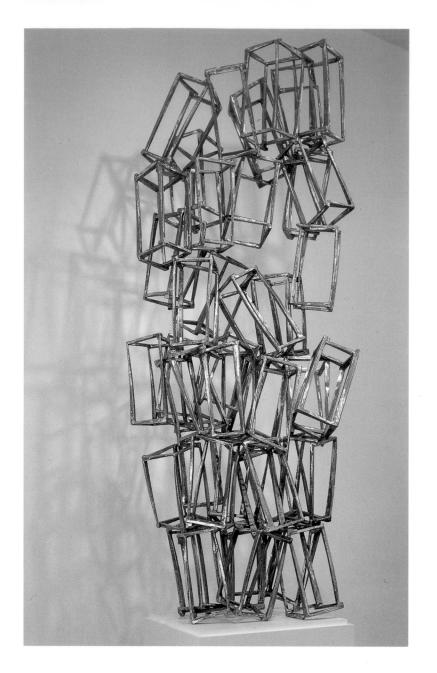

PLATE 96
JEDD NOVATT
VI, 1998
ground, welded steel
84 x 40 x 40 inches
Courtesy Salander-O'Reilly Galleries, New York

JEDD NOVATT

Basically geometric in character, the work of native New Yorker Jedd Novatt (b. 1958) consists of many rectangular outlines juxtaposed in a manner that seems to defy gravity, adding tension and a sense of precarious balance. Using a process involving ground, welded, and forged steel, Novatt creates a structural diagram in space. A piece such as *VI,* 1998 (pl. 96), illustrates the open dynamics of his work.

HOWARD McCALEBB

Howard McCalebb (b. 1947), born in Indianola, Mississippi, and now living in New York, has produced open, vertical work that thrusts dynamically upward. Smaller scale pieces such as *Balmoral,* 1981 (pl. 97), illuminate the structural and geometric character of this artist's work. His sculpture surrounds space, moving the eye about its frame.

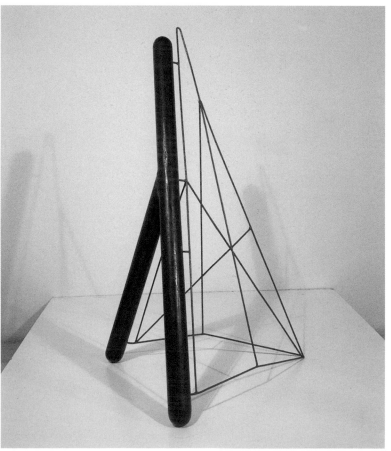

PLATE 97
HOWARD McCALEBB
Balmoral, 1981
brazed steel, painted wood
26½ x 16¼ x 14 inches
Courtesy of the artist

JONATHAN KIRK

A mainstay at the Sculpture Center in Utica, N.Y., Jonathan Kirk (b. 1957) was born in England and graduated from Saint Martin's School of Art in 1978. His is a constructivist approach to works that occupy and appear to function in space. The artist has used curvilinear as well as straight lines to suggest metaphorical contexts. *Burning Chamber*, 1993 (fig. 89), demonstrates the artist's allusion to functional machinery. The piece suggests potential use while maintaining its status as a sculptural object. Working from small models (pl. 98) to large, completed sculpture, his work spans utilitarian and artistic areas.

The foregoing array of talent illustrates some of the range available in welding, as well as a growing presence of women artists using the technique. Particular to the twentieth century, welded sculpture has moved from its utilitarian origins to imaginative realms of movement and structure. Welding has progressed quickly from a new-fangled industrial novelty to a forum for vigorous artistic experimentation. Undoubtedly, as we approach a new century, artists will continue to expand their ideas and techniques. Will welding become as venerable and widely used as bronze casting or marble carving? There is every reason to believe that such artists as those discussed here will continue to push welding forward by articulating and elaborating new visions in metal.

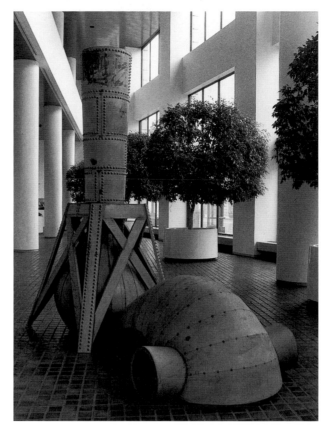

FIGURE 89
JONATHAN KIRK
Burning Chamber, 1993
painted steel
123 x 128 x 56 inches
Courtesy of the artist

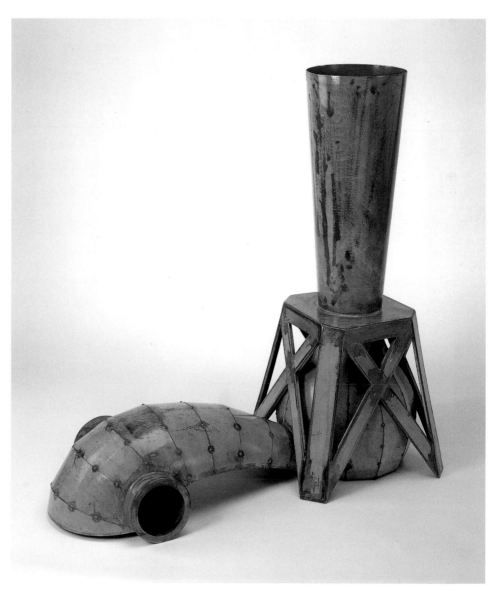

PLATE 98
JONATHAN KIRK
Model for Burning Chamber, 1993
painted steel
38 x 38 x 15 inches
Courtesy of the artist

NOTES

INTRODUCTION

1. Bernice Rose, *A Salute to Alexander Calder* (New York: Museum of Modern Art, 1969), 22.

CHAPTER 1
ORIGINS

1. Hilton Kramer, "González in Perspective," in *Julio González*, exh. cat. (New York: Galerie Chalette, 1961), 19.

2. Ibid., 23.

3. Ibid.

4. Ibid.

5. Margit Rowell, *Julio González: A Retrospective*, exh. cat. (New York: Solomon R. Guggenheim Museum, 1983), 87.

6. Ibid., 189.

7. Ibid., 16–17.

CHAPTER 2
DAVID SMITH

1. Cleve Gray, ed., *David Smith by David Smith* (New York: Holt, Rinehart and Winston, 1968), 172.

2. Edward F. Fry and Miranda McClintic, *David Smith: Painter, Sculptor, Draftsman*, exh. cat. (New York: George Braziller, 1982), 40–45.

3. Edward F. Fry, *David Smith*, exh. cat. (New York: Solomon R. Guggenheim Foundation, 1969), 23.

4. Fry and McClintic, *David Smith*, 41.

5. Karen Wilkin, *David Smith* (New York: Cross River Press, 1984), 31.

6. Ibid., 32.

7. Fry, *David Smith*, 46.

8. Ibid., 53.

9. Gray, *David Smith by David Smith*, 169.

10. Ibid., 118.

11. Fry, *David Smith*, 80.

12. Wilkin, *David Smith*, 63.

13. Fry, *David Smith*, 125.

14. Gray, *David Smith by David Smith*, 56.

15. Ibid., 162.

CHAPTER 3
POSTWAR WELDING

1. For Roszak's early years, see Joan M. Marter, "Theodore Roszak's Early Constructions: The Machine as Creator of Fantastic and Ideal Forms," *Arts Magazine* 54 (November 1979): 110–13; and Douglas Dreishpoon, *Theodore Roszak: Paintings and Drawings from the Thirties*, exh. cat. (New York: Hirschl & Adler Galleries, 1989).

2. William C. Agee, *Herbert Ferber: Sculpture, Painting, Drawing, 1945–1980*, exh. cat. (Houston: Museum of Fine Arts, 1985), 40–43.

3. Quoted in ibid., 15–16.

4. Quoted in Francis V. O'Connor, *Jackson Pollock*, exh. cat. (New York: Museum of Modern Art, 1967), 40.

5. Quoted in Dorothy C. Miller, ed., *Fifteen Americans*, exh. cat. (New York: Museum of Modern Art, 1952), 10.

6. *Seymour Lipton: Recent Works*, exh. cat. (New York: Marlborough Gallery, 1971).

7. Quoted in ibid., 4.

8. Judy Collischan Van Wagner, "The Abstractionists and the Critics, 1936–39," in *American Abstract Artists*, exh. cat. (Brookville, N.Y.: Hillwood Art Museum, Long Island University— C. W. Post Campus, 1986), 6.

9. Quoted in Dorothy C. Miller, ed., *Twelve Americans*, exh. cat. (New York: Museum of Modern Art, 1956), 65.

10. Quoted in ibid., 64.

11. Quoted in ibid., 80–82.

12. Wayne Andersen, *American Sculpture in Process: 1930/1970* (Boston: New York Graphic Society, 1975), 80–82.

13. Quoted in Andrew Carnduff Ritchie, *Sculpture of the Twentieth Century* (New York: Museum of Modern Art, 1952), 46.

14. Rosalind E. Krauss, *Passages in Modern Sculpture* (Cambridge: MIT Press, 1981), 173.

15. Michael Brenson, "Art People," *New York Times*, 12 December 1982.

16. The other two welded sculptures are *The Duchess of Alba*, 1959, Los Angeles County Museum of Art, and *Mars and Venus*, 1959–60, Albright-Knox Art Gallery, Buffalo, N.Y.

17. Robert Goldwater, "David Hare," *Art in America* 44 (winter 1956–57): 18–20.

18. Andersen, *American Sculpture*, 149–50.

19. Ibid., 136.

20. Quoted in Samella Lewis, *Richmond Barthe, Richard Hunt: Two Sculptors, Two Eras*, exh. cat. (Washington, D.C.: United States Information Agency, 1994), 20.

CHAPTER 4
KINETIC ART AND ASSEMBLAGE

1. Herbert Read, *A Concise History of Modern Sculpture* (New York: Praeger, 1964), 110.

2. Ibid., 105.

3. Krauss, *Passages in Modern Sculpture*, 207–9.

4. Pontus Hulten, *Jean Tinguely: A Magic Stronger than Death* (New York: Abbeville Press, 1987), 352.

5. George Rickey, "Kinetic Sculpture," in *Art and Artist* (Berkeley and Los Angeles: University of California Press, 1956), 112.

6. Ibid., 20.

7. Ibid., 27–28.

8. Statement in *Musical Sculpture by François and Bernard Baschet* (Chicago: Arts Club of Chicago, 1969), n.p.

9. George Rickey, "Sound Shaper," *Newsweek*, 18 October 1965, 112.

10. George Rickey, *Bernard and François Baschet: Sonorous Sculptures*, exh. cat. (New York: Staempfli Gallery, 1979), n.p.

11. Hulten, *Jean Tinguely*, 15.

12. Emmie Donadio, *Richard Stankiewicz: Sculpture in Steel*, exh. cat. (Middlebury, Vt.: Middlebury College Museum of Art, 1994), 9–10.

13. Grace Glueck, "One Man's Junk Is Another's Medium," *New York Times*, 21 March 1997.

14. Quoted in Andersen, *American Sculpture*, 103.

15. Virginia M. Zabriskie, essay in *Richard Stankiewicz: Thirty Years of Sculpture, 1952–1982*, exh. cat. (New York: Zabriskie Gallery, 1984).

16. Ibid.

17. Michael Auping, *John Chamberlain: Reliefs, 1960–1982*, exh. cat. (Sarasota, Fla.: John and Mable Ringling Museum of Art, 1982), 9.

18. Jule Sylvester and Klaus Kertess, *John Chamberlain: A Retrospective Exhibition*, exh. cat. (New York: Solomon R. Guggenheim Foundation, 1971), 26.

19. César (discussed in chapter 5) used entire crushed automobiles for sculptures, first shown in Paris in 1960.

20. Sylvester and Kertess, *John Chamberlain*, 25.

21. Eleanor Munro, *Originals: American Women Artists* (New York: Simon and Schuster, 1979), 380–81.

22. Carter Ratcliff, *Lee Bontecou*, exh. cat. (Chicago: Museum of Contemporary Art, 1972), n.p.

23. Andersen, *American Sculpture*, 127.

CHAPTER 5
ENGLISH AND EUROPEAN WELDERS

1. For details on this competition and public response to it, see Robert Burstow, "Butler's Competition Project for a Monument to 'The Unknown Political Prisoner': Abstraction and Cold War Politics," *Art History* 12, no. 4 (December 1989): 472–91. See also Joan Marter, "The Ascendancy of Abstraction for Public Art," *Art Journal* 53, no. 4 (winter 1994): 28–36.

2. Alastair Grieve, "Constructivism after the Second World War," in Sandy Nairne and Nicholas Serota, eds., *British Sculpture in the Twentieth Century,* exh. cat. (London: Whitechapel Art Gallery, 1981): 157.

3. William Rubin, *Anthony Caro,* exh. cat. (New York: Museum of Modern Art, 1975), 106.

4. Ibid., 98–99.

5. Hilton Kramer, *David Smith: A Memorial Exhibition,* exh. cat. (Los Angeles: Los Angeles County Museum of Art, 1965), 6.

6. Anthony Caro, "Some Thoughts after Visiting Florence," *Art International* 18 (May 1974): 22–23.

7. Paul Moorhouse, *Anthony Caro: Sculpture towards Architecture,* exh. cat. (London: Tate Gallery, 1991), 24.

8. Quoted in Karen Wilkin, *Isaac Witkin: The Past Decade,* exh. cat. (Hamilton, N.J.: Grounds for Sculpture, 1996), n.p.

9. William Tucker, *The Language of Sculpture* (London: Thames and Hudson, 1974; New York: Oxford University Press, 1974, as *Early Modern Sculpture*), 83.

10. Wilkin, *Isaac Witkin,* n.p.

11. Luc de Heusch, essay in *Reinhoud,* exh. cat. (New York: Lefebre Gallery, 1972).

12. Christian Dotremont, essay in *Reinhoud,* exh. cat. (New York: Lefebre Gallery, 1974).

CHAPTER 6
FORMALISM AND FABRICATION

1. Sam Hunter, essay in *Tony Smith: Ten Elements and Throwback,* exh. cat. (New York: Pace Gallery, 1979), 4.

2. Ibid., 5.

3. Quoted in ibid., 9.

4. Ibid., 8.

5. Donald Judd, "Recent Work," *Perspecta* 11 (1967): 44.

6. Quoted in Gregory Galligan, "Beverly Pepper: Meditations out of Callous Steel," *Arts Magazine* 62 (October 1987): 68.

7. *Nevelson at Purchase: The Metal Sculptures,* exh. cat. (Purchase: Neuberger Museum, State University of New York at Purchase, 1977), n.p.

8. Ibid., n.p.

9. Quoted in Leslie Schwartz, essay in *Joel Perlman: A Decade of Sculpture, 1980–90,* exh. cat. (Ithaca, N.Y.: Herbert F. Johnson Museum of Art, Cornell University, 1990), n.p.

10. Cynthia Nadelman, essay in *John Pai; One on One,* exh. cat. (New York: Sigma Gallery, 1994), 33.

11. Quoted in William Fasolino, "A Weave of Voices: On the Work of John Pai," in Yoon Soon-Young and William Fasolino, *John Pai: Sculpture, 1983–1993,* exh. cat. (Seoul: Gallery Hyundai, 1993), n.p.

12. Quoted in Yoon Soon-Young, essay in *John Pai: Down to the Wire,* exh. cat. (New York: Sigma Gallery, 1997), n.p.

13. Andersen, *American Sculpture,* 161.

14. Edward Bryant, "Jason Seley's Sculpture," in *Jason Seley,* exh. cat. (Ithaca, N.Y.: Herbert F. Johnson Museum of Art, Cornell University, 1980), n.p.

CHAPTER 7
MILLENNIAL METAL

1. Robert Hughes, "Nancy Graves: An Introduction," in E. A. Carmean, Jr., et al., *The Sculpture of Nancy Graves: A Catalogue Raisonné* (New York: Hudson Hills Press, 1987), 19.

2. Mary Stofflet, introduction to *Deborah Butterfield,* exh. cat. (San Diego, Calif.: San Diego Museum of Art, 1996), 9.

3. Quoted in ibid., 10.

GLOSSARY

Arc welding, made possible by the introduction of the coated electrode in the 1920s, is *welding* produced by a strong current of electricity. Electrical current melts the end of a rod to establish a weld. The steel rods utilized in this method are coated with *flux* and are shorter than oxyacetylene rods. Special protective helmets and garments must be used to protect the welder from ultraviolet rays. Arc welding is faster and more economical than *oxyacetylene welding* for connecting heavy steel parts.

Brazing, a method of joining two pieces of metal together, is similar to *soldering*. However, instead of an electric soldering iron or furnace, brazing utilizes propane or oxyacetylene gas. The *flux* used may be powder or flux-coated rods, or the propane torch may have a flux distributor. In brazed work the connective metal rods have a lower melting point than the metals they are intended to join. There is no need to heat to a molten state the surfaces to be connected. A propane torch is used to melt the brazing rods between parts intended for bonding (fig. 90). After brazing has taken place and the metal and the flux have hardened, flux residue must be chipped away from the new surface. Richard Lippold used soldering and brazing for his delicately precise creations (see pl. 22). The light, linear, airy effect is well served by this methodology. Theodore J. Roszak (pl. 15) and Seymour Lipton (fig. 33) used the brazing technique to cover finished surfaces. The resulting mottled effect provides a uniquely textured surface.

Chrome plating may be added to the surface of metal for its special sheen (fig. 91). Plating involves coating the surface with copper, nickel silver, and lastly chrome by

FIGURE 90 **BRAZING**

FIGURE 91 **CHROME PLATING**

an electroplating process. Exemplary is John Chamberlain's *Untitled, 1963* (fig. 49).

Fabrication in sculpture refers to the making of an object in a shop or factory setting by people with knowledge of special techniques. Artists may provide diagrams, specifications, models, or drawings from which a form is produced. Minimalist sculptors of the 1960s used fabrication for philosophical as well as artistic reasons. They wished to

remove evidence of the artist's hand, and they wanted significant scale to realize a simple object occupying a large space. Fabrication also functions in industry, in the building of airplanes, automobiles, and other manufactured goods of modern living. In art there is a degree of anonymity produced akin to that found in industrial usage.

Flux is a substance applied in *soldering* and *brazing* to portions of a surface to be joined. When heat is

applied, flux facilitates the flowing of *solder* and prevents the formation of oxide, thus promoting the union of separate pieces of metal.

Grinding and polishing are techniques employed to realize a shiny surface on steel (figs. 92, 93). David Smith used a power grinder to create a swirl pattern (fig. 29).

Heli-arc welding has been used since 1942. This method combines elements of *arc welding* and *oxyacetylene welding,* involving an arc welder transformer and gases such as helium or argon. The arc struck by touching the electrode tip against metal causes an electrical current to span the distance between rod tip and metal piece. A flow of gas surrounds the arc, protecting it from contamination and producing a shiny surface. It is a technique especially suited to welding aluminum or any pieces where precise control of heat is required.

Oxyacetylene welding utilizes the oxyacetylene torch, invented in 1900. The torch is fueled by pressurized tanks of oxygen and acetylene. Proportional amounts of these gases produce a brilliant blue flame, which is held at an angle to the surfaces to be joined (fig. 94). The flame of an ignited torch produces an area of melted metal that must be moved along the joint. A filler or welding rod adds extra enforcement. The "puddle" of liquid metal must be moved continuously for fusion to occur. An oxyacetylene torch equipped with a cutting tip can be used to sever metal.

Painting, often used to add coloration to metal sculpture, provides a protective surface, especially when the sculpture is placed outdoors. Epoxy, enamel, or lacquer paints are used. Alexander Liberman's *Odyssey* (pl. 67) has been painted, as has *Tanktotem VII* (fig. 27) by David Smith.

Solder is a metal alloy used in *soldering* metallic parts together. Solder melts more easily than the metals to which it is applied. Hard solders, consisting of silver or brass with additions of copper and zinc,

FIGURE 92 **GRINDING**

FIGURE 93 **POLISHING**

FIGURE 94 **OXYACETYLENE WELDING**

melt at relatively high temperatures. Soft solders, melting at lower levels, consist of tin and lead.

Soldering is a method of joining together metallic parts via a melted alloy, called *solder*. Soldering is a relatively simple, inexpensive means requiring only a soldering iron, solder, and rods or sheets of copper, brass, pewter, lead, or tin. Soldering copper may be electrified or heated in a small furnace. The metal area to be soldered is heated to facilitate the flow of solder. If surfaces are cold, the solder will ball up and fall away. Soldering is an exacting process requiring a pristine environment. Implements and materials must be kept pure and uncontaminated. The first step is to brush or etch the surfaces to be soldered. Then *flux,* used to prevent oxidation of fused metals, is applied and solder is melted from the soldering stick. Heat is applied to area to which solder is desired to flow. Solder will then run into the fluxed area (fig. 95). More heat is needed for thicker units, and various metals require adjustments in the flux mixture and heating process depending on their nature. Metal pieces can be soldered using different types of joints. One involves a simple overlapping of sheets or rods. The second type of joint butts one surface directly to another, and the third fuses interlocking surfaces. The latter can be achieved only with a metal bender. Clamps are used to hold metal parts together. In certain instances, solder is used to "tack" surfaces together or it is allowed to flow between joints.

Surface treatments include *chrome plating, grinding and polishing*, and *painting*. Sometimes surfaces are hammered, as in Ludvik Durchanek's *Soliloquy* (pl. 56). A torch can be used to cut into surfaces for texture and decorative appeal. In addition, found or rusted metal can be wire-brushed, heated to a dark hue, and painted with motor oil. The blackened effect appears like a warm external film

FIGURE 95 **SOLDERING**

FIGURE 96 **BLACKENING SURFACES**

(fig. 96). Another kind of coloration occurs with steel that rusts when exposed to the weather. Cor-ten is one such brand of steel that will rust only to a certain depth, ensuring the sculpture's longevity. Beverly Pepper (pl. 62) and Louise Nevelson both used Cor-ten steel for its rusting qualities.

Welding is different from *soldering* or *brazing* by virtue of its complete fusion of metal surfaces. Depending on the metal to be welded, various procedures are available to the artist—*oxyacetylene welding, arc welding,* or *heli-arc welding*. The process is a permanent joining of two pieces of metal into one. After cooling and hardening takes place, the welded joint is as strong as any other part of the metal.

BIBLIOGRAPHY

GENERAL

Alloway, Lawrence. *Topics in American Art since 1945*. New York: Norton, 1975.

Alloway, Lawrence, and Allan Kaprow. *New Forms–New Media I*. Exhibition catalogue. New York: Martha Jackson Gallery, 1960.

Andersen, Wayne. *American Sculpture in Process: 1930/1970*. Boston: New York Graphic Society, 1975.

Andrews, Oliver. *Living Materials: A Sculptor's Handbook*. Berkeley: University of California Press, 1983.

Arnason, H. H. *History of Modern Art*. New York: Harry N. Abrams, 1986.

Battcock, Gregory, ed. *Minimal Art: A Critical Anthology*. New York: Dutton, 1968.

Beardsley, John. *A Landscape for Modern Sculpture: Storm King Art Center*. New York: Abbeville Press, 1985.

Bochner, Mel. "Primary Structures." *Arts Magazine* 40 (June 1966): 32–35.

———. "The Serial Attitude." *Artforum* 6 (December 1967): 28–33.

Burnham, Jack. *Beyond Modern Sculpture: The Effects of Science and Technology on the Sculpture of This Century*. New York: George Braziller, 1968.

Busch, Julia M. *A Decade of Sculpture: The 1960s*. Philadelphia: Art Alliance Press, 1974.

Coplans, John. "Formal Art." *Artforum* 2 (summer 1964): 42–43.

———. *Serial Imagery*. Exhibition catalogue. Pasadena, Calif.: Pasadena Art Museum, 1968.

Davies, Hugh. *Artist and Fabricator*. Exhibition catalogue. Amherst: University Gallery, University of Massachusetts, 1975.

Fried, Michael. "Art and Objecthood." *Artforum* 5 (June 1967): 12–23.

Geldzahler, Henry. *New York Painting and Sculpture, 1940–1970*. Exhibition catalogue. New York: Metropolitan Museum of Art, 1969.

Goldwater, Robert. *What Is Modern Sculpture?* New York: Museum of Modern Art, 1969.

Greenberg, Clement. *Art and Culture: Critical Essays*. Boston: Beacon Press, 1961.

Hammacher, A. M. *Modern Sculpture: Tradition and Innovation*. New York: Harry N. Abrams, 1988.

Krasne, Belle. "Three Who Carry the Acetylene Torch of Modernism." *Art Digest* 25 (15 April 1951): 15.

Krauss, Rosalind E. *Passages in Modern Sculpture*. Cambridge: MIT Press, 1981.

Kultermann, Udo. *The New Sculpture: Environments and Assemblages*. New York: Praeger, 1968.

Licht, Fred. *Sculpture: Nineteenth and Twentieth Centuries*. Greenwich, Conn.: New York Graphic Society, 1967.

Lucie-Smith, Edward. *Sculpture since 1945*. New York: Universe Books, 1987.

McShine, Kynaston. *Primary Structures: Younger American and British Sculptors*. Exhibition catalogue. New York: Jewish Museum, 1966.

The Neuberger Collection: An American Collection: Paintings, Drawings, and Sculpture. Exhibition catalogue. Providence: Rhode Island School of Design, 1968.

Padovano, Anthony. *The Process of Sculpture*. New York: Da Capo Press, 1981.

Parente, Janice, and Phyllis Stigliano. *Sculpture: The Tradition in Steel*. Exhibition catalogue. Roslyn Harbor, N.Y.: Nassau County Museum of Fine Art, 1983.

Phillips, Lisa. *The Third Dimension: Sculpture of the New York School*. Exhibition catalogue. New York: Whitney Museum of American Art, 1984.

Plous, Phyllis. *7 + 5: Sculptors in the 1950s*. Exhibition catalogue. Santa Barbara: Art Galleries, University of California, 1976.

Popper, Frank. *Kinetic Art*. Greenwich, Conn.: New York Graphic Society/Studio-Vista, 1968.

Read, Herbert. *A Concise History of Modern Sculpture*. New York: Praeger, 1964.

Rickey, George. *Constructivism: Origins and Evolution*. New York: George Braziller, 1967.

Ritchie, Andrew Carnduff. *Sculpture of the Twentieth Century*. New York: Museum of Modern Art, 1952.

Robertson, Bryan, and Ann Elliot. *Sculpture at Goodwood: British Contemporary Sculpture*. West Essex, England: Goodwood, 1996.

Rose, Barbara. "ABC Art." *Art in America* 53 (October–November 1965): 57–69.

———. *American Art since 1900: A Critical History*. New York: George Braziller, 1967.

Rose, Bernice. *A Salute to Alexander Calder*. New York: Museum of Modern Art, 1969.

Rosenblum, Robert. "The American Action Painters." *Art News* 51 (December 1952): 22–23.

Sandler, Irving H. *The New York School: The Painters and Sculptors of the Fifties*. New York: Harper and Row, 1978.

Sculptural Expressions: Seven Artists in Metal and Drawing, 1947–1960. Exhibition catalogue. Bronxville, N.Y.: Sarah Lawrence College Gallery, 1985.

Seitz, Willliam C. *The Art of Assemblage*. Exhibition catalogue. New York: Museum of Modern Art, 1961.

———. *The Responsive Eye*. Exhibition catalogue. New York: Museum of Modern Art, 1965.

Seuphor, Michel. *The Sculpture of This Century*. New York: George Braziller, 1960.

Steel Sculpture. Exhibition catalogue. Antwerp: Museum of Sculpture in the Open, Middelheim, 1987.

Stein, Donna. *Ten Sculptors of the New York School*. Exhibition catalogue. Los Angeles: Manny Silverman Gallery, 1992.

Tuchman, Maurice, ed. *American Sculpture of the Sixties*. Exhibition catalogue. Los Angeles: Los Angeles County Museum of Art, 1968.

Van Wagner, Judy Collischan. "The Abstractionists and the Critics, 1936–39." In *American Abstract Artists*. Exhibition catalogue. Brookville, N.Y.: Hillwood Art Museum, Long Island University—C. W. Post Campus, 1986.

Waldman, Diane. *Transformations in Sculpture: Four Decades of American and European Art*. New York: Solomon R. Guggenheim Museum, 1985.

ROBERT ADAMS

Grieve, Alastair. "Robert Adams." *Art Monthly*, no. 121 (November 1988): 17–18.

———. *The Sculpture of Robert Adams*. London: Henry Moore Foundation and Lund Humphries Publishers, 1992.

Lewis, D. "Robert Adams." *Architectural Digest* 28 (March 1958): 120.

Spencer, Charles. "The Phenomenon of British Sculpture." *Studio International* 169, no. 863 (March 1965): 98–105.

———. "Robert Adams." *Studio International* 172, no. 882 (October 1966): 202–3.

DAVID ANNESLEY

Curtis, Penelope. *Modern British Architecture from the Collection*. London: Tate Gallery, 1988.

Nairne, Sandy, and Nicholas Serota, eds. *British Sculpture in the Twentieth Century*. Exhibition catalogue. London: Whitechapel Art Gallery, 1981.

Seymour, Anne, and Richard Morphet. *The Alistair McAlpine Gift*. Exhibition catalogue. London: Tate Gallery, 1971.

BERNARD AND FRANÇOIS BASCHET

Baschet, Bernard, and François Baschet. "Sound Sculpture: Sounds, Shapes, Public Participation, Education." *Leonardo* 20, no. 2 (1987): 107–14.

Glueck, Grace. "Sculptures that Make Music at Grippi and Waddell." *Art in America* 53 (December 1965): 123.

Grayson, John. *Sound Sculpture: A Collection of Essays by Artists Surveying the Techniques, Applications, and Future Directions of Sound Sculpture.* Vancouver, B.C.: Aesthetic Research Centre of Canada, 1975.

Muchnic, Suzanne. "François Baschet and Carol Ruth Shepherd." *Art News* 95 (November 1996): 140–41.

Musical Sculpture by François and Bernard Baschet. Chicago: Arts Club of Chicago, 1969.

Rickey, George. *Bernard and François Baschet: Sonorous Sculptures.* Exhibition catalogue. New York: Staempfli Gallery, 1979.

———. "Sound Shaper." *Newsweek,* 18 October 1965, 112.

FLETCHER BENTON

Albright, Thomas. "Fletcher Benton's Subtle Sculpture." *San Francisco Chronicle,* 10 March 1980, 46.

Burke, Diane, and Diane Ghirardo. *Fletcher Benton: Selected Works, 1964–1974.* Exhibition catalogue. Santa Clara: de Saisset, 1975.

Butterfield, Jan. "An Interview with Fletcher Benton." *Art International* 24 (November–December 1980): 126–43.

Del Parker, Marjorie. "Benton's Small Scale Sculpture." *West Art* 23, no. 8 (1985): 1.

de Sujo, Clara Diament. *Fletcher Benton.* Caracas: Estudio Actual, 1970.

Frankenstein, Alfred. "Fletcher Benton." *Art International* 20 (December 1966): 53.

Lucie-Smith, Edward. *Fletcher Benton.* With an essay by Paul J. Karlstrom. New York: Harry N. Abrams, 1991.

Monte, James. "Fletcher Benton: Studio Exhibition." *Artforum* 2 (April 1964): 14.

Nordland, Gerald. *Fletcher Benton: New Sculpture.* Exhibition catalogue. Milwaukee: Milwaukee Art Center, 1969.

HARRY BERTOIA

Harry Bertoia: An Exhibition of His Sculpture and Graphics. Exhibition catalogue. Allentown, Pa.: Allentown Art Museum, 1975.

Montgomery, Susan. "The Sound and the Surface: The Metalwork and Jewelry of Harry Bertoia." *Metalsmith* 7 (summer 1987): 22–29.

Nelson, June Kompass. *Harry Bertoia: Sculptor.* Detroit: Wayne State University Press, 1970.

Ratcliff, Carter. "Domesticated Nightmares." *Art in America* 73 (May 1985): 144–51.

LEE BONTECOU

Ashton, Dore. "Illusion and Fantasy: Lee Magica Fantasia di Lee." *Metro* 8 (April 1963).

———. "Unconventional Techniques in Sculpture: New York Commentary." *Studio International* 169 (January 1965): 23.

Dorfles, Gilo, Gerald Gassiot-Talabot, and Annette Michelson. *Lee Bontecou.* Exhibition catalogue. Paris: Galerie Ileana Sonnabend, 1965.

Field, Richard S. *Prints and Drawings by Lee Bontecou.* Exhibition catalogue. Middletown, Conn.: Davison Art Center, Wesleyan University, 1975.

Judd, Donald. "Lee Bontecou." *Arts Magazine* 39 (March–April 1965): 16–21.

Munro, Eleanor. *Originals: American Women Artists.* New York: Simon and Schuster, 1979.

Ratcliff, Carter. *Lee Bontecou.* Exhibition catalogue. Chicago: Museum of Contemporary Art, 1972.

The Sculptural Membrane. Exhibition catalogue. New York: Sculpture Center, 1986.

Towle, Tony. "Two Conversations with Lee Bontecou." *Print Collectors Newsletter* 2 (May–June 1971): 25–28.

HELENE BRANDT

Brenson, Michael. "Sculpture of Summer Is in Full Bloom: 'Bridges.'" *New York Times,* 8 July 1983, c1.

———. "Welded Sculptures by Helene Brandt." *New York Times,* 6 April 1984, c29.

Davis, Carol Becker. *Insight/On Site.* Brookville, N.Y.: Hillwood Art Museum, Long Island University—C. W. Post Campus, 1988.

Olejarz, Harold. "Bridges." *Arts Magazine* 58 (September 1983): 17.

Raven, Arlene. "Why Are You Painting Those Roses?" *Village Voice,* 13 September 1988, 103.

Van Wagner, Judy Collischan. *Lines of Vision: Drawings by Contemporary Women.* New York: Hudson Hills Press, 1989.

SIDNEY BUCHANAN

Buchanan, Sidney, with Judy K. Van Wagner. "Metal Sculptural Reliefs: Metal Paintings." *Leonardo* 10, no. 2 (spring 1977): 89–94.

———. "Sculpture: A 'Memorial' to a Tornado." *Leonardo* 12, no. 3 (summer 1979): 217.

Williams, Arthur. *Sculpture: Techniques, Forms, Content.* Worcester, Mass.: Davis Publications, 1990.

KENDALL BUSTER

Glueck, Grace. "Two Biennials." *New York Times,* 27 March 1983, b35.

Lang, Doug. "Kendall Buster and the Expanding Universe of American Art." *Washington Review,* February–March 1983, cover, 3–5.

Mahoney, Robert. "Reviews." *Arts Magazine* 61 (November 1986): 127.

Silverthorn, Jeanne. "Reviews." *Artforum* 11 (October 1983): 79.

Wilson, Janet. "Reviews." *Washington Post,* 18 July 1992, c2.

REG BUTLER

Burstow, Robert. "Butler's Competition Project for a Monument to 'The Unknown Political Prisoner': Abstraction and Cold War Politics." *Art History* 12, no. 4 (December 1989): 472–91.

Marter, Joan. "The Ascendancy of Abstraction for Public Art." *Art Journal* 53 (winter 1994): 28–36.

Penrose, Roland. Essay in *Reg Butler.* Exhibition catalogue. New York: Curt Valentin Gallery, 1955.

Reg Butler. Exhibition catalogue. London: Tate Gallery, 1984.

Reg Butler: A Retrospective Exhibition. Exhibition catalogue. Louisville, Ky.: J. B. Speed Art Museum, 1963.

DEBORAH BUTTERFIELD

Deborah Butterfield. Exhibition catalogue. Los Angeles: ARCO Center for the Visual Arts, 1981.

Deborah Butterfield. Exhibition catalogue. Winston-Salem, N.C.: Southeastern Center for Contemporary Art, 1983.

Horses: The Art of Deborah Butterfield. Exhibition catalogue. Coral Gables, Fla.: Lowe Art Museum, University of Miami, 1992.

Martin, Richard. "A Horse Perceived by Sighted Persons: New Sculptures by Deborah Butterfield." *Arts Magazine* 61 (January 1987): 73–75.

Stofflet, Mary. Introduction to *Deborah Butterfield.* Exhibition catalogue. San Diego, Calif.: San Diego Museum of Art, 1996.

Tucker, Marcia. "A Horse of a Different Color." *USAir Magazine,* June 1992, 44–50.

ANTHONY CARO

Caro, Anthony. Foreword to *Anthony Caro: Major New Work.* Exhibition catalogue. Chicago: Richard Gray Gallery, 1989.

———. "Some Thoughts after Visiting Florence." *Art International* 18 (May 1974): 22–23.

Kramer, Hilton. "Anthony Caro Adds New Forms." *New York Times,* 6 May 1977, c18.

Moorhouse, Paul. *Anthony Caro: Sculpture towards Architecture.* Exhibition catalogue. London: Tate Gallery, 1991.

Rubin, William. *Anthony Caro.* Exhibition catalogue. New York: Museum of Modern Art, 1975.

Russell, John. "Anthony Caro at Emmerich Gallery." *New York Times,* 21 March 1986, c24.

Wei, Lilly. "The Prime of Sir Anthony Caro." *Art in America* 82 (September 1994): 94–97.

CÉSAR (BALDACCINI)

Mason, Rainer Michael, ed. *César: Rétrospective des sculptures.* Exhibition catalogue. Geneva: Musée Rath, 1976.

Restany, Pierre. *César.* Exhibition catalogue. Milan: Galleria Schwarz, 1970.

———. *César.* New York: Harry N. Abrams, 1975.

———. *César: Recent Sculpture.* Exhibition catalogue. London: Hanover Gallery, 1960.

LYNN CHADWICK

Bowness, Alan. *Lynn Chadwick.* London: Methuen, 1962.

Chadwick, Lynn. "Portrait." *Das Kunstwerk* 14 (July 1960): 43.

———. "A Sculptor and His Public." *Listener* 21 (October 1954): 671–75.

Hodin, J. P. "Lynn Chadwick." *Werk* 3 (March 1957): 11–14.

Read, Herbert. *Lynn Chadwick.* Exhibition catalogue. Amriswil, Switzerland: Bodensee-Verlag, 1958.

JOHN CHAMBERLAIN

Auping, Michael. *John Chamberlain: Reliefs, 1960–1982.* Exhibition catalogue. Sarasota, Fla.: John and Mable Ringling Museum of Art, 1982.

Baker, Elizabeth C. "The Secret Life of John Chamberlain." *Art News* 68 (April 1969): 48–51, 63–64.

Canaday, John. "John Chamberlain's Sculptures." *New York Times,* 24 April 1971, A25.

Geldzahler, Henry. "Interview with John Chamberlain." In *John Chamberlain.* Exhibition catalogue. New York: Pace Gallery, 1992.

Judd, Donald. *John Chamberlain.* Exhibition catalogue. New York: Pace Gallery, 1989.

———. "Chamberlain: Another View." *Art International* 16 (January 1964): 38–39.

McGill, Douglas C. "Art People." *New York Times,* 1 August 1986, c24.

O'Doherty, Brian. *John Chamberlain.* Exhibition catalogue. New York: PaceWildenstein, 1994.

Sylvester, Julie, and Klaus Kertess. *John Chamberlain: A Catalogue Raisonné of the Sculpture, 1954–1985.* New York: Hudson Hills Press, 1986.

———. *John Chamberlain: A Retrospective Exhibition.* Exhibition catalogue. New York: Solomon R. Guggenheim Foundation 1971.

Waldman, Diane. *John Chamberlain: A Retrospective Exhibition.* Exhibition catalogue. New York: Solomon R. Guggenheim Museum, 1971.

PIETRO CONSAGRA

Carandente, Giovanni. *Mostra di Pietro Consagra.* Exhibition catalogue. Palermo, Sicily: Galleria Civica d'Arte Moderna, 1973.

Consagra. Exhibition catalogue. Rome: Marlborough-Gerson Gallery/Tiografia Christen, 1967.

De Donato, Agnese. "Don Antà: The Scale Is Immense." *Museum* (Paris) 43, no. 1 (1991): 31–32.

HAROLD COUSINS

Cousins. Exhibition catalogue. Paris: Galerie Raymond Creuge, 1955.

Cousins, Harold. *La Comédie humaine.* Brussels: Galérie Rencontre, 1977.

———. "'Plaiton' Sculpture: Its Origin and Development." *Leonardo* 4, no. 4 (1971): 351–54.

Dobson, Rona. *Three Americans in Brussels: Joan Aghib, Harold Cousins, Victor Seach.* Exhibition catalogue. Brussels: B. P. Gallery, 1985.

Hagen, Yvonne. "Four American Artists." *New York Herald Tribune,* 7 May 1958.

Harold Cousins: Sculptures—Beeldhouwerken, 1950–1975. Exhibition catalogue. Brussels: Kunsthaus, Schaerbeek, 1975.

JODY CULKIN

Glueck, Grace. "Art on the Beach: Works and Performances." *New York Times,* 5 July 1985, c14.

Phillips, Patricia. "Art on the Beach." *Artforum* 24 (November 1985): 105.

Reid, Calvin. "Jody Culkin and Miguel Ventura at Momenta Art." *Art in America* 83 (November 1995): 119.

Robinson, Walter. "The Year in Review: New Options in Sculpture." *East Village Eye,* August 1983.

HUBERT DALWOOD

Curtis, Penelope. *Modern British Architecture from the Collection.* Exhibition catalogue. London: Tate Gallery, 1988.

Nairne, Sandy, and Nicholas Serota, eds. *British Sculpture in the Twentieth Century.* Exhibition catalogue. London: Whitechapel Art Gallery, 1981.

DOROTHY DEHNER

Campbell, Lawrence. "Dorothy Dehner." *Art in America* 79 (December 1997): 119.

Cohen, Bunny H. "Dorothy Dehner at A. M. Sachs." *Art News* 83 (September 1984): 157.

De Bethune, Elizabeth. "Dorothy Dehner." *Art Journal* 53 (spring 1994): 35–37.

Diehl, Carol. "Dorothy Dehner." *Art News* 95 (June 1996): 148–49.

Johnson, Ken. "Dorothy Dehner at Twining." *Art in America* 76 (October 1988): 202–3.

Marter, Joan M. *Dorothy Dehner: Sixty Years of Art.* Exhibition catalogue. Katonah, N.Y.: Katonah Art Gallery, 1993.

O'Beil, Hedy. "Dorothy Dehner at A. M. Sachs." *Arts Magazine* 59 (September 1984): 41–42.

MARK DI SUVERO

Collins, David R. *Mark di Suvero: Twenty-five Years of Sculpture and Drawings.* Exhibition catalogue. Mountainville, N.Y.: Storm King Art Center, 1985.

Geist, Sidney. "A New Sculptor: Mark di Suvero." *Arts Magazine* 35 (December 1960): 40–43.

Hess, Thomas. "Mark Comes in Like a Lion." *New York Magazine,* 15 December 1975, 94.

Hughes, Robert. "Truth amid Steel Elephants." *Time,* 2 August 1971, 48–49.

Kozloff, Max. "Mark di Suvero: Leviathan." *Artforum* 5 (summer 1967): 41–46.

Kramer, Hilton. "Di Suvero: Sculpture of the Whitmanesque Scale." *New York Times,* 30 January 1966, 25.

Monte, James K. *Di Suvero.* Exhibition catalogue. New York: Whitney Museum of American Art, 1975.

Ratcliff, Carter. "Mark di Suvero." *Artforum* 11 (November 1972): 34–42.

———. "Taking Off: Four Sculptors and the Big New York Gesture." *Art in America* 66 (March–April 1978): 100–106.

Rosenstein, Harris. "Di Suvero: The Pressures of Reality." *Art News* 65 (February 1967): 36–39, 63–65.

GEORGE DUDDING

Brenson, Michael. "George Dudding." *New York Times,* 20 November 1987, c36.

Handy, Ellen. *George Dudding.* Exhibition catalogue. New York: David Beitzel Gallery, 1990.

———. "George Dudding." *Arts Magazine* 87 (January 1988): 105.

Heartney, Eleanor. "George Dudding." *Art News* 87 (March 1988): 204, 206.

Smith, Roberta. "George Dudding." *New York Times,* 17 March 1989, c32.

LUDVIK DURCHANEK

Baur, John I. H. *Contemporary American Sculpture: Selection I.* Exhibition catalogue. New York: Whitney Museum of American Art, 1966.

MEL EDWARDS

Brenson, Michael. "Going beyond Slickness: Sculptors Get Back to Basics." *New York Times,* 3 March 1989, c1.

———. "Sculpture: Private and Public." *New York Times,* 23 December 1988, c36.

Campbell, Mary Schmidt. Introduction to *Melvin Edwards: Sculptor.* Exhibition catalogue. New York: Studio Museum in Harlem, 1978.

Cotter, Holland. "Black Artists: Three Shows." *Art in America* 78 (March 1990): 171, 217.

Espiritu Materia. Exhibition catalogue. Caracas: Museo de Artes Visuales Alejandro Otero, 1991.

Feinberg, Jean E. Introduction to *Sculpture Update: Bertoia, Buchanan, Edwards, Mitchell.* Exhibition catalogue. Winston-Salem, N.C.: Diggs Gallery, Winston-Salem State University, 1991.

Gedeon, Lucinda H., ed. *Mel Edwards Sculpture: A Thirty-Year Retrospective, 1963 – 1991.* Purchase: Neuberger Museum, State University of New York at Purchase, 1993.

Kingsley, April. *Sculpture by Mel Edwards.* Exhibition catalogue. Trenton: New Jersey State Museum, 1981.

Mercer, Valerie J. "Sculptor's Horizons Have No Limits." *New York Times,* 3 June 1990, H12.

Patton, Sharon F. *The Decade Show.* Exhibition catalogue. New York: Studio Museum in Harlem, 1991.

Rapaport, Brooke Kamin. "Melvin Edwards: Lynch Fragments." *Art in America* 81 (March 1993): 60–65.

Wilson, Judith. "Melvin Edwards at 55 Mercer." *Art in America* 68 (October 1980): 136.

LIN EMERY

Emery, Lin, and Robert Morris. "Kinesone I: A Kinetic Sound Sculpture." *Leonardo* 19, no. 3 (1986): 207–10.

Lucie-Smith, Edward. *Lin Emery.* Exhibition catalogue. New Orleans: New Orleans Museum of Art, 1996.

CLAIRE FALKENSTEIN

Brown, Betty Ann. "The Decentered Artist." *Artweek* 20 (7 December 1989): 15–16.

Geer, Suvan. "An Emerging Dynamic." *Artweek* 19 (2 April 1988): 6.

Pincus, Robert L. "Claire Falkenstein at Jack Rutberg." *Art in America* 75 (March 1987): 145.

Plante, Michael. "Sculpture's Autre: Falkenstein's Direct Metal Sculpture and the Art Autre Aesthetic." *Art Journal* 53 (winter 1994): 66–72.

Schipper, Merle. "Claire Falkenstein." *Art News* 85 (December 1986): 26.

Williamson, Katya. "Seeking Beauty Bare." *Artweek* 17 (25 October 1986): 7.

Wolf, Toni Lesser. "Claire Falkenstein's Never-Ending Universe." *Metalsmith* 11 (summer 1991): 26–31.

HERBERT FERBER

Agee, William C. *Herbert Ferber: Sculpture, Painting, Drawing, 1945–1980.* Exhibition catalogue. Houston: Museum of Fine Arts, 1985.

Andersen, Wayne. *The Sculpture of Herbert Ferber.* Exhibition catalogue. Minneapolis: Walker Art Center, 1962.

Balken, Debra Bricker, and Phyllis Tuchman. *Herbert Ferber: Sculpture and Drawings, 1932–1983.* Exhibition catalogue. Pittsfield, Mass.: Berkshire Museum, 1984.

Berlind, Robert. "Herbert Ferber." *Art Journal* 53 (spring 1994): 45–47.

Faison, S. Lane, Jr. *New Sculpture by Herbert Ferber.* Exhibition catalogue. New York: Kootz Gallery, 1957.

———. "The Sculpture of Herbert Ferber." *College Art Journal* 17 (summer 1958): 363–71.

Ferber, Herbert. "On Sculpture." *Art in America* 42 (December 1954): 262–65, 307–8.

Goldwater, Robert. Introduction to *Herbert Ferber.* Exhibition catalogue. Bennington, Vt.: Bennington College, 1958.

Goodnough, Robert. "Ferber Makes a Sculpture." *Art News* 51 (November 1952): 40–43.

Goossen, E. C. "Environmental Sculpture." *Art International* 1 (May 1960): 70.

———. *Herbert Ferber.* New York: Abbeville Press, 1981.

Goosen, E. C., Robert Goldwater, and Irving Sandler. *Three American Sculptors: Ferber, Hare, Lassaw.* New York: Grove, 1959.

Miller, Dorothy C., ed. *Fifteen Americans.* Exhibition catalogue. New York: Museum of Modern Art, 1952.

Newman, Barnett B. *Herbert Ferber.* Exhibition catalogue. New York: Betty Parsons Gallery, 1947.

Tuchman, Phyllis. "An Interview with Herbert Ferber." *Artforum* 9 (April 1971): 52–57.

NAUM GABO

Fuchs, Heinz. *Naum Gabo: Kunsthalle Mannheim.* Exhibition catalogue. Mannheim: Kunsthalle Mannheim, 1965.

Garlake, Margaret. "Peter Lanyon's Letters to Naum Gabo." *Burlington Magazine* 137 (April 1995): 233–41.

Gibson, Eric. "Naum Gabo at the Guggenheim." *New Criterion* 4 (June 1986): 34–39.

Nash, Steven A., and Jörn Merkert, eds. *Naum Gabo: Sixty Years of Constructivism (Including the Catalogue Raisonné of the Constructions and Sculptures).* Munich: Prestel-Verlag, 1985.

Naum Gabo. Exhibition catalogue. Buffalo, N.Y.: Albright-Knox Art Gallery, 1968.

Olson, Ruth, Abraham Chanin, and Herbert Read. *Naum Gabo and Antoine Pevsner.* Exhibition catalogue. New York: Museum of Modern Art, 1948.

Sjöberg, Leif. "Naum Gabo: Some Reminiscences and an Unpublished Interview." *Structurist* 29/30 (1989–90): 86–89.

ARTHUR GIBBONS

Albee, Edward. Introduction to *Arthur Gibbons.* Exhibition catalogue. New York: Robert Freidus Gallery, 1982.

Ameringer, Will. *Arthur Gibbons: New Sculpture.* Exhibition catalogue. New York: André Emmerich Gallery, 1984.

Arthur Gibbons: New Sculpture. Exhibition catalogue. New York: André Emmerich Gallery, 1990.

Campbell, Lawrence. "Arthur Gibbons." *Art in America* 73 (September 1985): 135.

Cusick, Jessica. Essay in *Arthur Gibbons.* Exhibition catalogue. New York: Robert Freidus Gallery, 1982.

Gibbons, Arthur. *Square Bubbles.* Exhibition catalogue. Schenectady, N.Y.: Mandeville Gallery, Union College, 1996.

Raynor, Vivien. "Outdoor Home for Sculpture." *New York Times,* 12 July 1992, M12.

CHARLES GINNEVER

Alloway, Lawrence. "Charles Ginnever: Space as a Continuum. . . ." *Artforum* 78 (September 1967): 36–39.

Charles Ginnever. San Francisco: Anne Kohs and Associates, 1987.

Charles Ginnever. Exhibition catalogue. Mountainville, N.Y.: Storm King Art Center, 1980.

Charles Ginnever: Twenty Years—Twenty Works. Exhibition catalogue. New York: Sculpture Now, 1975.

Lubell, Ellen. "Charles Ginnever." *Arts Magazine* 52 (June 1978): 45.

Ratcliff, Carter. *Charles Ginnever: Large-Scale Sculpture.* Exhibition catalogue. New York: Marlborough Gallery, 1973.

———. "Ginnever's Daedalus: Beyond Right-Angled Space." *Art in America* 63 (May–June 1976): 98–100.

JULIO GONZÁLEZ

Dudley, Dorothy. "Four Post-Moderns." *Magazine of Art* 9 (September 1935): 546–47, 572.

Julio González. Exhibition catalogue. London: Tate Gallery, 1970.

Kramer, Hilton. *Julio González.* Exhibition catalogue. New York: Galerie Chalette, 1961.

Reynal, Maurice. Foreword to *J. González.* Exhibition catalogue. Paris: Galerie Percier, 1934.

Ritchie, Andrew Carnduff. *Sculpture of Julio González.* Exhibition catalogue. New York: Museum of Modern Art, 1956.

Rose, Bernice. *Julio González: Drawing for Sculpture.* Exhibition catalogue. New York: PaceWildenstein, 1995.

Rowell, Margit. *Julio González: A Retrospective.* Exhibition catalogue. New York: Solomon R. Guggenheim Museum, 1983.

Steinberg, Leo. "Julio González." *Arts Magazine* 30 (March 1956): 52–54.

Withers, Josephine. *Les Matériaux de son expression.* New York: Saidenberg Gallery, 1969.

JOSEPH GOTO

Joseph Goto. Exhibition catalogue. Providence: Museum of Art, Rhode Island School of Design, 1971.

"Joseph Goto at Frumkin Gallery." *Arts Magazine* 34 (April 1960): 56.

Sahlins, B. "Chicago: Joseph Goto." *Arts Magazine* 34 (November 1959): 21, 23.

NANCY GRAVES

Balken, Debra Bricker. *Nancy Graves: Painting, Sculpture, Drawing, 1980–1985.* Exhibition catalogue. Poughkeepsie, N.Y.: Vassar College Art Gallery, 1986.

Bourdon, David. Essay in *Nancy Graves: Paradigm and Paradox.* Exhibition catalogue. Philadelphia: Locks Gallery, 1991.

Carmean, E. A., Jr., et al. *The Sculpture of Nancy Graves: A Catalogue Raisonné.* New York: Hudson Hills Press, 1987.

Cathcart, Linda. *Nancy Graves: A Survey, 1969–1980.* Exhibition catalogue. Buffalo, N.Y.: Albright-Knox Art Gallery, 1980.

Rainer, Yvonne, and Martin W. Cassidy. *Nancy Graves: Sculpture and Drawings, 1970–71.* Exhibition catalogue. Philadelphia: Institute of Contemporary Art, 1972.

Tuchman, Phyllis. *Nancy Graves: Painting and Sculpture, 1978–82.* Exhibition catalogue. Santa Barbara: Santa Barbara Contemporary Arts Forum, 1983.

Tucker, Marcia, and Nancy Graves. *Nancy Graves: Camels.* Exhibition catalogue. New York: Whitney Museum of American Art, 1969.

DAVID HARE

Ashton, Dore. "Philosopher or Dog? A Consideration of David Hare." *Arts Magazine* 50 (May 1976): 80–81.

Campbell, Lawrence. "David Hare at Gruenebaum." *Art in America* 75 (September 1987): 184.

Goldwater, Robert. "David Hare." *Art in America* 44 (winter 1956–57): 18–20.

Goosen, E. C., Robert Goldwater, and Irving Sandler. *Three American Sculptors: Ferber, Hare, Lassaw.* New York: Grove, 1959.

Hare, David. Essay in *David Hare: Cronus, Elephants, Flying Heads.* Exhibition catalogue. Binghamton: University Art Gallery, State University of New York at Binghamton, 1983.

———. "The Myth of Originality in Contemporary Art." *Art Journal* 24 (winter 1964–65): 139–42.

———. "The Spaces of the Mind." *Magazine of Art* 43 (February 1950): 48–53.

Miller, Dorothy C., ed. *Fourteen Americans.* Exhibition catalogue. New York: Museum of Modern Art, 1946.

Rosenberg, Harold. "The Art World: American Surrealist." *New Yorker,* 24 October 1977, 155–58.

Sculpture from Surrealism. Exhibition catalogue. New York: Zabriskie Gallery, 1987.

ROBERT HUDSON

Danieli, Fidel A. "Robert Hudson." *Artforum* 6 (November 1967): 65–66.

French, Christopher C. "A Sculptor Undermined by Paint." *Artweek* 16 (7 July 1985): 1.

Hudson, Robert, and William Wiley. "It's Strange to Talk about Art . . . (A Conversation between Robert Hudson and William Wiley)." *Artweek* 22 (7 February 1991): 28.

Kuspit, Donald B. "Robert Hudson at Frumkin/Adams." *Art in America* 77 (September 1989): 206–7.

Nyo, Paula Tin. "Bright Paint, Cold Steel." *Artweek* 22 (31 January 1991): 1.

RICHARD HUNT

Flanigan, James F. Essay in *Richard Hunt: Growing Forward.* Exhibition catalogue. Notre Dame, Ind.: Snite Museum of Art, University of Notre Dame, 1996.

Glueck, Grace. "Metal Sculptures Bucking the Trends." *New York Times,* 3 January 1997, A22.

Lewis, Samella. *Richmond Barthe, Richard Hunt: Two Sculptors, Two Eras.* Exhibition catalogue. Washington, D.C.: United States Information Agency, 1994.

Lieberman, William S. *The Sculpture of Richard Hunt.* Exhibition catalogue. New York: Museum of Modern Art, 1971.

Wright, Beryl. Essay in *The Appropriate Object.* Exhibition catalogue. Buffalo, N.Y.: Albright-Knox Art Gallery.

ROBERT INDIANA

Indiana's Indianas: A Seventy-Year Retrospective of Paintings and Sculpture from the Collection of Robert Indiana. Exhibition catalogue. Rockland, Maine: William A. Farnsworth Library and Art Museum, 1982.

Mecklenburg, Virginia M. *Wood Works: Constructions by Robert Indiana.* Exhibition catalogue. Washington, D.C.: National Museum of American Art/ Smithsonian Institution Press, 1984.

Richard Stankiewicz, Robert Indiana: An Exhibition of Recent Sculptures and Paintings. Exhibition catalogue. Minneapolis: Walker Art Center, 1963.

Robert Indiana. Exhibition catalogue. Austin: University Art Museum, University of Texas at Austin, 1977.

Weinhardt, Carl J., Jr. *Robert Indiana.* New York: Harry N. Abrams, 1990.

DONALD JUDD

Agee, William C. *Don Judd.* Exhibition catalogue. New York: Whitney Museum of American Art, 1968.

Coplans, John. *Don Judd.* Exhibition catalogue. Pasadena, Calif.: Pasadena Art Museum, 1971.

Judd, Donald. *The Complete Writings of Donald Judd.* Halifax: Press of the Nova Scotia College of Art and Design, 1975.

———. "Recent Work." *Perspecta* 11 (1967): 44.

———. "Specific Objects." *Contemporary Sculpture, Arts Yearbook* 8 (1965): 74–82.

PENNY KAPLAN

Alloway, Lawrence. "Penny Kaplan." *Nation,* 23 September 1978, 284–86.

Braff, Phyllis. "Penny Kaplan." *New York Times,* 10 May 1992, M13.

Brenson, Michael. "Penny Kaplan." *New York Times,* 26 October 1984, C26.

Perreault, John. "Sculpture in the Wind." *SoHo Weekly News,* 30 June–5 July 1977.

Shirey, David. "Penny Kaplan." *New York Times,* 6 July 1980, U17.

LILA KATZEN

Comini, Alessandra. *Lila Katzen: Drawings/ Sculpture.* Exhibition catalogue. Iowa City: Museum of Art, University of Iowa, 1977.

Kuspit, Donald. Essay in *Lila Katzen: Sculpture.* Exhibition catalogue. Huntsville, Ala.: Huntsville Museum of Art, 1985.

———. Essay in *Lila Katzen: Sculpture Installation.* Exhibition catalogue. Williamsburg, Va.: Muscarelle Museum of Art, College of William and Mary, 1992.

Nemser, Cindy. "From a Conversation with Lila Katzen." *Feminist Art Journal,* summer 1974.

Raynor, Vivien. "Katzen's Monumental Sculptures." *New York Times,* 26 May 1978, C22.

Russell, John. "Recent Sculptures by Lila Katzen." *New York Times,* 3 October 1976, C15.

Self, Dana. Essay in *Lila Katzen: Force 1, Sculptures and Drawings.* Exhibition catalogue. Wichita: Edwin A. Ulrich Museum of Art, Wichita State University, 1995.

PHILLIP KING

Beaumont, Mary Rose. "Yorkshire Sculpture Park, West Britten, England." *Arts Review* 44 (August 1992): 346–47.

British Painting and Sculpture, 1960– 1970. Exhibition catalogue. London: Tate Gallery, 1970.

Finch, Paul. "Academy Forum: POPular Architecture." *Architectural Design* 62 (July–August 1992): 24–48.

Godfrey, Tony. "Mayor Rowan Gallery, Grab Gallery, London." *Art in America* 78 (December 1990): 177.

Lynton, Norbert. *Phillip King.* Exhibition catalogue. London: Arts Council of Great Britain, 1975.

Phillip King. Exhibition catalogue. Otterlo: Rijksmuseum Kröller-Müller, 1974.

Trier, Eduard. *Form and Space: Sculpture of the Twentieth Century.* New York: Praeger, 1962.

LYMAN KIPP

Bettendorf, Elizabeth. "Outdoor Museum." *Florida State Journal-Register,* 25 March 1995.

Lippard, Lucy. "New Yorker Letter: Recent Sculpture as Escape." *Art International* 10 (February 1966): 51–52.

Lobell, John. "Developing Technologies for Sculptors." *Arts Magazine* 45 (June 1971): 27–29.

Lynn, Elwyn. "Solving Problems of Sculpture." *Weekend Australian Magazine,* 31 August 1985.

Meyer, Ursula. "De-Objectification of the Object." *Arts Magazine* 44 (summer 1969): 20–22.

Saunders, Wade. "Lyman Kipp at Sculpture Now." *Art in America* 66 (August 1978): 113.

JONATHAN KIRK

Blanchfield, Joan Fiori. *Jonathan Kirk: Sculpture.* Exhibition catalogue. New York: Edith Barrett Art Gallery, 1987.

Brenson, Michael. "Outdoor Sculptures Reflect Struggles of Life in the City." *New York Times,* 15 July 1988, C1.

Glueck, Grace. "A Critic's Guide to the Outdoor Sculpture Shows." *New York Times,* 11 June 1982, 1: 2.

Mahoney, Robert. "New York in Review." *Arts Magazine* 63 (November 1988): 116.

Murray, Mary E. Essay in *Johathan Kirk: Recent Sculpture.* Exhibition catalogue. Rochester, N.Y.: Rochester Institute of Technology, 1995.

GRACE KNOWLTON

Ebony, David. "Grace Knowlton at M-13." *Art in America* 80 (November 1992): 137.

Muehlig, Linda, and Ann H. Sievers. Essays in *Grace Knowlton: Layers and Traces: An Imprecise Search for Angels.* Exhibition catalogue. Northampton, Mass.: Smith College Museum of Art, 1992.

Van Wagner, Judy Collischan. "Grace Knowlton's 'Secret Spaces.'" *Arts Magazine* 60 (April 1986): 74–75.

IBRAM LASSAW

Campbell, Lawrence. "Lassaw Makes a Sculpture." *Art News* 53 (March 1954): 24–27, 66–67.

Gatling, Eva Ingersoll. Introduction to *Ibram Lassaw.* Exhibition catalogue. Huntington, N.Y.: Hecksher Museum, 1973.

Goosen, E. C., Robert Goldwater, and Irving Sandler. *Three American Sculptors: Ferber, Hare, Lassaw.* New York: Grove, 1959.

Hunter, Sam. *The Sculpture of Ibram Lassaw.* Exhibition catalogue. Detroit: Gertrude Kasle Gallery, 1968.

Ibram Lassaw. Exhibition catalogue. Durham, N.C.: Duke University, 1963.

Lassaw, Ibram. "Color for Sculpture." *Art in America* 43 (March 1961): 48–49.

———. "Perspectives and Reflections of a Sculptor: A Memoir." *Leonardo* 1 (1968): 361.

Miller, Dorothy C., ed. *Twelve Americans.* Exhibition catalogue. New York: Museum of Modern Art, 1956.

Sawin, Martica. "Ibram Lassaw." *Arts Magazine* 30 (December 1955): 22–26.

JENNY LEE

Brenson, Michael. "Magdalena Abakanowicz, Jenny Lee, and Shigeo Toya." *New York Times,* 14 April 1989, c25.

Campbell, Lawrence. "Gabriel Kohn, Jenny Lee, and Richard Stankiewicz at Herstand." *Art in America* 76 (May 1988): 184–85.

Magnan, Kathleen Finley. "Reflections of Two Cultures." *Asian Art News,* May/June 1994, 53.

Suter, W. Noel. "Jenny Lee/Grace Borgenicht." *New York Review of Art* 1, no. 2 (April 1994).

Tully, Judd. Essay in *Jenny Lee.* Introduction by Nancy McDermott Herstand. Exhibition catalogue. New York: Arnold Herstand & Company, 1991.

———. Essay in *Jenny Lee: Song for a Sculptor.* Exhibition catalogue. New York: Grace Borgenicht Gallery, 1994.

SOL LEWITT

Arcs from Corners and Sides, Circles, and Grids and All Their Combinations. Exhibition catalogue. Bern: Bern Kunsthalle and Paul Bianchini, 1972.

Chandler, John N. "Tony Smith and Sol LeWitt: Mutations and Permutations." *Art International* (September 1968): 17–19.

Legg, Alicia, et al. *Sol LeWitt: The Museum of Modern Art, New York.* Exhibition catalogue. New York: Museum of Modern Art, 1978.

LeWitt, Sol. *Geometric Figures and Color.* New York: Harry N. Abrams, 1979.

Lippard, Lucy R. "Sol LeWitt: Non-Visual Structures." *Artforum* 5 (April 1967): 42–46.

Sol LeWitt: Wall Drawings, 1968–1984. Exhibition catalogue. Amsterdam: Stedelijk Museum, 1984.

ALEXANDER LIBERMAN

Calas, Nicolas. "Liberman's Many Faces of the Cylinder." *Arts Magazine* 45 (May 1971): 40–42.

Goosen, E. C. "Alex Liberman: American Sculptor." *Art International* 15 (October 1971): 20–25.

Hopps, Walter. Interview in *Alexander Liberman: Painting and Sculpture, 1950–1970.* Exhibition catalogue. Washington, D.C.: Corcoran Gallery of Art, 1970.

Ratcliff, Carter. "Alexander Liberman at Storm King." *Art in America* 65 (November–December 1977): 100–101.

RICHARD LIPPOLD

Campbell, Lawrence. "Lippold Makes a Construction." *Art News* 55 (October 1956): 30–32.

Lippold, Richard. "How to Make a Sculpture." *Art in America* 44 (winter 1956–57): 27–29.

———. "Sculpture?" *Magazine of Art* 44 (December 1951): 315–19.

Miller, Dorothy C., ed. *Fifteen Americans.* Exhibition catalogue. New York: Museum of Modern Art, 1952.

Richard Lippold, 1952–1962. Exhibition catalogue. New York: Willard Gallery, 1962.

Tomkins, Calvin. "Profiles: A Thing among Things." *New Yorker,* 30 March 1963, 47–107.

SEYMOUR LIPTON

Elsen, Albert. "Lipton's Sculptures as Portraits of the Artist." *Art Journal* 24 (winter 1964–65): 113–18.

———. *Seymour Lipton.* New York: Harry N. Abrams, 1968.

———. "Seymour Lipton: Odyssey of the Unquiet Metaphor." *Art International* 5 (1 February 1961): 39–44.

Lipton, Seymour. "Experience and Sculptural Form." *College Art Journal* 9 (autumn 1949): 52–54.

———. "Some Notes on My Work." *Magazine of Art* 40 (November 1947): 264–65.

Miller, Dorothy C., ed. *Twelve Americans.* Exhibition catalogue. New York: Museum of Modern Art, 1956.

Rand, H. *Seymour Lipton: Aspects of Sculpture.* Exhibition catalogue. Washington, D.C.: National Collection of Fine Arts, 1979.

Ritchie, Andrew C. "Seymour Lipton." *Art in America* 44 (winter 1957): 14–17.

Seymour Lipton: Recent Works. Exhibition catalogue. New York: Marlborough Gallery, 1971.

Van Wagner, Judy K. Collischan. *Seymour Lipton: Sculpture.* Brookville, N.Y.: Hillwood Art Museum, Long Island University—C. W. Post Campus, 1984.

KENNETH MARTIN

Curtis, Penelope. *Modern British Sculpture from the Collection.* Liverpool: Tate Gallery, 1988.

Forge, Andrew. *Kenneth Martin.* Exhibition catalogue. New Haven: Yale Center for British Art, 1979.

Grieve, Alastair. "Kenneth and Mary Martin." *Burlington Magazine* 129 (November 1987): 758–59.

———. "Towards an Art of Environment: Exhibitions and Publications by a Group of Avant-Garde Abstract Artists in London, 1951–1955." *Burlington Magazine* 132 (November 1980): 773–81.

Kenneth Martin. Exhibition catalogue. London: Tate Gallery, 1975.

Steele, Jeffrey. "Chance, Change, Choice and Order: A Structural Analysis of a Work by Kenneth Martin." *Leonardo* 24, no. 4 (1991): 407–17.

HOWARD McCALEBB

Andrews, Benny. Introduction to *Ambience/Stimuli.* Exhibition catalogue. New York: Alternative Museum, 1982.

Grove, Nancy. "Brian Gayman/Howard McCalebb." *Arts Magazine* 60 (February 1986): 104.

Raynor, Vivien. "Lehman Shows Products of Bronx Alternative Spaces." *New York Times,* 10 May 1987, wc32.

Yau, John. Essay in *Airlines.* Exhibition catalogue. Brookville, N.Y.: Hillwood Art Museum, Long Island University—C. W. Post Campus, 1989.

Zimmer, William. "Schooling Around (cont'd)." *SoHo News,* 29 October 1980, 62.

CLEMENT MEADMORE

Davies, Hugh M. "Clement Meadmore." *Arts Magazine* 51 (May 1977): 24.

Fordyce, Randy. "Geometric Magician." *Not Just Jazz: Viewpoints,* fall 1980, 4–5.

Gibson, Eric. *The Sculpture of Clement Meadmore.* New York: Hudson Hills Press, 1994.

Hannan, William. *Clement Meadmore.* Exhibition catalogue. Melbourne: Gallery A, 1959.

Hughes, Robert. "Solid Man." *Time,* 5 April 1971, 66.

Robertson, Bryan. Essay in *Clement Meadmore: Sculptures, 1966–1973.* Exhibition catalogue. New York: Max Hutchinson Gallery, 1973.

Siegel, Jeanne. "Clement Meadmore." *Art News* 72 (January 1973): 80.

———. "Clement Meadmore: Circling the Square." *Art News* 70 (February 1972): 56–59.

LÁZLÓ MOHOLY-NAGY

Kaplan, Louis. *Lázló Moholy-Nagy: Biographical Writings*. Durham, N.C.: Duke University Press, 1995.

Mansbach, Steven A. *Visions of Totality: Lázló Moholy-Nagy, Theo Van Doesburg and El Lissitzky*. Ann Arbor: University of Michigan Research Press, 1979.

Moholy-Nagy, Sibyl, and Walter Gropius. *Moholy-Nagy: Experiment in Totality*. Cambridge: MIT Press, 1969.

Norton, Deborah. "The Bauhaus Metal Workshop, 1919–1927." *Metalsmith* 7 (winter 1987): 40–45.

Passuth, Krisztina. *Moholy-Nagy*. New York: Thames and Hudson, 1987.

Senter, Terence A., and Krisztina Passuth. *Lázló Moholy-Nagy*. Exhibition catalogue. London: Arts Council of Great Britain, 1980.

ROBERT MORRIS

Compton, Michael, and David Sylvester. *Robert Morris*. Exhibition catalogue. London: Tate Gallery, 1971.

Michelson, Annette. Essay in *Robert Morris*. Exhibition catalogue. Washington, D.C.: Corcoran Gallery of Art, 1969.

Morris, Robert. "Notes on Sculpture, Part 1." *Artforum* 4 (February 1966): 42–44.

———. "Notes on Sculpture, Part 2." *Artforum* 5 (October 1966): 20–23.

Tucker, Marcia. *Robert Morris*. Exhibition catalogue. New York: Whitney Museum of American Art, 1970.

ROBERT MÜLLER

Bachmann, Dieter. "Robert Müller: Hüterseines Schlafs." *Du* 5 (May 1990): 66–78.

ROBERT MURRAY

Davies, Hugh M. "Robert Murray: Generating Sculpture from the Metal Plate." *Arts Magazine* 52 (February 1977): 127–31.

Finkelstein, Christine F. *Robert Murray*. Exhibition catalogue. Hamilton, N.J.: Grounds for Sculpture, 1997.

Greenwood, Michael. "Robert Murray: Against the Monument." *Arts Canada* 31, no. 2 (February 1974): 28–39.

Metzger, Robert P. *Robert Murray: Retrospective*. Exhibition catalogue. Reading, Pa.: Reading Public Museum, 1994.

Nasgaard, Roald. "Robert Murray at David Mirvish." *Arts Magazine* 48 (May 1974): 74.

Skoggard, Ross. "Robert Murray at Mirvish." *Art in America* 64 (January–February 1976): 105.

REUBEN NAKIAN

Arnason, H. H. "Nakian." *Art International* 7 (April 1963): 36–43.

Brenson, Michael. "Art People." *New York Times,* 12 November 1982, 3: 25.

Goldwater, Robert. "Reuben Nakian." *Quadrum* 11 (1961): 95–102.

Hess, Thomas B. "Introducing the Steel Sculpture of Nakian: The Rape of Lucrece." *Art News* 57 (November 1958): 36–39, 65–66.

———. *Nakian*. Exhibition catalogue. Washington, D.C.: Washington Gallery of Modern Art, 1963.

Kuh, Katharine. "Portraits in Paganism." *Saturday Review,* 31 July 1965, 28–29.

Nordland, Gerald. Introduction to *Reuben Nakian: Recent Works*. Exhibition catalogue. New York, Marlborough Gallery, 1982.

———. *Reuben Nakian: Sculptures and Drawings*. Exhibition catalogue. Milwaukee: Milwaukee Art Museum, 1985.

O'Hara, Frank. *Nakian*. Exhibition catalogue. New York: Museum of Modern Art, 1966.

Silberman, Robert. "Sport of the Gods." *Art in America* 74 (May 1986): 147–51.

LOUISE NEVELSON

Albee, Edward. Introduction to *Louise Nevelson: Atmospheres and Environments*. Exhibition catalogue. New York: Whitney Museum of American Art, 1980.

Friedman, Martin. *Nevelson*. Exhibition catalogue. Minneapolis: Walker Art Center, 1973.

Glimcher, Arnold. *Louise Nevelson*. New York: Praeger, 1972.

Kramer, Hilton. "Nevelson: Her Sculpture Changed the Way We Look at Things." *New York Times,* 30 October 1983, 6: 28.

Lipman, Jean. *Nevelson's World*. New York: Hudson Hills Press, 1983.

Nevelson, Louise, with Diana MacKown. *Dawns + Dusks*. New York: Charles Scribner's Sons, 1976.

Nevelson at Purchase: The Metal Sculptures. Exhibition catalogue. Purchase: Neuberger Museum, State University of New York at Purchase, 1977.

Seckler, Dorothy Gees. "The Artist Speaks: Louise Nevelson." *Art in America* 55 (January–February 1967): 33–42.

Shirey, David L. Essay in *Nevelson: Wood Sculpture and Collages*. Exhibition catalogue. New York: Wildenstein, 1980.

BARNETT NEWMAN

Alloway, Lawrence. *Barnett Newman: The Stations of the Cross*. Exhibition catalogue. New York: Solomon R. Guggenheim Museum, 1966.

Hess, Thomas B. *Barnett Newman: The Tate Gallery*. Exhibition catalogue. London: Tate Gallery, 1972.

———. *Barnett Newman by Thomas B. Hess*. New York: Walker, 1969.

Rosenberg, Harold. *Barnett Newman*. New York: Harry N. Abrams, 1978.

———. *Barnett Newman: Broken Obelisk and Other Sculptures*. Exhibition catalogue. Seattle: Henry Art Gallery/ University of Washington Press, 1971.

CLAES OLDENBURG

Johnson, Ellen H. *Claes Oldenburg*. Harmondsworth: Penguin, 1981.

Oldenburg, Claes, Germano Celant, Dieter Koepplin, and Mark Rosenthal. *Claes Oldenburg: An Anthology*. New York: Solomon R. Guggenheim Foundation, 1995.

Rose, Barbara. *Claes Oldenburg*. Exhibition catalogue. New York: Museum of Modern Art, 1969.

JOHN PAI

Cohen, Mark Daniel. "John Pai." *Review* 1 (December 1997): 12–13.

Nadelman, Cynthia. Poem and essay in *John Pai: One on One*. Exhibition catalogue. New York: Sigma Gallery, 1994.

Sharpe, Bruce E. Essay in *John Pai*. Exhibition catalogue. Seoul: Gallery Hyundai, 1996.

Soon-Young, Yoon. Essay in *John Pai: Down to the Wire*. Exhibition catalogue. New York: Sigma Gallery, 1997.

———. "Exploring the Universe within John Pai." *Koreana: Korean Art and Culture* 10, no. 2 (February 1996): 52–55.

Soon-Young, Yoon, and William Fasolino. *John Pai: Sculpture, 1983–1993*. Exhibition catalogue. Seoul: Gallery Hyundai, 1993.

EDUARDO PAOLOZZI

Curnow, Wystan. "Heads and Tales." *Studio International* 197, no. 1007 (1984): 52.

Eduardo Paolozzi. Exhibition catalogue. London: Arts Council of Great Britain, 1977.

Eduardo Paolozzi: Recurring Themes. Lyons, France: Musée Saint-Pierre, 1985.

Kirkpatrick, Diane. *Eduardo Paolozzi*. London: Studio Vista, 1970.

Overy, Paul. "The Britishness of Sculpture." *Studio International* 200, no. 1018 (November 1987): 9–13.

Sylvester, David. Introduction to *Paolozzi and Turnbull*. Exhibition catalogue. London: Hansher Gallery, 1950.

Whitford, Frank. Essay in *Eduardo Paolozzi*. Exhibition catalogue. London: Tate Gallery, 1971.

BEVERLY PEPPER

Baker, Kenneth. "Interconnections: Beverly Pepper." *Art in America* 72 (April 1984): 176–79.

Cohen, Ronny. Introduction to *Beverly Pepper: Umbrian Altars and Ritual Sculpture*. Exhibition catalogue. New York: André Emmerich Gallery, 1986.

Fry, Edward. *Beverly Pepper*. Exhibition catalogue. San Francisco: San Francisco Museum of Art, 1976.

Galligan, Gregory. "Beverly Pepper: Meditations out of Callous Steel." *Arts Magazine* 62 (October 1987): 68–69.

Glueck, Grace. "Beverly Pepper." *New York Times,* 30 December 1983, c21.

Hughes, Robert. "A Red Hot Mamma Returns." *Time,* 16 June 1975, 51.

Pepper, Beverly. "Space, Time, and Nature in Monumental Sculpture." *Art Journal* 37 (spring 1978): 251.

Ratcliff, Carter. Introduction to *Beverly Pepper: Tall Wall Reliefs, Sentinels and Columns.* Exhibition catalogue. New York: André Emmerich Gallery, 1990.

Sheffield, Margaret. "Beverly Pepper's New Sculpture." *Arts Magazine* 15 (September 1979): 172–73.

Stevens, Mark. Introduction to *Beverly Pepper: Private-Scale Sculpture, 1966–1987.* Exhibition catalogue. New York: André Emmerich Gallery, 1987.

JOEL PERLMAN

Brenson, Michael. "Joel Perlman." *New York Times,* 31 May 1985, c22.

Frackman, Noel. "Joel Perlman." *Arts Magazine* 53 (September 1978): 26.

Horowitz, Glenn. "Joel Perlman." Interview in *Joel Perlman: Small Sculpture, 1981–1996.* East Hampton, N.Y.: Glenn Horowitz Bookseller, 1996.

Masheck, Joseph. "Five Sculptors." *Artforum* 54 (April 1972): 72.

Messinger, Lisa Mintz. Essay in *Joel Perlman.* Exhibition catalogue. New York: André Emmerich Gallery, 1985.

Schwartz, Leslie. Essay in *Joel Perlman: A Decade of Sculpture, 1980–90.* Exhibition catalogue. Ithaca, N.Y.: Herbert F. Johnson Museum of Art, Cornell University, 1990.

ANTOINE PEVSNER

Olson, Ruth, Abraham Chanin, and Herbert Read. *Naum Gabo and Antoine Pevsner.* Exhibition catalogue. New York: Museum of Modern Art, 1948.

Sims, Lowery Stokes. "Fresco, Fauna of the Ocean." *Metropolitan Museum of Art Bulletin* 48 (fall 1990): 71.

Weber, Nicholas Fox. "Art: Russian Constructivism, Dynamic Aesthetic of a Revolutionary Era." *Architectural Digest* 50 (November 1993): 162–65.

JUDY PFAFF

Brenson, Michael. "Painted Forms: Recent Metal Sculpture." *New York Times,* 4 January 1991, c20.

Gardner, Helen. *Art through the Ages.* 9th ed. San Diego: Harcourt Brace & Company, 1991.

Gedeon, Lucinda. *Inspired by Nature.* Exhibition catalogue. Purchase: Neuberger Museum, Purchase College, State University of New York, 1994.

Marshall, Richard. *Immaterial Objects.* Exhibition catalogue. New York: Whitney Museum of American Art, 1992.

Phillips, Patricia C. "Sculptors Drawings: Marking Time and Space." *Sculpture* 14 (January–February 1995): 33–37.

Raven, Arlene. "Double Bed." *Village Voice,* 10 March 1992, 91.

Remer, Abby. *Pioneering Spirits: The Lives and Times of Remarkable Woman Artists in Western History.* Worcester, Mass.: Davis Publications, 1997.

Stein, Judith. *Judy Pfaff: New Work.* Exhibition catalogue. Philadelphia: Pennsylvania Academy of the Fine Arts, Morris Gallery, Fabric Workshop, 1991.

Talalay, Marjorie, Anselm Talalay, and Ellen Landau. *Twenty-five Years: A Retrospective.* Exhibition catalogue. Cleveland: Cleveland Center for Contemporary Art, 1993.

PABLO PICASSO

Barr, Alfred H., Jr. *Picasso: Fifty Years of His Art.* Exhibition catalogue. New York: Museum of Modern Art, 1946.

Cocteau, Jean. *Pablo Picasso.* Paris: Somogy, 1975.

Gimenez, Carmen, ed. *Picasso and the Age of Iron.* Exhibition catalogue. New York: Solomon R. Guggenheim Museum, 1993.

Johnson, Ron. *The Early Sculpture of Picasso.* New York: Garland, 1976.

Kahnweiler, Daniel-Henri. *The Sculptures of Picasso.* London: R. Phillips, 1949.

Penrose, Roland. Introduction to *Picasso: Sculpture, Ceramics, Graphic Work.* Exhibition catalogue. London: Tate Gallery, 1967.

———. *Picasso: His Life and Work.* London: Vicor Gollancz, 1958.

———. *The Sculpture of Picasso.* Exhibition catalogue. New York: Museum of Modern Art, 1967.

Penrose, Roland, and John Golding, eds. *Picasso in Retrospect.* New York: Praeger, 1973.

Picasso from the Musée Picasso, Paris. Exhibition catalogue. Minneapolis: Walker Art Center, 1980.

Spies, Werner. *Sculpture by Picasso.* New York: Harry N. Abrams, 1971.

PETER REGINATO

Clothier, Peter. Essay in *Peter Reginato: Recent Sculpture.* Exhibition catalogue. New York: Adelson Galleries and William Beadleston, 1992.

Firestone, Evan. "Three Musicians at the Harlequin's Carnival: Peter Reginato's New Sculpture." *Arts Magazine* 59 (February 1985): 116–19.

Gardner, Paul. Essay in *Peter Reginato: New Sculpture.* Exhibition catalogue. New York: Patricia Hamilton, 1989.

Hamilton, Patricia. Introduction to *Peter Reginato: New Sculpture.* Exhibition catalogue. Chicago: Patricia Hamilton, 1988.

Peter Reginato, 1994. Exhibition catalogue. New York: Adelson Galleries and William Beadleston, 1994.

Ratcliff, Carter. "Reginato's Improvisations." *Art in America* 77 (December 1989): 146–51.

Tuchman, Phyllis. Essay in *Peter Reginato: New Sculpture.* Exhibition catalogue. Los Angeles: Patricia Hamilton, 1986.

REINHOUD (D'HAESE)

de Heusch, Luc. Essay in *Reinhoud.* Exhibition catalogue. New York: Lefebre Gallery, 1972.

Dotremont, Christian. Essay in *Reinhoud.* Exhibition catalogue. New York: Lefebre Gallery, 1974.

GEORGE RICKEY

Adlow, Dorothy. "Rickcy's Kinetic Sculptures." *Christian Science Monitor,* 17 January 1959.

George Rickey. New York: Maxwell Davidson Gallery and Zabriskie Gallery, 1986.

George Rickey: Kinetic Sculptures. Exhibition catalogue. Boston: Institute of Contemporary Art, 1964.

George Rickey in Berlin. Exhibition catalogue. Berlin: Ars Nicolai, 1992.

Kramer, Hilton. "Art: The Mobiles of George Rickey." *New York Times,* 26 April 1975, 19.

Nestler, Peter. *George Rickey in Köln.* Exhibition catalogue. Cologne: Moderne Stadt, 1992.

Piene, Nan R. "Going with the Wind: Rickey's 'Lines' and 'Planes.'" *Art in America* 63 (November–December 1975): 89–93.

Rickey, George. "Kinetic Sculpture." In *Art and Artist.* Berkeley and Los Angeles: University of California Press, 1956.

———. "Sound Shaper." *Newsweek,* 18 October 1965, 112.

Rosenthal, Nan. *George Rickey.* New York: Harry N. Abrams, 1976.

Schmied, Wieland, ed. *George Rickey: Skulpturen, Material, Technik.* Exhibition catalogue. Berlin: Amerika Haus, 1979.

Secunda, A. "Two Motion Sculptors: Tinguely and Rickey." *Artforum* 1 (June 1962): 16–18.

JAMES ROSATI

Ashton, Dore. Introduction to *James Rosati: Recent Sculpture.* Exhibition catalogue. New York: Otto Gerson Gallery, 1962.

———. "James Rosati—World of Inner Rhythms." *Studio* 167 (May 1964): 196–99.

Kramer, Hilton. "The Sculpture of James Rosati." *Arts Magazine* 33 (March 1959): 26–31.

McGill, Douglas. "James Rosati, 76, Sculptor Noted for Monumental Works, Is Dead." *New York Times,* 27 February 1988, 12.

Rose, Barbara. "Blow Up: The Problem of Scale in Sculpture." *Art in America* 56 (July–August 1968): 80–91.

Seitz, William C. Introduction to *James Rosati: Sculpture, 1963–1969.* Exhibition catalogue. Waltham, Mass.: Rose Art Museum, Brandeis University, 1969.

THEODORE ROSZAK

Arnason, H. H. "Growth of a Sculptor: Theodore Roszak." *Art in America* 44 (winter 1956–57): 21–23, 61– 64.

———. *Theodore Roszak.* Exhibition catalogue. Minneapolis: Walker Art Center, 1956.

Dreishpoon, Douglas. *Theodore Roszak: Paintings and Drawings from the Thirties.* Exhibition catalogue. New York: Hirschl & Adler Galleries, 1989.

Griffin, Howard. "Totems in Steel." *Art News* 55 (October 1956): 34–35, 64–65.

Marter, Joan M. "Theodore Roszak's Early Constructions: The Machine as Creator of Fantastic and Ideal Forms." *Arts Magazine* 54 (November 1979): 110–13.

McBride, Henry. "Roszak's Moral Lesson." *Art News* 50 (May 1951): 46.

Miller, Dorothy C., ed. *Fourteen Americans.* Exhibition catalogue. New York: Museum of Modern Art, 1946.

Pachner, Joan. "Theodore Roszak and David Smith: A Question of Balance." *Arts Magazine* 58 (February 1984): 102–13.

Roszak, Theodore. *In Pursuit of an Image.* Chicago: Art Institute of Chicago, Time to Time Publications, 1955.

———. "Some Problems of Modern Sculpture." *7 Arts,* March 1955, 58–68.

Sawin, Martica. "Theodore Roszak: Craftsman and Visionary." *Arts Magazine* 31 (November 1956): 18–19.

CHRISTY RUPP

Cembalest, Robin. "A Sewage Plant Grows in Brooklyn." *Art News* 90 (April 1991): 55–56.

"Christy Rupp at Williams College." *Flash Art* 159 (summer 1991): 153.

Cyphers, Peggy. "Christy Rupp." *Arts Magazine* 64 (May 1990): 114.

Kaplos, Janet. "Christy Rupp." *Art in America* 78 (October 1990): 203–4.

Upshaw, Reagan. "Christy Rupp." *Art in America* 82 (July 1994): 87–88.

JASON SELEY

Battcock, Gregory. "New York Developments." *Art and Artists* 9 (February 1975): 4.

Bryant, Edward. "Jason Seley's Sculpture." In *Jason Seley.* Exh. cat. Ithaca, N.Y.: Herbert F. Johnson Museum of Art, Cornell University, 1980.

Genauer, Emily. "Art and the Artist." *New York Post,* 28 December 1974.

Gruen, John. "On Art." *SoHo Weekly News,* 12 December 1974.

Jason Seley. Exhibition catalogue. Hanover, N.H.: Jaffe-Friede Gallery, Dartmouth College, 1968.

Miller, Dorothy C., ed. *Americans 1963.* Exhibition catalogue. New York: Museum of Modern Art, 1963.

Selz, Peter. *Jason Seley.* Exhibition catalogue. Ithaca, N.Y.: Andrew Dickson White Museum of Art, Cornell University, 1965.

DAVID SMITH

Carmean, E. A., Jr. *David Smith.* Exhibition catalogue. Washington, D.C.: National Gallery of Art, 1982.

Cone, Jane Harrison. Introduction to *David Smith, 1906–1965: A Retrospective Exhibition.* Exhibition catalogue. Cambridge: Fogg Art Museum, Harvard University, 1966.

Cummings, Paul. *David Smith: The Drawings.* Exhibition catalogue. New York: Whitney Museum of American Art, 1979.

de Kooning, Elaine. "David Smith Makes a Sculpture." *Art News* 50 (September 1951): 38–41, 50–51.

Fry, Edward F. *David Smith.* Exhibition catalogue. New York: Solomon R. Guggenheim Museum, 1969.

Fry, Edward F., and Miranda McClintic. *David Smith: Painter, Sculptor, Draftsman.* Exhibition catalogue. New York: George Braziller/Hirshhorn Museum and Sculpture Garden, 1982.

Gray, Cleve, ed. *David Smith by David Smith.* New York: Holt, Rinehart and Winston, 1968.

Kramer, Hilton. *David Smith: A Memorial Exhibition.* Exhibition catalogue. Los Angeles: Los Angeles County Museum of Art, 1965.

———. "The Sculpture of David Smith." *Arts Magazine* 34 (February 1960): 22–43.

Krauss, Rosalind E. "The Essential David Smith, Part 1." *Artforum* 7 (February 1969): 24–26.

———. "The Essential David Smith, Part 2." *Artforum* 7 (April 1969): 34–41.

———. *The Sculpture of David Smith: A Catalogue Raisonné.* New York: Garland, 1977.

———. *Terminal Iron Works: The Sculpture of David Smith.* Cambridge: MIT Press, 1971.

Marcus, Stanley E. *David Smith: The Sculptor and His Work.* Ithaca, N.Y.: Cornell University Press, 1983.

McCoy, Garnett. *David Smith.* London: Allen Lane, 1975.

Pachner, Joan. "Theodore Roszak and David Smith: A Question of Balance." *Arts Magazine* 58 (February 1984): 102–13.

Smith, David. "González: First Master of the Torch." *Art News* 54 (February 1956): 34–37, 64–65.

———. "Notes on My Work." *Arts Magazine* 34 (February 1960): 44.

———. "Second Thoughts on Sculpture." *College Art Journal* 13 (spring 1954): 203–7.

———. "Thoughts on Sculpture." *College Art Journal* 13 (February 1954): 96–100.

Smith, David, and Sidney Geist. "Sculpture and Architecture." *Arts Magazine* 31 (May 1957): 20–21, 64.

Wilkin, Karen. *David Smith.* New York: Cross River Press, 1984.

TONY SMITH

Baro, Gene. "Tony Smith: Toward Speculation in Pure Form." *Art International* 11 (summer 1967): 27–30.

Chandler, John N. "Tony Smith and Sol LeWitt: Mutations and Permutations." *Art International* (September 1968): 17–19.

Friedman, Martin. Foreword to *Tony Smith: Recent Sculpture.* Interview by Lucy Lippard. New York: M. Knoedler & Company, 1971.

Goossen, Eugene C. Introduction to *Tony Smith.* Exhibition catalogue. Newark, N.J.: Newark Museum, 1970.

Hunter, Sam. Essay in *Tony Smith: Ten Elements and Throwback.* Exhibition catalogue. New York: Pace Gallery, 1979.

Lippard, Lucy R. *Tony Smith.* New York: Harry N. Abrams, 1972.

———. "Tony Smith: 'The Ineluctable Modality of the Visible.'" *Art International* 11 (summer 1967): 24–26.

Wagstaff, Samuel, Jr. *Tony Smith: Two Exhibitions of Sculpture.* Exhibition catalogue. Hartford, Conn.: Wadsworth Atheneum, 1967.

ANN SPERRY

Kingsley, April, and John Perreault. Essays in *Ann Sperry: A Twelve-Year Survey.* Exhibition catalogue. New York: Sculpture Center, 1987.

Phillips, Patricia C. "Meditations on Metal." *Sculpture* 15 (October 1996): 19–23.

Princenthal, Nancy. Essay in *Ann Sperry: Personal Interiors, New Sculpture.* Exhibition catalogue. New York: A.I.R. Gallery, 1992.

Stein, Judith. "Flowering: The Recent Sculpture of Ann Sperry." *Arts Magazine* 56 (April 1982): 68–69.

Van Wagner, Judy K. Collischan. Essay in *Ann Sperry/Barbara Zucker: A Decade of Work.* Exhibition catalogue. Brookville, N.Y.: Hillwood Art Museum, Long Island University—C. W. Post Campus, 1984.

RICHARD STANKIEWICZ

Campbell, Lawrence. "Gabriel Kohn, Jenny Lee, and Richard Stankiewicz at Herstand." *Art in America* 76 (May 1988): 184–85.

Donadio, Emmie. *Richard Stankiewicz: Sculpture in Steel.* Exhibition catalogue. Middlebury, Vt.: Middlebury College Museum of Art, 1994.

Geist, Sidney. "Stankiewicz: Miracle in the Scrapheap." *Art Digest* 28 (1 December 1953): 10.

Glueck, Grace. "One Man's Junk Is Another's Medium." *New York Times,* 21 March 1997.

Kramer, Hilton. "Art: New Power in Old Metal." *New York Times,* 8 April 1977, c21.

Phillips, Deborah. "Sculpture from the Scrap Heap." *Art News* 84 (March 1985): 87–89.

Porter, Fairfield. "Stankiewicz Makes a Sculpture." *Art News* 54 (September 1955): 36–39.

Richard Stankiewicz, Robert Indiana: An Exhibition of Recent Sculptures and Paintings. Exhibition catalogue. Minneapolis: Walker Art Center, 1963.

Sandler, Irving. "Stankiewicz's 'Personages.'" *Art in America* 68 (January 1980): 84–87.

Sawin, Martica. "Richard Stankiewicz." *Arts Yearbook* 3 (1959): 157–59.

Stankiewicz, Richard. "The Prospects for American Art." *Arts Magazine* 30 (September 1956). 16–17.

Wright, Clifford. "Stankiewicz, Junk Poet." *Studio International* 164 (July 1962): 2–5.

Zabriskie, Virginia M. Essay in *Richard Stankiewicz: Thirty Years of Sculpture, 1952–1982.* Exhibition catalogue. New York: Zabriskie Gallery, 1984.

FRANK STELLA

Frackman, Noel. "Tracking Frank Stella's Circuit Series." *Arts Magazine* 56 (April 1982): 134–37.

Hopkins, Budd. "Frank Stella's New York: A Personal Note." *Artforum* 15 (December 1976): 58–59.

Kimmelman, Michael. "Frank Stella Crosses the Sculpture Threshold." *New York Times,* 16 October 1992, c27.

Leider, Philip. "Stella since 1970." *Art in America* 66 (March–April 1978): 120, 123–30.

Ratcliff, Carter. "Frank Stella: Portrait of the Artist as an Image Administrator." *Art in America* 73 (February 1985): 95–106.

Rubin, William S. *Frank Stella.* Exhibition catalogue. New York: Museum of Modern Art, 1970.

LESLIE THORNTON

Pacher, William. "Leslie Thornton." *Arts Review* 21 (25 October 1969): 686.

JEAN TINGUELY

Ashton, Dore. "Tinguely at the Staempfli Gallery." *Arts and Architecture* 78 (June 1961): 5.

Canaday, John. "Machine Tries to Die for Its Art." *New York Times,* 18 March 1960, 27.

Hulten, Pontus. *Jean Tinguely: A Magic Stronger than Death.* New York: Abbeville Press, 1987.

Michaud, E. *Jean Tinguely.* Paris: Centre of Research on Contemporary Art, 1970.

Secunda, A. "Two Motion Sculptors: Tinguely and Rickey." *Artforum* 1 (June 1962): 16–18.

Sekler, D. G. "Audience Is His Medium." *Art in America* 51 (April 1963): 62–67.

Sweeney, James Johnson. Introduction to *Jean Tinguely: Sculpture.* Exhibition catalogue. Houston: Museum of Fine Arts, 1965.

Thabit, W. "The Tinguely Machine." *Village Voice,* 30 March 1960, 4.

Tomkins, Calvin. "A Profile of Jean Tinguely: Beyond the Machine." *New Yorker* 37, no. 52 (10 February 1962): 44–93.

LEE TRIBE

Brenson, Michael. "Lee Tribe." *New York Times,* 7 November 1986, 3: 26.

———. "Welded Steel from Lee Tribe." *New York Times,* 28 June 1991, c21.

Carter, Anthony. Essay in *Lee Tribe: Sculpture.* Exhibition catalogue. New York: Victoria Munroe, 1988.

Cyphers, Peggy. "Lee Tribe." *Arts Magazine* 63 (February 1989): 101.

Oxlade, Roy. "British Artists in New York." *Modern Painters* 3, no. 3 (March 1990).

Princenthal, Nancy. "Lee Tribe at Robert Morrison and Victoria Munroe." *Art in America* 82 (July 1994): 89.

Wilkin, Karen. "At the Galleries." *Partisan Review* 57, no. 3 (summer 1990): 444–55.

WILLIAM TUCKER

Ashton, Dore. "William Tucker: New Sculpture," *Arts Magazine* 61 (June 1987): 84–85.

Goodman, Jonathan. "William Tucker, McKee Gallery." *Art News* 93 (May 1994): 159–60.

Sculpture 1970–73. London: Arts Council of Great Britain, 1973.

Tucker, William. *Early Modern Sculpture: Rodin, Degas, Matisse, Brancusi, Picasso,*

González. New York: Oxford University Press, 1974.

———. *The Language of Sculpture.* London: Thames and Hudson, 1974.

WILLIAM TURNBULL

Alloway, Lawrence. "Sculpture and Painting of William Turnbull." *Art International* (1 February 1961): 46–52.

Baro, Gene. "Changed Englishman: William Turnbull." *Art in America* 54 (March–April 1966): 102–3.

Bowness, Alan. *William Turnbull.* Exhibition catalogue. São Paulo: British section, IX São Paulo Bienal, 1967.

Cohen, Bernard. "William Turnbull: Painter and Sculptor." *Studio International* 186, no. 20 (July–August 1973): 9–16.

Morphet, Richard. *William Turnbull: Sculpture and Painting.* Exhibition catalogue. London: Tate Gallery, 1973.

Sylvester, David. Introduction to *Paolozzi and Turnbull.* Exhibition catalogue. London: Hansher Gallery, 1950.

ISAAC WITKIN

Canaday, John. "Isaac Witkin at Elkon." *New York Times,* 22 May 1971, B27.

Glueck, Grace. "Isaac Witkin's Lyrical Sculpture." *New York Times,* 3 May 1985, c23.

Isaac Witkin: Small Sculpture. Exhibition catalogue. Philadelphia: Locks Gallery, 1993.

Mellow, James. "Isaac Witkin: A Formidable Talent." *New York Times,* 16 November 1969, B25.

Raynor, Vivien. "A Sculptor of Welded Steel." *New York Times,* 10 February 1978, c18.

Sandler, Irving. "Isaac Witkin at Robert Elkon." *Art in America* 61 (September–October 1973): 110–11.

Wilkin, Karen. *Isaac Witkin.* New York: Hudson Hills Press, 1998.

———. *Isaac Witkin: The Past Decade.* Exhibition catalogue. Hamilton, N.J.: Grounds for Sculpture, 1996.

INDEX

Page numbers in *italics* refer to illustrations.

CREDITS

© 1996 Whitney Museum of American Art: plate 40.

© 1998 Museum Associates, Los Angeles County Museum of Art: figure 37.

© 1998 Sol LeWitt/Artists Rights Society (ARS), New York: figure 70.

© 1998 Frank Stella/Artists Rights Society (ARS), New York: plate 79.

© 2000 Artists Rights Society (ARS), New York/ADAGP, Paris: figures 6–10, 15, 17, 43.

© 2000 Artists Rights Society (ARS), New York/DACS, London: plate 44.

© 2000 Estate of Louise Nevelson/Artists Rights Society (ARS), New York: figure 81.

© 2000 Estate of Tony Smith/Artists Rights Society (ARS), New York: figures 64, 66.

© 2000 The Museum of Modern Art, New York: figures 31, 39, 52, 56; plates 15, 21, 22, 26, 35.

© 2000 The Willem de Kooning Revocable Trust/Artists Rights Society (ARS), New York: plate 39.

© Archives of Lincoln Center for the Performing Arts, Inc.: figure 33.

© Piermarco Menini: figure 38.

© Metropolitan Museum of Art: figure 79.

© The Solomon R. Guggenheim Foundation, New York: figure 1.

© Tate Gallery, London: figures 42, 53, 57.

© Whitney Museum of American Art: figures 16, 35, 49, 50, 69, 77.

Photograph © 1997 The Detroit Institute of Arts; work © Estate of David Smith/Licensed by VAGA, New York, New York: figure 29.

Photograph © 1998 Whitney Museum of American Art; work © 2000 Barnett Newman Foundation/Artists Rights Society (ARS), New York: figure 67.

Photograph © 1998 Whitney Museum of American Art; work © Estate of David Smith/Licensed by VAGA, New York, New York: figure 26; plate 11.

Photograph © 1998 Whitney Museum of American Art; work © Estate of Donald Judd/Licensed by VAGA, New York, New York: figure 68.

Photograph © 1998 Whitney Museum of American Art; work © 2000 Estate of Tony Smith/Artists Rights Society (ARS), New York: figure 65.

Photograph © 2000 The Museum of Modern Art, New York; work © 2000 Artists Rights Society (ARS), New York/ADAGP, Paris: figures 12–14, 19; plate 3.

Photograph © 2000 The Museum of Modern Art, New York; work © 2000 Artists Rights Society (ARS), New York/DACS, London: plates 43, 62, 63.

Photograph © 2000 The Museum of Modern Art, New York; work © 2000 Artists Rights Society (ARS), New York/Pro-Litteris, Zurich: plate 29.

Photograph © 2000 The Museum of Modern Art, New York; work © 2000 Estate of Pablo Picasso/Artists Rights Society (ARS), New York: plate 1.

Photograph © 2000 The Museum of Modern Art, New York; work © 2000 Joseph Goto/Licensed by VAGA, New York, New York: figure 40.

Photograph © Réunion des Musées Nationaux, Paris; work © 2000 Estate of Pablo Picasso/Artists Rights Society (ARS), New York: figure 3; plates 4, 5.

Photograph © Servei Fotogràfic Museum Nacional d'Art de Catalunya; work © 2000 Artists Rights Society (ARS), New York/ADAGP, Paris: figures 4, 5.

Photograph © The Solomon R. Guggenheim Foundation, New York; work © 2000 Artists Rights Society (ARS), New York/ADAGP, Paris: plate 28.

Photograph © The Solomon R. Guggenheim Foundation, New York; work © Estate of David Smith/Licensed by VAGA, New York, New York: plate 13.

Photograph © Tate Gallery, London; work © 2000 Anthony Caro/Licensed by VAGA, New York, New York: figures 58, 60; plate 46.

Photograph © Tate Gallery, London; work © 2000 Artists Rights Society (ARS), New York/ADAGP, Paris: figure 11.

Photograph © Whitney Museum of American Art; work © 2000 Estate of Alexander Calder/Artists Rights Society (ARS), New York: figure 20.

Photograph courtesy Burlington Industries, Inc., Greensboro, N.C.: figure 45.

Photograph courtesy The Studio Museum in Harlem, New York: plates 24, 25.

PHOTOGRAPHY

Oliver Baker: figure 55.

Ricardo Blanc: plate 7.

Robin Brown: plate 95.

Geoffrey Clements: figures 16, 23, 24, 35, 40, 49, 67–69, 77.

Dennis Cowley: plate 84.

Patrick P. Cunningham: plate 47.

M. Lee Fatherree: plate 80.

Jim Frank: figures 32, 90–96; plates 8, 14, 18, 19, 27, 30–32, 36, 41, 42, 44, 45, 48, 52, 55–58, 62, 64, 66–68, 70–72, 81.

Carlo Gatenazzi: figure 70.

Mick Hales: plate 49.

Béatrice Hatala: plate 4.

David Heald: figure 1; plates 13, 28.

J. Ralph Jackman: figure 44.

Debera Johnson: figure 82.

Becket Logan: plates 24, 25.

Al Mozell: figure 81.

Akira Nalai: figure 87.

Adam Reich: figure 88.

John Riddy: plate 50.

Sandak, Inc./Macmillan Publishing Co.: plates 17, 20.

Bob Serating: figure 33.

David Smith: figure 22.

Lee Stalsworth: figures 16, 25, 59; plates 2, 23.

Jerry L. Thompson: figures 26, 27, 71, 83; plate 11.

Robert Van Wagner: figure 80.

Jean Vong: figure 86.

DISCARD